Catherine Millet
Dalí and Me

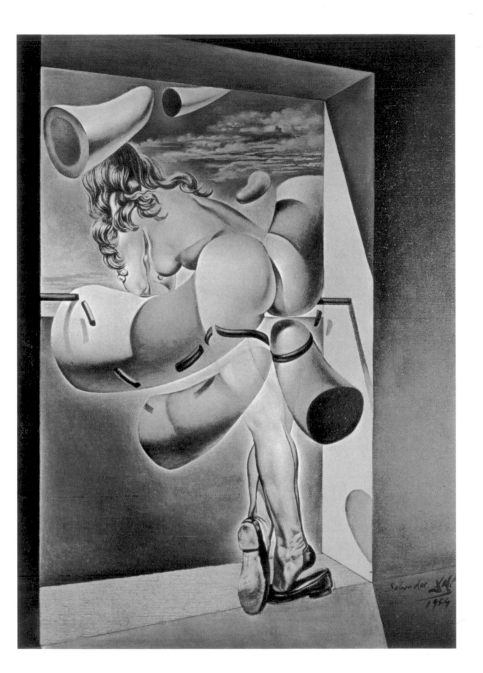

Catherine Millet

Dalí and Me

Translated
by Trista Selous

Scheidegger & Spiess

CONTENTS

Exhibition

This book is the result of about four years' sporadic study of Salvador Dalí, and particularly his writings, which provided material for several lectures. After one of these, given at a conference at the Abbaye d'Ardenne in the spring of 2002,[1] Jean-Loup Champion [of the publishers Gallimard] suggested I should pursue my work in a book. It must be said that my audience seemed to have been greatly amused by my readings from Dalí's writings. I had also aroused their curiosity as, in France at least and for specialists, Dalí had long since ceased to be the subject of serious research.

So I started rereading Dalí. And I was impressed – no doubt because I was rereading him at the time in my life corresponding to the publication of *The Sexual Life of Catherine M.* – by the precision of his observations about bodies, including his own, and the relations between them, including the most apparently anodyne of these. For example, in *Le Mythe tragique de l'Angélus de Millet* [The tragic myth of Millet's *Angélus*] **fig.1** – perhaps his masterpiece as a writer – one of the elements that unleash the obsession he goes on to analyse is a micro-event: bumping into a fisherman on the way back from a swim. "I saw the fisherman quite a long way off and yet I felt all the inevitability of the impact, due

to the coinciding clumsiness we had both involuntarily put into intercepting each other's steps, our movements proving identical and corresponding like those of a man and his image in a mirror." Imagining this *pas de deux*, the reader smiles, remembering having acted in a similarly clumsy way on a street corner. Indeed Dalí goes on to refer to "the parapraxis repeated every day on the pavement between individuals walking in opposite directions and required to pass each other". But, using Freud, he immediately strips the action of its apparent benignity: "This seems to be [...] the stereotypical and now symbolic repetition of ancestral sexual aggression."

This attention to the slightest detail goes hand in hand with a fairly great sexual honesty that was bound to appeal to me. I say "fairly great" because I know that in this area, even more than in any other, one is never sure of speaking the truth entirely, and first of all to oneself. But *Le Mythe tragique* is nevertheless an exploration, across a hundred and fifty pages, of the fear of the female genitals, involving returns to childhood memories and a frank presentation of hallucinatory fantasies. Jean-François Millet's peasant woman is seen as a praying man-

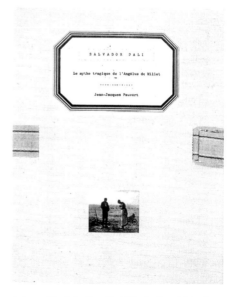

1 Cover of the first edition of *Le Mythe tragique de l'Angélus de Millet*, Paris (J.J. Pauvert), 1963

8

tis, in other words the devouring phallic mother. This first long manuscript was written in the years 1932–35, a period in which a fear of being engulfed that far exceeded any individual fear of castration was spreading across Europe, and it accompanied the formation of Dalí's theory of the paranoiac-critical phenomenon. It also belongs to the early years of Dalí's life with Gala, whom he married in 1934, the Gala who "cured" Dalí – this is the word he uses – of his fear of the sexual act.**fig. 2**

I said that *Le Mythe tragique* was Dalí's literary masterpiece, but I should have been more peremptory: it is a masterpiece pure and simple. Are there any other extremely detailed studies of a painting in which the analysis readily takes such detours through popular culture and is driven by the revelation of the author's fantasies? The revelation is as frank as the study of the painting is systematic. In the book's closing pages Dalí writes, "I think that I have simply contributed a document *'of extreme authenticity'* to this subject and, in so doing, have made it possible to illuminate a (perhaps) tiny part of the real content"[2] – meaning the content of the *Angelus*. Indeed a reader of the book who was as honest as its author would acknowledge that the interpretation of the picture and the fascination it exerts over the public is no less pertinent for its use of one of the author's sexual fantasies. I would not hesitate to compare Dalí's work to that of André Chastel on the iconographic fortunes of the *Mona Lisa*,[3] except that Chastel tells us nothing of his personal liking for the *Mona Lisa*, and this is perhaps a pity.

An understanding of the subjective and often buried links that bind us to a work of art is a perfectly valid means of access to an objective understanding of the work itself. In identifying one's fantasies one needs to find the right words. It is in naming that we come to understand. One word is no replacement for another. And when self-analysis uses an external object, that object comes under the same scrutiny and there is every chance that the particular truth that analysis brings to light will simultaneously illuminate the object (the work of art) that has acted as a touchstone. *Le Mythe tragique* exposes the sexual inhibitions of its author, but it also reveals the hidden, licentious face of Jean-François Millet, apparently such a sedate painter. And the anchoring of his doleful painting in the context of a contrastingly terrible myth is entirely plausible.

9

Dalí published a prologue to "The paranoiac-critical interpretation of the haunting image of Millet's 'The Angelus'" in the first issue of the surrealist magazine *Minotaure*. It was followed, in the same issue, by a piece by Jacques Lacan, "The problem of style and the paranoid forms of experience", often cited in studies on Dalí because it is regarded as a pendant to his piece. The painter and the psychoanalyst are known to have exchanged thoughts on paranoia and it is now recognised that Lacan was impressed by Dalí's intuitions.[4] In this piece Lacan accords paranoia a power of "communicability" when invested in symbolic modes of expression, in other words art and literature. He gives the example of Jean-Jacques Rousseau, "in whom the diagnosis of typical paranoia can be made with the greatest certainty [and who] owes to his own morbid experience the fascination that he exerted over his century through his person and style".[5] There could be no greater approval of Dalí's approach to Millet's so enigmatically popular painting, nor more prestigious authorization to embark on a study of the person and work of Dalí – also fascinating to a great number of people – based on the echo they have in our own psychic life.

Dalí's body

Addressing his readers, Dalí courteously begins by presenting and describing himself with the same attention to detail. So at the very beginning of *Journal d'un genie* [Diary of a Genius] he writes, "To write the following, I am wearing for the first time some patent-leather shoes that I have never been able to wear for long at a time, as they are horribly tight. I usually put them on just before beginning a lecture. The painful pressure that they exert on my feet goads my oratorical capacities to their utmost." (DG, p. 19) How could readers not feel honoured by an author motivated to such a degree? So many of them tell us or explain a whole load of things without telling us how they themselves cope with these things and put their names to their books without being present in them, that we appreciate a writer who makes his physical person and the material conditions of the writing of what is written into the frame around what he has to say.

2 Dalí wearing reproductions of Millet's *Angelus*,
photograph by Georges Allié, 1934
Fundació Gala-Salvador Dalí, Figueres

The Secret Life of Salvador Dalí similarly opens and closes with a physical presentation of the author. The first lines of the first chapter: "Fortunately I am not one of those beings who when they smile are apt to expose remnants, however small, of horrible and degrading spinach clinging to their teeth." (SL, p. 9) We should understand that this physical dignity guarantees the serious nature of the words and also the respect of the listeners. Meanwhile in the epilogue it is written, "I am thirty-seven years old. It is July 30th, 1941, the day I promised my publisher I would finish this manuscript. I am completely naked and alone in my room at Hampton Manor [Virginia]. I approach the wardrobe mirror and look at myself; my hair is still black as ebony, my feet have not yet known the degrading stigma of a single corn; my body exactly resembles that of my adolescence, except for my stomach which has grown bigger." (SL, p. 399) As the years go by the conditions change, but this does not mean that the initial "setting" ceases to be a reference point: Dalí returned to and commented on this description almost twenty years later, in *Diary of a Genius*. Significantly, he notes in 1960 that the incipient obesity of his belly has been corrected. He retouches his self-portrait: between *The Secret Life* and the *Diary*, Dalí has refined his image and learned to exploit his own myth more deliberately. However, there is no reason not to believe the self-proclaimed hero to the extent that, hero though he may be, he puts his slimming down to an ordinary operation for appendicitis.

In the autobiographical writings there is practically no scene in which Dalí does not detail the position or state of his body, the way he is dressed, or what he has in his stomach. Very often he gives the time of day. The body is not just its external appearance, which is itself conditioned by its surroundings, it is also subject to whatever it has absorbed and a prisoner of time. A convinced Freudian like Dalí knows that it is also a prisoner of its fears and desires. This is what *Rêverie* is. *Rêverie* is the most surprising, the most beautiful, and was, on its publication in 1931, the most controversial text of the Surrealist period. In it Dalí records in detail how "a very slight desire to urinate", probably of an obsessional nature, prevents him from pursuing his reflections on the frontal nature of space in Böcklin's *Island of the Dead*. These reflections ultimately give way to

a masturbatory reverie, via a comparison with Vermeer's *The Letter* and a discontinuous erection. Following a mechanism of unbelievable complexity, the narrator imagines that an eleven year-old girl is taken through a sexual initiation by her own mother and an old prostitute, and prepared for the final scene in the course of which he will sodomize her (let paedophilophobes be reassured: at the last moment the narrator's unconscious replaces the girl with "the woman I love").

In the notebooks kept in the years 1919–20, whose contents were published with the title *Journal d'un génie adolescent* [Diary of an adolescent genius], Dalí notes political events and comments on them from the point of view of a very young man of revolutionary generosity; he describes his already clear-sighted manoeuvres to attract girls; he notes the light of morning when he wakes, that of dusk during his walk on the Ramblas, and he describes his first acts of masturbation. At sixteen, Dalí confines himself to metonymy: "I felt a voluptuous emotion. I went to the toilet." He felt guilty about it: "I felt a great pleasure in the sensuality. But coming out I felt crushed and I felt disgusted with myself. As always I promised myself I wouldn't do it again." The style of *Rêverie* is more direct: "With one hand I play with the hairs above my testicles." Further on, under the effects of an image that is paradoxically less obscene than others, but which carries emotion, "At that moment I feel an erection and masturbate by hitting my penis against my belly." Every woman who has observed one of her partners engaged in this act is bound to be touched by the description of this very specific movement, expressed with such perfect simplicity.

But the most troubling sensory presence manifests itself in yet another way, through the intervention of the voice, always identifiable. Sadly it is accessible only through manuscripts or their literal transcription. Dalí wrote his main pieces in a phonetic form of French, and when one reads them in this form it is like having the master dictate into your ear! Frédérique Joseph-Lowery, who has studied these manuscripts and has published some extracts from them, had the idea of interviewing Michel Déon, who was their main adaptor: "It was often gobbledygook with no punctuation, interminable, unfinished sentences. […] He insisted on writing phonetic French with a Catalan accent."[6]

Moreover this was, as Déon said, an "accent you could cut with an axe".[7] Let the reader judge:

"Ge peut dire sans peur de tomber dans la moindre exaggeration que chaque contour de rocher, /et/des plages de Cadaques, chacune des onomalies geologiques de son peisage et de sa lumiere hunique je les conais par queur, car dans le transcurs de mes errantes solitudes, ce furent ces siluetes des pierres, et ses etats de l'umiere acroches a l'estructure/et a la substance estetique du peisage les huniques protagonists sur le minerale inposibilite des quells ge progete jour après jour toute la tension acumulai et croniquement insatisfaite de ma vie erotique-sentimentalle."

[I can say without fear of falling into the slightest exaggeration that each outline of a rock, /and/of the beaches of Cadaques, each of the geological anomalies of its landscape and its unique light I know by heart, for in the paths of my wandering solitudes, it was these silhouettes of stones and its states of light attached to the structure/and the aesthetic substance/of the landscape that were the sole protagonists on the mineral impossibility of which I project day after day all the accumulated and chronically unsatisfied tension of my erotic-emotional life.[8] Dalí writes "poAtrine" [*poitrine*, chest], "moAsisure" [*moisissure*, mould], "cette chosse [...] que moi j Apelle 'le paisage'". The same word may not be spelled the same way on the same page ("poison" and "poAson" for "poisson" [fish]), "mere" and "maire" for "mère" [mother]), so that it feels as though the writing is following the intonations of the voice. In the arbitrary distribution of capital letters, apostrophes and double consonants we recognise the emphasis that Dalí gave to certain words and his way of placing the tonic stress. It is striking. Of course he had not been a very good student at the Hispano-French school in Figueres, and Félix Fanés, who edited his teenage diary written in Catalan, suspects he had a "certain dyslexia".[9] It remains the case that he did not seek to correct this practice, adopted very early, and it seems that for him communication with words could only be oral. It can sometimes happen, when, for example, we are writing a piece intended for specific readers (a letter, a lecture), that we imagine ourselves in the act of speaking the words in front of them. Perhaps, because of a mental structure that means that some people can-

not think without thinking of themselves in performance, Dalí could only write/speak to interlocutors, however distant, anonymous or hypothetical they may have been.

"Polymorphous pervert"[10]

Ricard Mas Peinado notes that it never "bothered" Dalí to describe the romantic exploits of his childhood, any more than it did to talk about his sexuality in public. He cites an interview published in *Playboy* in 1976 in which Dalí talks about the picture *The Great Masturbator* **fig.3**: "Every time I lose a little sperm I'm convinced I've wasted it. I always feel guilty afterwards." And, as though to rectify an aspect of his fame that might have been somewhat exaggerated, "To start with, I'm not as impotent as all that."[11] The same statement appears in interviews with Alain Bosquet published in 1966, but that isn't quite the same thing as making it in the pages of a popular magazine. The sexual inclinations, repulsions and complexes described in the writings are approached in a necessarily more schematic – and direct – manner in the interviews, including the books of interviews with Louis Pauwels, Alain Bosquet and André Parinaud (this last known in English as *The Unspeakable Confessions of Salvator Dalí*). On opening these books we soon realise who we are dealing with: someone who, once he has got over his initial inhibitions, has had sexual relations with only one woman ("I swear I've only ever made love with Gala [PSD]") and is more voyeuristic than active ("personally I avoid contact, accompanying the pleasures of voyeurism with a bit of masturbation [PSD]"). Dalí takes on the problem of impotence and succeeds in rationalizing the need for abstinence in great men, artists and tyrants alike: "Men who fuck easily, and can give themselves without difficulty, have only a very diminished creative potency [...]. Look at Leonardo da Vinci, Hitler, Napoleon, they all left their mark on their times, and they were more or less impotent (ESD)."[12] He does it so openly that this extreme honesty should perhaps be seen as one of those precipitate confessions in which you come to terms with a fault that is more feared than actually present, as when you hurriedly warn, "I'm clumsy" before picking up some fragile ob-

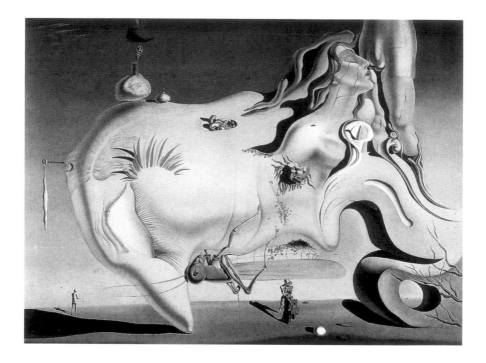

ject that you do indeed run the risk of breaking, but which can also be moved from one place to another without damage.

Added to this is a pronounced liking for scatology, doubtless less dreadful than his surrealist friends might have feared when looking at the undeniably disturbing *Le Jeu lugubre* [The lugubrious game] **fig. 4**, in which the figure in the foreground is wearing stained underpants – a fondness in any case shared, at least in part, by all who delight in tales of farts and excrement, in other words quite a lot of people.[13] Onanism is particularly celebrated in the title of *The Great Masturbator* **fig. 3**, one of Dalí's most famous pictures, painted in 1929 – a title that was moreover borrowed in a poem of 1930. As far as I know we do not have nearly as much information available on the sexual personalities of Matisse or Picasso.

I concede that Dalí gives no details on the particular form of anal onanism that he seems to have practised. A letter he wrote to a friend precisely while he

3 *The Great Masturbator,* 1929, oil on canvas, 110 x 150 cm
Museo Nacional Reina Sofía, Madrid, Dalí bequest to the Spanish state

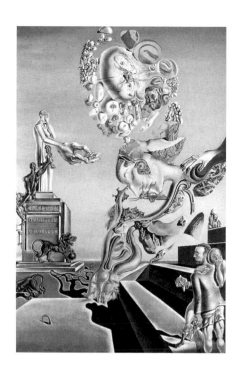

was painting *Le Jeu lugubre*, cited by Ian Gibson in his very complete biography, in any case reveals that it was no secret to his close friends: "I would be delighted for you to come and I would have my fingers (as always) plunged into the famous hole, which is the arse hole and no other."[11] We also find an allusion in the *Diary*. Dalí receives a visit from Princess P, whose husband had promised him a gift of the "Chinese masturbatory violin". Instead of this she gives him a porcelain goose. "She claims that since I devised the famous swoon by vibrations in the anus, she has fears at the border and could not see herself easily explaining the use of this instrument to customs officials." (DG, p.146)

It is unfair to claim that, while Dalí may have acknowledged his onanism and his paranoia, he was not prepared to admit to his homosexual inclinations. This view is expressed by Raphael Santos Torroella, a critic and friend of Dalí 's, in words reported by Gibson. But in the sexual register surely everyone sees and hears what they want to – or can – see and hear. Pauwels records the fol-

17

4 *Le Jeu lugubre*, 1929, oils and collage on card,
44.4 × 30.3 cm; Private collection

lowing observation: "When Garcia Lorca wanted to possess me, I refused in horror. But as I grow older I'm a little more attracted to men. [...] On a very supple, almost feminine body, the sight of erect virility delights my eyes." Clues are scattered here and there, if only in *The Secret Life*. Perhaps precisely because the idea is placed in the chapter presented by its author as "False Childhood Memories" (SL, Ch. 4) we should take seriously what Dalí said of his friend called Buchaques. "Buchaques appeared to me as beautiful as a little girl, yet his excessively chunky knees gave me a feeling of uneasiness, as did also his buttocks too tightly squeezed into pants that were too excruciatingly narrow." (SL, p. 47) Dalí had a predilection for buttocks, which he placed at the centre of major paintings such as *Young Virgin self-sodomized by the horns of her own chastity* **fig. 30**; it is tempting to correct his words to read *"above all* his buttocks too tightly squeezed into pants that were too excruciatingly narrow." Dalí openly cried, "I love Buchaques! I love Buchaques!" (SL, p. 48)

Most of the major writings cited here post-date the paintings in which Dalí reveals his emotional and sexual life, his desires and terrors. These are often very small in size, as required no doubt by their excessively detailed technical realisation, but perhaps also by the mental concentration that gave rise to them, and include *Le Jeu lugubre, The Great Masturbator, Portrait of Éluard, The Invisible Man* (1929), *The Old Age of William Tell* (1931) **fig. 5** and *The Enigma of William Tell* (1933), or the different variations on Millet's *Angelus*. Not only is Dalí history's "first painter of arses", but also one of the first painters of masturbation,[15] to which it must be added that fellatio (as dreamed of by *The Great Masturbator*) and emasculation are not so commonly found on the walls of our museums and galleries, either. Small in size, intimate in content and very directly autobiographical, to the point of being almost contemporary, in some cases, with the events that inspired them, these pictures nevertheless had immense effect, first on the history of Surrealism and later on modernism. After his meetings with Federico García Lorca and Luis Buñuel in Madrid in 1922–23, this period of the late 1920s and very early 1930s saw the main upheavals in both Salvador Dalí's adult life and in his work, from his arrival in Paris and participation in Surrealism to his meeting with Gala, then the wife of Paul Eluard, his break

with his family and lean times, soon followed by his first contracts with galleries and beginnings of support from collectors (which matters).[16] Lastly these were years in which he was developing his paranoiac-critical approach, which curiously would not be truly applied in the paintings until the second half of the 1930s – aside from the experimentation of *The Invisible Man* and *Paranoid Horse-Woman* of 1930. Aged only twenty-five in 1929, Dalí first took on the monsters that occupied his field of vision, sometimes since childhood, creating a profusion of roaring lion's heads, portraits of grimacing old men – all with protruding eyes – locusts and ants. The *Metamorphosis of Narcissus* (1936–37) ^{fig.6} came only later. Dalí wrote that it was "the first picture obtained entirely after the integral application of the paranoiac-critical method". (MPC 6 It is the image of a young man squatting above a stretch of water, who becomes a hand holding an egg from which a narcissus is emerging. Then came *The Endless Enigma* (1938), the image of the body of man lying down, which is also the body of a horse lying down, which is the body of a standing greyhound, which is a woman

19

5 *The Old Age of William Tell,* 1931, oil on canvas, 98 x 140 cm
Private collection

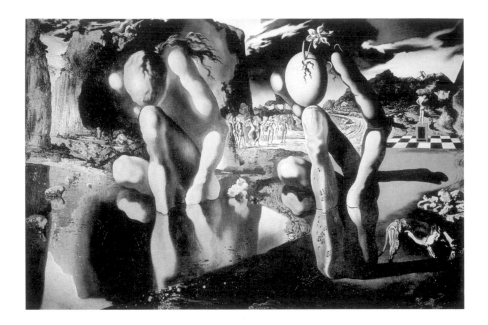

sitting next to a boat, the two of them simultaneously a bowl next to a man-
dolin, the seated woman-cum-bowl also being a face. Before calling up these
"double-images" (and even triple or more, since he envisaged obtaining up to
thirty images [MPC 37]), whose surface holds the eye as a calm swell holds a
boat, Dalí had to locate the threatening figures.

Of the iconic profusion of *Le Jeu lugubre*, we shall confine ourselves to not-
ing here, in relation to the subject we embarked on earlier, a finger pointing to
an anus, the statue's enlarged hand and of course the spattered underpants of the
figure entering the picture from the bottom right corner, his feet still on the
painter's – or observer's – own floor. On the right in *The Invisible Man*, a fright-
ening group of three adults and three youths confronts the viewer with the
theme of emasculation (also identifiable in *Le Jeu lugubre*). It is hardly sur-
prising that Dalí is at his least explicit in depicting the figure of the father. He
does this by taking a detour through the figure of the Swiss hero William Tell,
a father who placed his son in danger. The works whose titles feature Tell's name
20 notably refer to the episode in which Dalí's father, a lawyer in Figuerés (al-

6 *The Metamorphosis of Narcissus,* oil on canvas,
50.8 × 78.3 cm
Tate, London

though he was a free thinker), drove out and disinherited his son, who was sharing his life with a divorcee and whom he suspected of taking drugs.

Concrete and nothing but

During this period the images are as raw as the words, which Dalí never uses euphemistically. It was his way to retain the frank speech of his social origins and, anyway, if he was going to be the first painter of arses and the first to devote a piece of writing to pubic hair, it was better to express himself clearly: "It was necessary, entirely necessary, to come some day to the question of pubic hair. [...] It is not really possible to talk about it other than in a language stripped of euphemism, a natural language, clear and pared down, which means more or less that to speak this language it is preferable by a long way not to have too hairy a tongue."[17] (MPC 59)

However extraordinary, the stories Dalí tells us, with their characters, settings and props, are not offered as poetic transpositions, but as real people and proven facts. For similar reasons, the fauna and flora of the pictures should not be regarded as symbols. These elements are not dressed up to pander to the viewer's sensibilities. Dalí stresses that, when he is painting, he does not himself understand the meaning of his pictures, many of which have titles containing the word "enigma". This "does not mean that these paintings have no meaning [...] on the contrary, their meaning is so profound, complex, coherent and involuntary that it escapes the simple analysis of logical intuition." (MPC 53)

To psychoanalysts both amateur and professional, I say please put your demystificatory arsenal away. While it was Dalí's ambition to paint "with the most imperialist rage for detail the images of concrete irrationality" (MPC 53), this was so that we would believe in them as strongly as he did. If, in the deceptive twilight darkness, a peasant man and woman in meditative contemplation turn into two lubricious and death-dealing monsters, and the painter, rather than taming them into insubstantial mirages, restores them to their full, petrified solidity, as tangible as the fear they inspire, who could or would dare take his place and reduce these monsters to handy symbols?

According to the new conception advanced at the same time by both Lacan and Dalí, paranoia is not an error of judgement on which irrational reasoning is built, but a phenomenon "consubstantial with fact". (MPC 44) "The world is transformed [...] far more in its perception than in its interpretation", said Lacan.[18] The concrete nature of paranoid interpretation led Dalí to pay acute attention to the Surrealist objects known as "objects functioning symbolically", "object-poems" and "dreamlike objects". He gave them very detailed descriptions in an article that appeared in *Le Surrealisme au service de la Révolution* in 1931; he himself made a few striking examples (we shall see how apt this is), such as the *Retrospective Bust of a Woman* of 1933. These "delirious objects [are] intended to be put into circulation, in other words to intervene, to enter generally, daily into *collision* [my emphasis] with the others in life, in the full light of reality." (MPC 440 The power Dalí gives to these objects he also gives to the images he materializes on canvas, which are neither displacements nor symbols substituted for reality, nor simulacra debilitated by a little common sense, nor bad dreams that the first event of the day casts back into the deepest depths of the unconscious. They too provoke collisions, and that can hurt! One can "really hurt oneself" with them, or at the least be seriously inconvenienced by them. As proof of this, *Le Jeu lugubre* certainly smelled no worse than any other painting on which the oil was not yet dry, yet some of the first people to see it were really afraid of smelling shit. The episode is well known: on a visit to Cadaqués, the little port where Dalí had spent his holidays since his youth, the Surrealists started to worry and Gala decided to ask their new companion whether he indulged in scatological and indeed coprophagic practices. The account of the meeting in *The Secret Life* suggests that Dalí was initially tempted to say yes out of provocation, but decided against it faced with "the expression of [Gala's] face, exalted by the purity of an entire and lofty honesty". (SL, p. 231) Perhaps it is because he recalled this incident that in 1930, in the emblematic piece *L'Âne pourri* [The Rotten Donkey], Dalí praises the paranoid power that "uses the external world to highlight the obsessional idea, with *the troubling particularity of making the reality of this idea valid for others*" (MPC 38) (my emphasis). He was often to make this cheering observation. Is paranoid

"madness" more easily shared than reason? This would explain why, a few years later, it was the most "delirious" of them all who captured the attention of the widest public.

Dalí replied differently to his visitors in Cadaqués in the long poem entitled, like the painting, *Le Grand Masturbateur*: "the man who eats/the incommensurable/turd/that the woman/shits/with love/into his mouth". (MPC 39) We should note that in the meantime the woman who first came on reconnaissance had become the woman with whom he had established a relationship of love. But he gives another more theoretical answer when he starts to assert that the paranoiac-critical approach is an advance on the tried and tested Surrealist method of psychic automatism: "Surrealism in its early period offered specific methods to bring images closer to concrete irrationality. These methods, based on the exclusively passive and receptive role of the surrealist subject, are bankrupt and are giving way to new surrealist methods for the systematic exploration of the irrational. [...] The new delirious images of concrete irrationality suggest their physical, real 'possibility'; they go beyond the domain of psychoanalysable fantasies and 'virtual' representations." Further on he says, "Against the dream memory and impossible, virtual images of purely receptive states *that one can only recount* [Dalí's emphasis], the physical facts of 'objective' irrationality with which one can already hurt oneself". (MPC 53) When one is hurt, one bleeds. "Bloody" is a recurrent word in Dalí's vocabulary, as in his homage to De Chirico's "bloody perspectives". Perhaps one can graze oneself on their sharp corners.

Shared memories

There is one point on which I disagree with Dalí. Here is the justification he gives in the prologue to *The Diary of a Genius*: "This book will prove that the daily life of a genius, his sleep, his digestion, his ecstasies, his nails, his colds, his blood, his life and death are essentially different from those of the rest of mankind." (DG, p. 11) Of course not everyone has driven in a Rolls Royce stuffed with cauliflowers (which is how he arrived at the Sorbonne to give a lec-

ture in 1955), nor been spoiled by the Vicomte and Vicomtesse de Noailles, far less produced an equivalent body of work; yet, in addition to the presence of a body, the writings give a tangible sense of the proximity of a person who was all in all, in his daily life, fairly normal. Between the accounts of events where, as they say, Dalí made a spectacle of himself (and from my point of view this is a gift of oneself), and behind the comic exaggeration of his style, we are given access to memories, anecdotes and observations that we could or do easily share. Of course many of these appear in the account of his youth and training. One of my favourite episodes, from *The Secret Life*, concerns the entrance exam for the Madrid Academy of Fine Art. The candidate goes to the capital with his father. By chance the latter meets the concierge of the art school and, through talking to him, realises that the main criterion of the exam is the size of the drawing. Dalí's drawing is very small. There follow endless discussions between father and son, accompanied by doubts. Is the drawing as small as this knife, or this crumb of bread that his father is holding in his hand? Dalí can't remember. They argue. In the end they go to the cinema. The next day Dalí rubs out his drawing and starts again – but it's too big! His father is desperate and feels guilty. Dalí rubs his drawing out, starts again – and it's even smaller! In the end Dalí does get a place at the Academy. Surely this chaotic mix of failure and the desire to do well, of anxious affection and the impossibility of making oneself understood would awaken some memory of a family squabble in most readers.

Even in the *Diary*, whose hero more has had more time than that of *The Secret Life* in which to construct himself, the reader finds opportunities to identify. The book is structured (largely with the help of Michel Déon) around a few major events, such as the harsh discussions with the Surrealists, the account of the death of René Crevel, the memory of Dalí's meeting with Freud in 1938 or the text of the lecture given to the Sorbonne. Between these pieces, which are part of the history of culture, the author scatters observations of a less universal significance. June 1952: Dalí learns from the voice of Georges Briquet that Louison Bobet, wearer of the yellow jersey [in the Tour de France], has strained his knee. November: having just lengthily expounded his opinion on the AEAR, or Association des Écrivains et Artistes Révolutionnaires [Association of Revo-

lutionary Artists and Writers], and advanced his suspicion that Polyclitus was a fascist (!), Dalí suddenly reinforces his idea with the words, "As Raimu used to say". 4 May 1953: "On the way to Cadaqués, Gala found a sheep-pen. She would like to convert it, and has spoken to the shepherd about buying it." (DG, p. 86) 12 August: Dalí was present when a set of balloons was released. I am surely not the only person within the cultural sphere of the Tour de France to remember Bobet – that goes without saying – but, like me, many also remember the radio commentator Georges Briquet and, like many adults, I am still touched by watching balloons being released, even though it does not make me rethink Hegel's dialectics, as it did Dalí. Anyone with normal aspirations to happiness has at some time dreamed of restoring a sheepfold where they can take refuge from the vexations of the world, and I assure those who have not yet visited the fishermen's houses of Port Lligat, where Dalí was living and working, that it is a place one definitely feels one could hang one's hat.

Dalí explains to a young man who has come to ask for his advice on how to succeed, that, like the comedian Harry Langdon, he was always turning up in a place he should never have gone to. The artist arranges to be always out of place and makes sure his public is too. Readers expect to enter into the secrets of an exceptional being, only to find they are privy to the observations of Mr Anybody, as though they had got all dressed up to visit a celebrity who then receives them in pyjamas. It is highly possible that, in a book intended to prove that the daily life of a genius is fundamentally different from that of the rest of humanity, these details in which common mortals can so easily share are there to serve as a reminder, to those who might precisely become too quickly fascinated by the genius, that he really is the son of a solicitor from Figueres, a man who thinks nothing of inviting to his house, at the same time as King Umberto of Italy, an old friend of his father's (who does not believe that a king is also there), or his Barcelona publisher, an old acquaintance "from the heroic days".

The coprophiliacs of old modern art

The first book that I read by Salvador Dalí was *Le Mythe tragique de l'Angélus de Millet*. It was a long time ago and, frankly, I no longer remember the circumstances in which I read it. Perhaps it was in relation to a history of the avant-gardes that I never actually completed. The choice of this book, out of all Dalí's written output, can be explained only by the arbitrary choices one makes for fun when one is very young, allowing oneself to be guided by a name because one has not yet had time to uncover the logic of one's own ideas (and one rejects the ideas of others!). It was on this basis, for example, that Alain Jacquet painted his first canvases drawing on the triangles of the Jacquet board game (similar to backgammon), and later included a Jacquet bread bag as a signature in his famous *Déjeuner sur l'herbe*. Dalí himself made frequent reference to the meanings of both his first name ('saviour'), which he interpreted as a predestination to save painting, and his surname ('desire'), though this involved twisting the etymology somewhat.[19] The fact remains that it was not a liking for his painting that led me to read this book. At the time I tended to share the opinion of those whose perverse judgment did not escape the master: "Others […] have seen my literary talents as superior to the talent I display in my paintings" (foreword to Dalí's only novel, *Hidden Faces*, initially published in the USA in 1944). (HF, p. XI) I admired the virtuosity of his analysis in *Le Mythe tragique* and, as a good formalist, appreciated the construction of the book (whose first part expounds the "initial delirious phenomenon" that the second part methodically explores, quotation by quotation, analysing its every stage). But although the present work draws primarily on Dalí's still insufficiently recognized writings, I should never have undertaken it had my opinion of his painting not been overturned by the retrospective of 1979–80 at the Centre Georges-Pompidou, whose beneficial effects were then consolidated by the André Breton exhibition of 1991 in the same gallery.

If we can use the word 'crystallization' to refer to the link that, under the influence of a sketchy rationalization, attaches you to a body of work that is – dare I say it – 'not your type', my interest crystallized in 1998 when I was working on shit in modern and contemporary art. This study was part of a sustained

reflection begun many years earlier, notably in a book on Yves Klein published in 1982, which had shown me how much archaism could be contained by advanced modernism. At first my attention was drawn to religious and philosophical archaism: Klein, with his curiosity about scientific and technological inventions and skill in exploiting what would soon become known as media presence, took abstract painting to its monochrome extreme while simultaneously drawing on the theories of the Rosicrucians, miming the transubstantiation of gold and imagining a utopia that turned out to be the return of the state of nature and the earthly paradise. Many other utopians and engineer artists, those sorcerer's apprentices of the twentieth century, seized on new technologies with the same goal in mind – I'm thinking of Takis or, in a similar vein to Klein, Otto Piene, or, with a more rationalist approach, Schöffer and Vasarely. Before them, and without seeking a utopia, Duchamp had combined scientism and esotericism. Meanwhile Beuys's utopianism showed a fairly obscurantist naivety, combining Paracelcus with Rudoph Steiner. Even the pared-down aesthetics that gave rise to the "modernist reductionism" dear to the Marxist Greenberg were infused with spiritualism, from Malevich's encounters with God-seekers and God-builders to Mondrian's Theosophy.

As I thought about all this I realised that, all things considered, if human beings really were nincompoops, it would be more conducive to thought if the poop were real rather than some philosophical or mystic treacle. For reasons less paradoxical than they may first appear, consideration of their own excrement allows human beings to adopt an ironic distance in relation to their own condition, while the hope of transfiguration into perfect beings sucks them in. To put it another way, there is less narcissism in people who examine their own shit than in those who claim to work for the elevation of humanity.

Piero Manzoni put "*merda d'artista*" in a can – and made his oppositional "achromes" – as a response to thickly textured painting *en matière* (in matter). Gérard Gasiorowski produced a series of objects called *La Guerre* [War] and represented himself as a "wounded artist", before making *Tourtes* [Flans] with his own excrement. Erik Dietman made sculptures cast in bronze and entitled *Bronzes*, shaped like the results of the action vulgarly known in French as 'cast-

ing a bronze' (these sculptures were intended to delay the decomposition of art).[20] These individuals did not allow their status as artists to make them forget the organic aspects of their existence, nor to repress the pleasures they had enjoyed as babies; none claimed to be reconstructing paradise on earth. On the contrary, and with an irony that was drastic to say the least, they made manifest a symbolic crisis from which our civilisation has not yet emerged at the dawn of a millennium they did not live to see. But their lucidity at least helps us not to deceive ourselves and to understand that crisis a little better. Dalí was their forerunner in adopting this position: "And man's highest mission on earth is to spiritualize everything, it is his excrement in particular that needs it most. As a result, I increasingly dislike all scatological jokes and all forms of frivolity on this subject. Indeed, I am dumbfounded at how little philosophical and metaphysical importance the human mind has attached to the vital subject of excrement." (DG, p. 65)

Dalí's art and thought provide an exemplary reflection of this mix of modernism and archaism characteristic of the twentieth century. As a gifted young painter – not true of all the great modern artists – he started out by leaving aside his talent as a draughtsman to go through the great experiments of the late nineteenth and early twentieth centuries: Divisionism, Futurism and Cubism. His writings from the 1920s have a futurist tone: "Telephone, pedal washbasin, white refrigerators gleaming with Ripolin, bidet, small phonograph [...] objects of authentic and pure poetry". (MPC 11) "The Parthenon was not built as a ruin. It was built on a new surface without patina, like our automobiles./We will not always bear on our shoulders the weight of our father's corpse". (MPC 13) Leaving aside their attacks on backward-looking Catalan culture, the *Manifeste antiartistique (Manifeste jaune)* [Antiartistic Manifesto (yellow Manifesto)], launched with the critics Sebastia Gasch and Lluís Montanyá, could have been published at the Bauhaus: "*We denounce* stylistic architecture./*We denounce* decorative art that does not follow standardization." (MPC 12) In 1933, when the radical modernist who had signed these declarations began re-evaluating the modern style so despised at the time by those who thought themselves more modern still, it was, without going back on his words, to emphasize its "essen-

tially *extra-plastic*" nature, its "ornamental automatism", its "stereotyping" (MPC 46, emphasis in the text). The same concepts are in operation, the modern style being a kind of standardized naturalism. Furthermore, in Dalí's logic what is called "noodle aesthetics" is necessarily a "comestible beauty" and is advocated by the painter as a counterpoint to the "convulsive beauty" extolled by André Breton. And anything comestible is inevitably bound to end up as excrement.

These paradoxes will, I hope, be explained in the following chapters, but we now need to consider the broader dialectics of which they are a part. Dalí, who, as time went by, consumed more and more books and magazines of popular science, was fascinated by the theory of the atom and the discontinuity of matter. Transposing this idea, he draws our attention to the "pointillist" technique of Vermeer. Similarly, while criticizing Mondrian's abstraction and poking fun at Jackson Pollock, he was appreciative of the exploding forms generated by action painting and did not shrink from venturing in that direction himself. Thanks to the support of Georges Mathieu, who gave him an arquebus, he invented "bouletism", a technique in which bullets filled with colour are fired on to lithographic stones. This was in 1956, five years before Niki de Saint-Phalle's famous *Tirs* [Shots].

The twentieth century witnessed lightning advances in scientific research whose application in spectacular technology simultaneously facilitated an ever more rampant barbarism. Dalí is one of those who adopted this combination of progress and the return of the repressed, the better to reveal it – for there is reason to think that his interest in matter's discontinuity was a sublimation of his attraction to its decomposition. The person who refers to René Thom's theory of catastrophes also reminds us of the cloaca.

"July 1952/the 27th/This morning an exceptional defecation: two small turds in the shape of rhinoceros horns. Such a scanty stool worries me. I would have thought the champagne, so alien to my routine, would have had a laxative effect." (DG, p. 59) "the 29th/Because of a very long fart, really a very long, and let us be frank, melodious fart, that I produced when I woke up, I was reminded of Michel de Montaigne." (DG, p. 60) "September 1952/the 2nd/Again

this morning, while I was on the toilet, I had a truly remarkable piece of insight. My bowel movement, by the way, was perfectly exceptional, smooth and odourless." (DG, p. 64) As the *Journal* is self-glorification at its most extreme, it particularly idealizes the genius's sessions in the lavatory. Even when he is caught, one day in 1958, by what the Americans call 24-hour flu, he retains and expresses his optimism at the end of a busy day striking profitable deals with New York billionaires. The Freudian equation of gold with shit is never far from Dalí's mind.

Just as not all of us enjoy the patronage of a Viscountess, we do not necessarily share Dalí's luck of having "odourless" stools of such good omen. But, as with memories of the Tour de France, far more of us than is generally acknowledged turn round after defecating to have a look. Here again this is not really for the purposes of divination but to check on our physiological state or to assure ourselves that a belly emptied of matter of the right consistency will leave our heads clear for the rest of the day.

Though Dalí may well have claimed to despise Montaigne – "that chilly man, archetype of the spirit of reason (PSD)" – he must nevertheless have read him as an example of self-examination. In the tradition of those who have marked literature with their personal writings, we could also mention Pontormo – who could have outdone Dalí where paranoia was concerned – the Rousseau of the *Confessions* (ditto), the Michelet of the *Journal* and the Goncourt brothers or, closer in time, Artaud and Leiris, Dalí's friend Crevel and Pierre Guyotat. However, fewer are those whose autobiographical writing skims their whole lifetime while removing any hierarchy of events running through it. It is a matter of regret that so many so-called "personal" journals, whose authors are not necessarily any less egocentric than Dalí, are nevertheless more prudish – like the aunt Dalí describes in the *Diary*[21] who staked all her honour on the claim that she had never once farted in her life – or more hypocritical, and do not tell us more about more humble situations in their authors' lives. Lingering over the insignificant events of his childhood, Rousseau takes the entirely rhetorical precaution of writing, "I knew that the reader has no great need to know all this, but I have a need to tell him".[22] Well, actually, readers also need

to read it. If they are interested in an exceptional event that the author has wit-
nessed or been part of, in his meeting with this or that great figure, they will
surely want to check at the same time whether such a rich social, intellectual and
love life has any consequences on the more prosaic aspects of daily life. They
would surely be pleased to discover that there is at least something they share
with the prestigious author.

The sex appeal of Narcissus

The care Dalí took in shaping his public persona, of which the revelation of
some of his most personal habits is a part, makes him a predecessor of the avant-
gardists who claimed to have as much control over their lives as over their
works. Although Warhol in his books is far meaner with confidences about his
sexuality, he is rightly compared to Dalí. In a way, Dalí demonstrated a "Pop"
intuition at a time when the artist who would later become its icon was still a
student at the Carnegie Institute of Technology, and was a few years ahead of
him in designing motifs for fabrics[23] and occupying the pages of *Vogue* and
Harper's Bazaar. Dalí also preceded Warhol in the film world, having under-
stood the value of being photographed with the stars. Dalí began staging his
public appearances and exploiting their echoes as soon as the media that made
them possible came into being. By the time Warhol was predicting that every-
one would be famous for fifteen minutes, Dalí had already managed to hold on
a little longer, and on repeated occasions. "It is difficult to hold the world's in-
terest for more than half an hour at a time. […] I have been successful for twenty
years, to the extent that papers publish the most incomprehensible news items
of our time, sent by teletype […] PARIS. Dali gave lecture at Sorbonne on Ver-
meer's *Lacemaker* and the rhinoceros. […] NEW YORK. Dali landed in New
York dressed in a golden space-suit." (DG, pp. 171–72) And so on. While Dalí
became interested very early in photography as a creative medium, as soon as
he could he also became interested in it as a vector for celebrity. Just as Yves
Klein had himself followed by the photographer Harry Shunk, so in 1941 Dalí
began a long collaboration with Philippe Halsman. One could write a book

31

about the very studied poses, the elegance – which we might describe as "off-beat" – of the suits, the extravagant disguises and repertoire of grimaces of the figure taking shape in front of cameras. In addition to Halsman, Dalí was photographed by Man Ray, Brassaï, Català-Roca, Eric Schaal, Platt Lynes and others. It was no coincidence that one of Dalí's friends, Robert Descharnes, who became an interpreter of and specialist on his work, started out as a photographer. As David Vilaseca rightly observes, "In the model of subjectivity proposed by Dalí, the self no longer pre-exists its representations, but is on the contrary constituted performatively through them, entirely externally, on the surface; in a word, ex-centrically."[24]

The media era was just beginning, but writing perhaps brought more weight to this work of constructing an image. *The Secret Life of Salvador Dalí*, first published in English in 1942, and *Diary of a Genius*, published in 1964, are dense books. Not published until 1963 but written in the first half of the 1930s, *Le Mythe tragique de l'Angélus de Millet* can be regarded as belonging to a new genre, the autobiographical essay. Dalí became annoyed when, in 1962, the collector A. Reynolds Morse wanted to publish a notebook from his youth. He must have feared that those pages, which he had not revised, might damage the image he had so carefully refined in his other books. We should note, however, that he did give in, on condition that the publication would not be made commercially available. These notebooks, seven of which are now published under the title *Journal d'un genie adolescent* [Diary of an adolescent genius], prove that at fifteen the budding genius displayed a stunning precocity in his capacities for observation and self-observation. And his fears were unfounded: it is amazing to find the seeds of so many obsessions that would be cultivated later.

All this material, in which we can include the other, extremely numerous publications that are not autobiographical but in which Dalí cannot resist being extremely present, did not discourage the insatiable hordes who came to his door with their note-pads and tape-recorders. As we can imagine, they were playing into Dalí's hands. Having told his own story once, Dalí told it again, like a painter who never stops retouching his painting. These conversations are structured around the same major themes (Gala, death, religion, eroticism and

so on) and in them we reread – in slightly different versions – anecdotes we have already encountered in *The Secret Life* and the *Diary*. The greatest quantity of new material or new detail is to be found in accounts and thoughts of a sexual nature, which may be due simultaneously to the period, the oral character of the narration, encouragement from the interlocutors – and the maturity of the interviewee. The confidants are all well-known: Alain Bosquet (*Entretien avec Salvador Dalí*, 1966), Louis Pauwels (*Les Passions selon Dalí*, 1968) and André Parinaud (*Comment on devient Dalí, les aveux inavouables de Salvador Dalí*, 1973). The latter two books are written in the first person singular, which produces a bizarre effect when the style, which is moreover very pure, is that of Pauwels rather than Dalí. We are even treated to an interweaving of styles when we reach the appendix in which Dalí comments on what Pauwels has written, saying "I" in his place, and, to a lesser extent, with the quotations in bold that Parinaud includes throughout his book so that the reader can experience the master's "inimitable language".

Were these interlocutors hoping to discover the truth of the human being behind the myth? Even when they ask impertinent questions, one suspects they did not believe there was one. Rather they wanted to find out if the myth definitively was the truth. In his preface Pauwels says that Dalí "does not distort reality, he […] returns it to its initial ductility." Parinaud's foreword begins with the lines, "This book is a dalinian novel and if the hero, Dalí, speaks in the first person, this is simply a stylistic stipulation. Dalí never says "*je*" [I], but "*jeux*" [games]." Many authors, possibly less shrewd than these two, have noted how hard it was to grasp the character even when he seemed to open himself up so willingly. But this is because it would be wrong to try to flush out the man hiding behind the appearance. Dalí must be looked at in the way that we look at his paintings from the 1930s. They contain several images that are not arranged one behind the other, like theatrical backdrops, but intertwined on a single surface.

Although it is an everyday phenomenon, we continue to be delighted, amused, scandalized or appalled, depending on our characters, that it should be the most narcissistic individuals, to the point in some cases of making it their job

– actors, supermodels and the greatest hams among tennis and football players – who attract the most attention from those whom we hardly dare describe as their fellows. In every case we are amazed that people who are absorbed by self-love, and so, we think, least likely to regard the feeling of love as something to share, do not discourage the love that a great many others feel for them. Such love can sometimes entail seriously aggressive reactions, as when Valerie Solanas lodged two .22 bullets in Warhol's abdomen. "The Divine Dalí" was protected against such a thing by his good fortune (or by his seemingly more familiar exchanges with his flock?), but it is clear that his celebrity and the admiration of his fans were equalled only by the loathing with which he was viewed by another section of the public. The admiration and desire for identification that excellence in the practice of an art or any other discipline engenders are not enough to £explain everything; we can see from our own private lives that a Narcissus can focus the attention of others without having displayed any merits at all. At the end of his study, cited above, carried out as an investigation, in other words without indulgence, Ricard Mas Peinado offers an explanation: "Exploring boundless egocentricity helps us to know ourselves a little better".

I would go further: exploring egocentricity like Dalí's helps us break down our own inhibitions. Going up close to a statue, even one partially self-erected, we are forced to measure the height of our own gaze against its size and to try to regain a piece of the space it disputes with us. While our ambivalent feelings towards Narcissus may include the desire to imitate him, part of that is the desire to imitate his autonomy. His attraction is due partly to the fact that he frees us from the duties that a shared love imposes and gives us access to the royal road of self-love. While ceaselessly watching over Dalí, Gala is also a model of very great freedom. We have the right to say to ourselves, let's dare to do as he does. Allowing oneself a little self-absorption soothes the need for aggression engendered by the other's self-absorption (it diverts reactions like that of Solanas).[25] While Dalí's entourage seems to have included a few natural eccentrics, he undoubtedly encouraged them down that path by his own behaviour, and also provided them with a social space in which it was possible.

That the exhibition of oneself leads to self-revelation by others was some-

thing of which Dalí was well aware. However narcissistic he may have been, he would not have been the painter and writer we know had he settled for being the sole object of his own observations. We have to assume that he agreed to so many meetings and received importunate journalists as much to satisfy the voyeur that he was as for the happiness of being a focus of interest. But there was surely an even greater satisfaction in responding to both desires at the same time. Certain of having drawn his own portrait, as he understood it, in his autobiographies, Dalí could afford to be curious about the touches added to it by others and, simultaneously, oblige those others to appear in what then became a double portrait. At least he did not regard his interviewers as machines for asking questions, but as people whom he involved in the interview and whose questions he sometimes turned back on them. To the journalist Jacques Chancel, who felt duty bound to ask him about his appetite for acquiring wealth, Dalí retorted that this was indeed one difference between them, Dalí having to earn money to work while Chancel worked to earn money.[26]

The portraits he creates in his writings are always sharp. (The portrait of Picasso is striking in its truth, Picasso who "will not be any taller but [who] will bear his flies in that imposing way that the author of *Faust* showed before him. [...] If he smiled at a wardrobe the smile came from his overcoat." (MPC 54). The first chapters of *Hidden Faces* are largely a satire, entirely plausible sadly, on the aristocratic and bourgeois milieus of the immediately post-war period, who are shown as frivolous and thoughtless, their main concern being "to cuddle up" to avoid thinking about danger. Had Breton, who was so worried about Dalí's pseudo-Hitlerism during this period, actually read what was being published by Éditions Surréalistes itself? In *La Conquête de l'irrationnel* Dalí demonstrates a staggering lucidity: "Our contemporaries, systematically cretinized [...] by imaginative fasting, by famines of paternal affection and all sorts, vainly seek to bite into the senile, triumphal sweetness of the plump, atavistic, tender, militaristic and territorial back of a Hitlerian wet-nurse."[27] (MPC 53)

Among famous people there are those who "control" their image and those who play with it. The relationship to images of oneself circulating in the media does not depend on narcissism alone; it may depend as much, if not more, on a

greater or lesser degree of intellectual maturity. Marie-José Mondzain observes that, contrary to what might be expected in a society that has grown used to the proliferation of images, there is "a fascinated, mute adhesion to everything we see, an infantile, magical gluttony of the eye".[28] For her this evokes primitive practices and delirious behaviours, when a subject is incapable of telling the difference between himself and his reflection in a mirror or a photograph. In her view those who believe that they "own" their image are in fact "possessed" by it. From this point of view Dalí was not credulous and fooled still less. Nor was Warhol, fatalistically allowing himself to think that if he looked at himself in a mirror he would see nothing, because people claimed that he was himself a mirror and so logically, "if a mirror looks into another mirror, what is there for it to see?"[29] In a mirror, as in everything that came before his eyes, Dalí was certainly able to see several images. He worked with photographers like a true actor, in costume, striking significant poses, exploiting his physiognomy: his habit of rolling his eyes, in the manner of Groucho and Harpo Marx whom he admired, is as much a part of his image as his moustaches. But he does not seem to have feared the cameras that captured images at random when he was part of a crowd. Indeed he behaved as though he completely accepted being multifaceted and as though splitting in two was one of his characteristics. In his writings Dalí often talks about himself in the third person and, in his novel, manages to refer to a "Dalinian maxim". This is not merely megalomania, it is also proof that the "I" had fully incorporated the "he" by which it was designated in the mouths of others. As if that were not enough, again in his novel Dalí suddenly intervenes, mingling with his characters and addressing one of them, "But I see you on your knees, Solange de Cléda, in your room when you are alone…" This direct address appears on a page that deals with the fact that "Solange de Cléda offers psychiatry a truly singular case. […] Splitting more and more every day"!

In 1966, in a collection entitled "Lettre ouverte" [Open letter], Dalí published an open letter to … Salvador Dalí. The exchange of letters between the "anarchistic" or "surrealist" Dalí and "Dalí Avida Dollars", who call each other "excellentissimo" and "beloved", but who sometimes also do not agree, is an artifice intended to comment on opinions circulating on Dalí, and indeed to re-

spond to attacks addressed to him, or to his double, adopting and retouching the image that others have of him. You have to live with this other self that society assigns to you like a Siamese twin, particularly if you are a public figure. In the short piece *Borges and I*, Borges summed up the situation very well: "I know of Borges from the mail and see his name on a list of professors or in a biographical dictionary. I like hourglasses, maps, eighteenth-century typography [...] he shares these preferences, but in a vain way that turns them into the attributes of an actor." Borges ends with a question: "I do not know which of us has written this page."[30] At the end of *Lettre ouverte à Salvador Dalí*, one gets a bit lost and it is hard to tell which Dalí is addressing the other. However, one of them notes the transcription errors made by Alain Bosquet in the interviews published shortly before and dryly criticizes the writer's work as "based on surrealist banalities and commonplaces". Yet – and let us salute this rhetorical detour – "the plebeian word 'bastard' will never leave or fall from the lips or pen of Dalí". Of which Dalí? It's a cunning manoeuvre. Those who have taken Dalí on, or betrayed him, meet with responses from several Dalís. So who exactly was their target? Where is he? It is quite possible that he is primarily in their own heads. One more Dalí! One among many ….

The Bottle of Optrex

While we can ask which Dalí is the target of those who criticize Dalí, the same also applies to those who love him. Perhaps to love Dalí is precisely to accept the colourful, protean being or, to put it another way, the monster. Severo Sarduy, a great connoisseur of Baroque art, gives a very precise definition of the meaning of the word 'monster' in the theatre of Calderón: "It implies not the effect of animaloid or grotesque features, but *the illogical meeting of one species and another*, of two possible but contradictory faces – 'species' derives from *spicere*, to look, to see, and has also meant external beauty".[31] So the Dalí we see here in undershirt and top hat, there dressed as a dandy **fig.7** – smoking jacket, Texan shirt, tweed trousers and Catalan espadrilles with, unless I'm mistaken, jasmine blossom behind his left ear – and striking a friendly pose on the arm of a Port Lligat fisherman, this magnificent Dalí is a monster as Calderón and Sarduy understand the term. How can one be at once man of the world in evening dress, gentleman farmer and Catalan peasant? Observers faced with this composite being find it hard to grasp the logic of his look, though they may at least deduce that this man of many faces has several pairs of eyes looking in different directions at once.

39

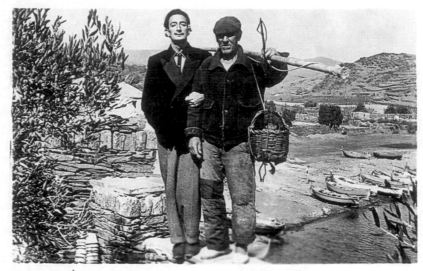

CADAQUÉS Salvador Dalí y un Pescador de Port-Lligat

Gala was apparently first to know how to adapt to the "monster", since we learn by reading a piece of wonderful shamelessness, the chapter of the conversations with Parinaud entitled "How to make love with Gala", that "Each time Gala makes love with all the Dalís that have existed". The interesting thing about this remark is not that it allows us to imagine playful scenes in the course of which the waggish lover would create many different situations and positions in order to stimulate his partner's desire afresh, but that the idea of a multiple Dalí is associated with that of multiple images. It is not so much that Gala could feel she was making love with several men through one alone, it is that this man could embark on copulatory activity only by bringing to it all the images he had recorded in his lifetime – starting with the clocktower of the church in Figueres that he used to look at while masturbating as a teenager – and corresponding to the different stages of his life, the different people he had been. As he put it, "The pleasure of the flesh can be fulfilled only if a particular dimension is created, a kind of stereoscopic phenomenon, an imaginary hologram as real as reality. [...]

40

7 Dalí holding the arm of a fisherman of Port Lligat, postcard

I need all these suddenly present images of my past that form the fabric of my entire life." (UC p. 96) To explain this sensation, he makes a comparison with the multidirectional vision of flies. Just like the fly's multi-faceted eye, Dalí as a carnal being receives his impulses from masses of images reflecting the many different shards of his personality.

The eye of the Zeiss

The Dalí of 1939 did not yet have his upturned pointy moustache – at that time only his eyebrows traced two very pure arcs (at one point Dalí is known to have blackened his eyebrows) – but he already had a talent for exhibiting and staging his own persona. For example, it was in that year that, unhappy that the managers of the Bonwitt Teller stores of New York had, without warning, modified the window dressings they had commissioned from him, he caused a scandal by tipping a bathtub through one of the windows involved, without actually injuring passers-by or himself, though his deed propelled him through the broken glass. A photograph taken that same year shows him lying down fully dressed in another bathtub – happily empty – wearing a dressing-gown over his clothes **fig. 8**. He seems absorbed in the execution of a drawing. Of course the image is intended to make us believe that inspiration cannot wait and that nothing disturbs the artist at work, be it his position, which can't be that comfortable, or the presence of the photographer (which we're supposed to forget). The clean, anonymous setting looks like a hotel bathroom. Only a few objects can be seen: a sponge in the soap holder, two clean towels on a bar and a bathmat that has been slightly displaced, no doubt when the painter climbed into the bath. To me this minute trace of disorder is evidence of the naïvety with which this kind of reportage was produced at the time, as I think that today a professional photographer would have thought to straighten out the mat. However, when I opened the magazine[32] in which this photograph was reproduced, what immediately struck me was not this detail, any more than the drawing Dalí is pretending to make. No, what I immediately noticed was the bottle of Optrex placed in one corner on the edge of the bath. I have just measured it: in the re-

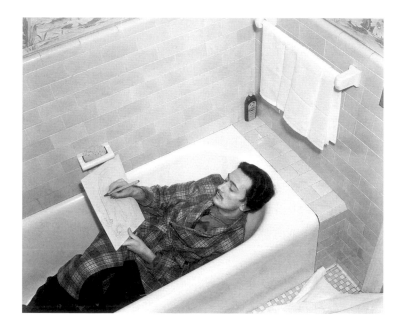

production the bottle is no more than a centimetre high. So you have to be pretty sharp-sighted to identify the shape of the bottle and the brand label immediately. I wonder what sharp-sightedness signifies in this case.

The beginnings of an answer can be found in a piece Dalí published in 1935 in *Minotaure*, "Psychologie non-euclidienne d'une photographie" [Non-Euclidean psychology of a photograph] (MPC 52). This he terms "snooper's attention [*attention fouinarde*]", explaining that one must be capable of "turning one's eyes from the hypnotizing centre of the image". Inviting his readers to examine a photograph that is at once banal and strange **fig.9** – three people posing by the front door of a shop, two women standing proudly and a man, behind, like a ghost in the shadow – Dalí draws their attention to the insignificant detail of a tiny, empty cotton-reel lying by the kerb in the bottom-left corner of the photograph. It follows that this "livid piece of rubbish" is calling out "loudly" for interpretation and that it is in fact a "mad thing". The "snooper's attention" is thus reserved for those who refuse to have their gaze trapped by the

42

8 Dalí drawing in a bathtub, photograph, 1939

net of the world as it is organized, notably according to the laws established by Euclid, particularly when that world has been framed by a photographic lens. Sharp eyes pierce the image of the world that is imposed upon us. True, I do have good reason to recognize a bottle of Optrex, the lotion for cleaning and refreshing tired eyes, having often been afflicted with painful conjunctivitis that deprives me of my favoured mode of perception and hinders me in carrying out my profession. But perhaps this bottle drew my attention because I spontaneously refused to credit the excessively artificial scene proposed by Dalí and his photographer.

The advantage of the "naked, lashless eye of the Zeiss" (a well-known camera brand) is "that it is invulnerable to the red rash of conjunctivitis" (MPC 4). This Dalí notes in 1927 in *La Photographie, pure création de l'esprit* [Photography, a pure creation of the mind]. That a painter should give priority to visual perception seems obvious, but, to gauge the specificity of Dalí's work, we should think of the way that his contemporary Marcel Duchamp discredited "retinal" painting, while pursuing his own exploration of perspective and optical illusions – admittedly not in his pictures. Dalí is no less cerebral than Duchamp, with the difference that in his case speculation takes second place to the specular.

Let us briefly recall the early days. As a child Dalí discovered modern painting through the Impressionism of a family friend, Ramon Pitchot. "It was this

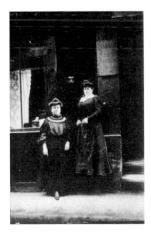

43

9 Illustration to "Psychologie non-euclidienne d'une photographie", *Minotaure*, no. 7, June 1935, p. 56

School that impressed me the most in my life." (VSD) He was fascinated by the "paint marks placed apparently without order […] and which suddenly became magnificently ordered if one knew how to take the right distance […] to communicate a deep, sun-drenched image of a stream, landscape or face." (UC p. 42) He adds, "My eyes were popping out of my head". They were never to stop. In one of the best studies on Dalí, Jean-Louis Gaillemin observes that in *Petites Cendres* [Little ashes], an important picture of 1927–28, the profile with a widely staring, bloodshot eye is a self portrait.[33] The more time passed, the more often Dalí posed before the camera with eyes exaggeratedly open, signifying that he was capturing the image of his photographer as much as the latter was capturing him.

Throughout his life Dalí remained faithful to this inherited conception of Impressionism; as late as 1979 he painted a pointillist version of Millet's *Angelus*.[34] He saw Vermeer as a precursor of this method. While we may admire the Dutch painter's smooth-surfaced scenes, Dalí puts us right: the paranoiac-critical copy of *The Lacemaker* **fig. 10** that he made in 1954 reveals its near-divisionism, accentuated by the relatively rough canvas on which Vermeer painted, a choice imitated by Dalí. He never ceased repeating that Vermeer was the contemporary and compatriot of Anton von Leeuwenhoek, inventor of the microscope. He was fascinated by everything connected with optical research, stereoscopic sight and holograms, which he attempted to use in a few works of the 1970s.

This absolute priority given to the eye was closely connected to the model of photography, whose systematization and objectivity had to be equalled. This model returns obsessively in Dalí's writings from the late 1920s, several of which deal with photography or with documentary film: in addition to those cited above are *Le Témoignage photographique* [The photographic witness] (1929) and the six articles collected under the title *Documentaire* [Documentary], published in *La Publicitat* throughout 1929, in other words while Dalí was fully involved in Surrealism. In a way he turned Leonardo da Vinci's formula back on itself. If painting is a *cosa mentale*, this may be because "knowing how to look is a way of inventing". (MPC 4) And photography helps us look. "The simple fact of photographic transposition already implies total invention: the recording of an en-

tirely new reality". (MPC 20) Back in Cadaqués after a stay in Paris, assailed by childhood memories and the images they brought with them, Dalí decided to paint what would become *Le Jeu lugubre*: "After a few days in which I gave my-self over entirely to the pleasure of following these images, I decided to make them into a painting by reproducing them as faithfully as possible according to the time they appeared. My personal taste would not be involved." (VSD) Thinking about what the picture represents (soiled underpants, buttocks spit-ting blood, a face hiding its shame), and if "personal taste is not involved", we can see just how far the subject has distanced himself from his most distressing fantasies. The pictorial objectification of these fantasies that Dalí produces is per-haps worth a few years of psychoanalysis. Perhaps the neutral detail of the brush is as effective as verbalization on the couch.

Gaillemin's book highlights the fact that the theory of objectivity was de-veloped in exchanges with Federico García Lorca during the 1920s. The two 45

10 *Paranoiac-Critical Painting of Vermeer's "Lacemaker"*, 1954–55, oil on canvas over wood, 27.1 x 22.1 cm
The Solomon R. Guggenheim Museum, New York

friends both worshipped "Holy Objectivity" and elaborated a corpus of shared references centring on the pierced yet impassive, hieratical (if graciously lop-sided) body of St Sebastian (who happened to be the patron saint of Cadaqués). St Sebastian receives the arrows without being affected by them, a recording machine showing now more emotion than a camera. In his *Ode to Dalí* (1925), García Lorca advocates a cold aesthetics: "The painters of today in their white studios/Cut the aseptic flower from its square roots";[35] in *Sant Sebastia*, a poem of 1927 that Dalí dedicated to García Lorca, we read, "The more I looked at his face [that of St Sebastian], the more curious it seemed. That said, I seemed to have always known it and the aseptic morning light revealed its smallest details with such clarity, such purity, that I was impossibly moved." (MPC 1). Or again, "In the upper part of the heliometer was St Sebastian's magnifying glass. [...] I put my eye to the magnifying glass, product of a slow distillation, at once numerical and intuitive. Each drop of water, a number. Each drop of blood a geometry." St Lucy, whose name means "light" or "path of light" and who pre-sents her eyes on a plate, was also part of their hagiographic repertoire. Their pantheon included Giorgio De Chirico for his impeccable separation of forms and space which, let us remember, Dalí called "his bloody perspectives". (MPC 9)

In subsequent years, taking this ideal to its logical conclusion, Dalí went so far as to define painting as "hand-made, colour 'photography' of concrete irra-tionality". (MPC 49) Perhaps this definition contains an echo of something said by René Crevel, who, as early as 1924, was writing of De Chirico, "The ques-tion of art is no longer posed. This is the most exact, the most precise, the most objective photography of an inner landscape."[36]

Painting as "hand-made photography" is a phrase dating from 1933–34. By that time Dalí's passion for impressionist and then photographic objectivity had given way to the paranoiac-critical method. It cannot be over-emphasized that the latter differs from surrealist automatism by being anchored in the visible. Gaillemin writes, "It was with looking and not with dreaming or any kind of abandonment to automatism that Dalí was ready to face the forces of the un-conscious that began to emerge in 1927". He explains the young painter's de-velopment as follows: "It was looking that enabled Dalí to preserve and trans-

form his aesthetics of objectivity into a paranoid aesthetics. [...] The wandering eye of the lens returns to its socket, but disorganizes the world at will." It disorganizes and resegments the world to suit itself. Gaillemin also observes, "The limit of automatic recording is the eye that frames, that slices", the "lancet-eye".

Detailed inspection

I shall not discourse at length on the feeling – alarming for some, including me – you may have while looking at some of Dalí's paintings, when you have to accept the obvious fact that you will never exhaust all their details, despite or because of the perfection with which they are rendered (when necessary Dalí used a magnifying glass). This is one of the main experiences shared by lovers of his painting and in his book Luis Romero well describes the challenge of taking a long wander through a painting, in this case *The Hallucinogenic Torero* of 1969–70. As I have chosen to base my discussion primarily on Dalí's writings, I shall confine myself to noting the poems, contemporary with the articles cited on photography, that are swarming with very small and indeed minute elements (moreover one of these poems is called *Poème des petites choses* [Poem of small things], some of which, such as the ants and "eyelash hairs", return obsessively, as they do in the paintings. In *Poisson poursuivi par un raisin* [Fish pursued by a grape] (1928), the observer's sharp eye makes out the two sides of a blade of grass: "The finest grasses have an illuminated side and a side in shadow, like planets". (MPC 16). In *Une plume* [A feather] (1929) he detects "A feather, which is not a FEATHER, but a very small blade of GRASS representing a little sea-horse". As is only right, details can be hallucinatory – and cruel, as in *Mon amie et la plage* [My girlfriend and the beach] (1927): "One morning with Ripolin I painted a newborn that I then left to dry on the tennis-court. After two days I found it bristling with ants that made it move to the anaesthetized, silent rhythm of sea-urchins. However I at once realised that this newborn child was none other than the pink breast of my girlfriend, being frenetically eaten by the shining, metallic thickness of the phonograph. But it wasn't her breast either: it

was little pieces of my cigarette paper nervously grouped around the magnetic topaz of my fiancée's ring." (MPC 7)

In 1927 biomorphism – scattered organic fragments in bare landscapes – was still distancing Dalí's painting from the illusionist realism by which it would later be characterized; however, Dalí boasted that a Cadaqués fisherman thought his canvas was better than the real landscape "because you can count the waves in it." (MPC 1) He wanted nothing so much as to equal the precision of Vermeer. And the same requirement applied to his writing. In *Hidden Faces* he proposes to describe [the] physical embraces of his protagonists "with the objectivity of an entomologist".[37] To be honest, let's say that he describes waiting for the embrace far more than the embrace itself, this waiting being one of the book's key themes. But just as waiting, an interval of time, often corresponds to a spatial interval that must be removed, the situation and position of bodies in space are always perfectly described. This placement of bodies requires that the setting, including its sound, be also perceived in its entirety, so that the imagination can complete things unattainable to the eye by reference to the sounds. Let the reader judge. Angerville loves Solange, who has been rejecting him for years. As a consequence of the chaos of war, they are obliged to live under the same roof, without ever touching. In the end, "He came close and rested his head on Solange's garnet-coloured bosom. Thus they remained without exchanging a word, as the light of the gasoline lamp began to flicker more and more feebly around its mantle, that hung crooked and half consumed. Before them the seepage of the rain on the wall shone like the slimy trail of a giant nocturnal snail. From the kitchen came the sound of the dishpan being emptied and of plates being piled upside down on the draining board." (HF p. 231) But we have to wait some more before Angerville attains his ends, on the dining-room table, "on this table of their abstinence, where for two years, at each meal, they had swallowed their desire the wrong way". (HF p. 253) Two years to cover a space the breadth of a table, in other words of a size corresponding more or less to the enigmatic gap between the peasant man and woman in *The Angelus*. Two other characters in the novel are seen from afar, in a sitting-room, "the two haunting blond figures of Veronica and Baba stood out from the rest, with

the same anguishing fixity as the two figures of the famous 'Angelus' painted by Millet". (HF p. 113) Later these figures are "as a pair of praying mantidae, in the role of Tristan and Isolde devouring each other". (HF p. 124) In the last chapter they play chess, "so quiet, so close, facing each other, their heads slightly bent over the chessboard, like the couple in Millet's 'Angelus' in a sitting posture." (HF p. 280).

The main hero, the Comte de Grandsailles, is gifted with such keen eyes that he sometimes finds himself, like the painter of critical paranoia, looking at double images. Listening to the account of a political demonstration in the streets of Paris, he "sees" it unfold "as in a film montage", so that his guests, in the drawing-room, become merely "a kind of background". In the course of a candlelit dinner he enjoys an "inquisition of optical physics" (HF p. 31), having discovered that the silver objects on the table contain the distorted reflection of each of his companions. His attention shifts from one detail to the next and these shifts give rise to associations. "A stark naked young Silenus, masterfully chiselled in oxidized silver, was holding down a rough branch of the candelabrum, bringing the light very close as if in calling attention to the budding curves of Solange de Cléda's breasts exposed above her décolleté. Here her skin was so fine and white that Grandsailles, looking at her, cautiously dipped his dessert spoon into the smooth surface of his cream cheese."(HF p. 33)

Throughout, the story is told by a narrator who seems to be alternately provided with a microscope and a pair of binoculars, which he gradually moves over the surfaces of things and bodies. Here's how we enter the Count's house at the beginning: "In the Chateau de Lamotte the best situation was that of his room and in this room there was a spot from which the view was unique. This spot was exactly limited by four great rectangular lozenges in the black-and-white tiled floor, on whose four outer angles were exactly placed the four slightly contracted paws of a svelte Louis XVI work-desk signed by Jacob, the cabinet-maker. It was at this desk that the Count of Grandsaille was seated, looking through the great Regency balcony at the plain of Creux de Libreux illuminated by the already setting sun. [...] Nevertheless one thing egregiously marred for him the perennial harmony of its landscape. This was a section about three

hundred metres square where the trees had been cut away, leaving a peeled and earthen baldness which disagreeably broke the melodic and flowing line of a great wood of dark cork-oaks." (HF p. 18)

Dalí's precocious intellectual maturity – the kind that allows adults never to dismiss entirely the child they once were – is reflected in the fact that almost all his obsessional themes are set out very early, in the diary he kept as a teenager, the first articles he published in student magazines, the first poems of the late 1920s, and sometimes even before they appeared in his painting. Grasshoppers and the fear they induce are so present throughout his work, starting with *The Great Masturbator* on the one hand and *Le Mythe tragique de l'Angélus de Millet* on the other, that it is not surprising to find them already mentioned in the diary he kept in 1920. The reappearance of more singular details gives one the impression, in noting them, of breaking into Dalí's unconscious. For example, thinking of the strange, very small picture, *Portrait of Gala with two lamb chops balanced on her shoulder* (1933), it is disturbing to read, in the notebook of 1920, the description – highly successful from a literary point of view – of a meal in the country at which "wine flows, chops fly over heads".

In *Mon amie et la plage*, cited above, we find, among other things, putrefaction, ants, sea-urchins, the female breast and the modern camera. There is also talk of "delicate lancet cuts on the curved pupil"; obsessions with the eye and the lesion that threatens it are endlessly recurrent. These obsessions are illustrated as much in the poems as in the autobiographical writings that anchor them in experience. Dalí often describes how, while playing as a child, he would come upon the corpses of small animals made to move by swarming vermin. We can well believe him. Similarly, the image of "the pink breast of my girlfriend" echoes scenes from the *Journal d'un génie adolescent* and *The Secret Life* in which evocations of seaside walks with a girl combine early feelings of sexual arousal with inoffensive experiments in sadistic relationships, both equally plausible. Through *Mon amie et la plage* we witness the establishment of the device of multiple images, long before it was theorized and ten years before it was truly illustrated in the paintings: the newborn that looks like a sea-urchin, which is in fact a breast, which is in fact a pile of little papers. Very early Dalí built up a pool

of visual impressions on which he later drew continually, from one picture, one piece of writing, to the next. He was a master of recycling long before the word passed into everyday language, returning throughout his life to the same observations, the same scenes, the same anecdotes, enriching them and adding new comments. His retina had been imprinted in childhood with bottomless images.

'Categorical' realism

Sideless and bottomless. Entering the Comte de Grandsailles's bedroom as we have, we first identify the spot where we are supposed to stand by focusing on the feet of the Louis XVI desk, before looking out at the distant perspective stretching away from the window. This is a cinematographic vision. The camera-eye moves and focuses alternately on objects near and far. However it's not any old film; this is a documentary. From April to June 1929, in *La Publicitat*, Dalí devoted no fewer than six articles to the documentary mode. The articles are presented as reports of things he has seen and heard during a stay in Paris, not arranged in any hierarchy, from meteorological observations and small news items noted at random, to the price of a painting by Miró or a cocktail recipe. He also mentions a film that uses "the maximum degree of slow motion possible today: 20,000 images per second".[38] (MPC 32) This speed gives one the leisure to grasp a shot in its slightest details and to peruse it systematically: "The documentary notes anti-literarily the things said to be of the objective world". (MPC 30) Moreover a parallel is drawn with surrealist writing, which, "transcribes with the same rigour [...] the REAL, liberated, functioning of thought." The most disorientating passages correspond to the camera-eye's shift from one very big close-up to another, which, because of the inversion of the relationships between things, requires viewer-readers to refocus their own inner eye in order to understand what's going on. For example, "There are, still, five biscuit crumbs situated in the manner indicated in illustration number 1.[39] After the crumbs, and following on the right hand, there is a black gulf around two spans wide. On the other side of the gulf 'there is' a table hooked to a long, thin trail

of smoke. On this table are the number 86, a cup, a teaspoon and four finger-tips. As this is noted the biscuit crumbs change place and form a new group (il-lustration number 2). [...] Suddenly, very quickly, the following happens: seven hands chase each other, three gloves enter three hands, two hands jump up on to a chair and one on to a table three metres away." (MPC 34) We can see that objective description does not prevent twists and turns[40] The reader's aware-ness, initially as stripped of preconceived ideas as the case of a Zeiss camera, al-lows itself to be caught by the sudden departure of the group of clients leaving the café tables.

Dalí asks the question, why does a novelist who aims for realism "never speak of things as simple as those that follow? The oscillations caused by the distance between the heel of the character's shoe, during the fixed time of the conversa-tion, and some other object, a sponge for example; the noting of a match lying on the ground, at the other end of the room, with no relationship to the char-acter ..." (MPC 30) Dalí the writer practises this extremist realism, for exam-ple, in *Un jeune homme* [A young man]: "The sponge in question was some dis-tance from the shoe heel of a character standing in front of a pretty, rotting mouth (FULL OF SMALL INFECTED WOUNDS) 1.35 m away. But suddenly the character changed position and moved his foot back; the distance between the sponge and the shoe heel was 1.40 m; then the character moved almost im-perceptibly and the distance between the sponge and the shoe heel of the said character was 1.38 m." (MPC 27) It goes on like this for almost a page (and a dis-tance of 80,000 km!), which could become tedious for readers if, at the end of the tracking shot, they were not met with a reward in the form of the sight of "a magnificent girl's head from which the skin of the cranium was hanging, torn into fringes." Extremist realism ends up on the paranoiac-critical side of Sur-realism. The painter of double images paradoxically uses very few metaphors when he undertakes to transcribe reality in writing. As a result he clearly does not attain the poetry of Francis Ponge's *Parti pris des choses* [Siding with things], but his way of looking at the world directly nevertheless heralds that of the poet who later condemned "any value judgment brought to bear on the World or Nature" and who knew how much imagination owes to simple observation:

"The 'beauty' of nature is in his *imagination*, that way of being able to take man out of himself, of the narrow merry-go-round, etc. *In its very absurdity ... /* Freudianism, Automatic Writing, Sadism and so on have permitted discoveries. /Scrutinizing objects permits many more."[41]

Dalí made several forays into film, not all of them successful, including his collaboration with Buñuel, to which he was fully committed for *Un chien andalou*, more reservedly for *L'Âge d'or*,[42] his sets for Alfred Hitchcock's *Spellbound* **fig. 11**, some of which were made as small-scale models by Hollywood technicians but ultimately left out, the screenplay for a nightmare sequence for a film called *Moontide* featuring Jean Gabin, which Fox rejected because it was so frightening, uncompleted projects for the Marx Brothers and Walt Disney, the screen-

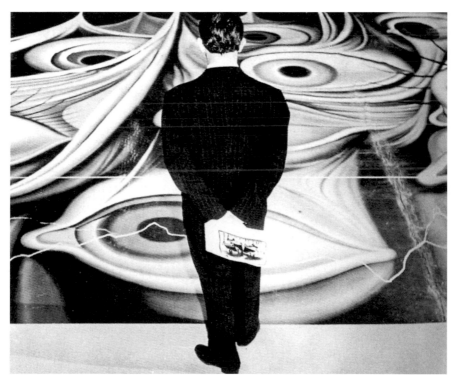

53

11 Set for the film *Spellbound* by Alfred Hitchcock

play for *Babaouo* that was never made and the film version of *L'Aventure prodigieuse de la Dentellière et du Rhinocéros* [The marvellous adventure of the Lacemaker and the Rhinoceros], a project started with Robert Descharnes, which was never completed. As James Bigwood has observed, "the *softness* that film allows: dissolves, superimpositions etc."[43] would have served the paranoiac-critical method particularly well. As a small consolation, the influence of cinema can be felt strongly in Dalí's writings. Some passages of *Hidden Faces* almost constitute a storyboard, particularly the first pages of the epilogue. There is a close-up of "a fist more and more obstinately closed with rage and decision, and this fist, since the character was sitting in a large armchair with his back to us, was the sole thing which it was given us to see". (HF p. 301) In the background we hear fragments of *The Valkyrie*, *Parsifal* and *Tristan and Isolde*. The tension rises. The fist strikes the armrest until it bleeds, while its owner utters a terrible monologue against "the vile dragon of Christianity …". The music becomes "strident". Change of shot: the attention shifts to the feet of the figure, who removes his shoes, pushes "his forefinger between his two toes", notes by putting it to his nose that it gives off a smell and rushes to the bathroom to plunge his feet into the bathtub. Having completed this operation, the figure retraces his steps and at last faces the viewer: "He went back into the large room which he had just left and sat down again in the armchair. Then one saw that this character was Adolf Hitler." (HF p. 302)

Then the 'camera' pulls back and we can see the whole of the set. "One perceived then that this armchair was surrounded by the greatest artistic treasures in the world. Raphael's 'Betrothal of the Virgin', from the Museum of Milan, Leonardo's 'Virgin of the Rocks' …." (HF p. 303) A transition through the paintings enables the scene to tip over into fantasy. "Familiar ghosts" start to invade the room: Dürer, old Nietzsche, Ludwig II of Bavaria …. The vision becomes epic with the appearance of "the procession of Prussian generals". Until we hear a voice speaking to Hitler: "'But what about the body? What about the body of the German people?" This 'body' materializes, "all covered with black veils, and its feet were frozen – and odourless …." The book was written in 1943, which means that to his talents as a novelist and "scriptwriter" this

painter of visions added that of the visionary. One cannot read this piece without mixing up its images with those one has of Hitler's suicide in his bunker two years later.

Hidden Faces belongs to the generation of novels, including those of André Malraux and Hemingway, that are infiltrated by cinema, whether in the unfolding of a scene, as we have just seen, the revelation of a panoramic view or the detail of movements made by the protagonists. In Elia Kazan's *On the Waterfront*, Marlon Brando does something that is famous in the history of cinema. During a love scene with Eva Marie Saint, he picks up the glove she has dropped and plays with it mechanically, staring at it, while continuing with the dialogue. Such disconcertingly natural actions are apparently typical of the methods taught at the Actor's Studio. Here is how Dalí, who had not benefited from such training, sees a scene of disappointed love between Grandsailles and Solange de Cléda, whom he loves, but keeps at a distance. Grandsailles is standing on the balcony and, drawing Solange's attention to the forest stretching away before them, provokes her, pretending to place more value on his domain than on their "five years of stupid and snobbish flirtation". (HF p. 48) He says this "while he tried to tear loose a big section of moss that had grown in a joint between the stones on the balustrade of the balcony. Finally, the moss yielded, pulling with it a piece of the cement that filled the fissures in the stone." (HF p. 48) Surely it is cinema that has trained our perception in this dissociation of sound (dialogue) and image.

The camera either sweeps across an area containing more or less static objects or, fixed to its tripod, films everything that passes before its lens. The difference between tracking and static shots is purely mechanical; it is not ethical. The same principle guides both approaches: the aim is to record everything in a perfectly objective way, without making choices or creating hierarchies. This is the mechanism imagined by Dalí to "be done, above all else, with the repugnant rhythm of today's cinematography, that conventional, boring rhetoric of the camera movement. How can one believe in the most banal of melodramas, even for a second, when the camera is always tracking along behind the murderer, even into the toilets where he goes to wash away the blood that stains his

hands?" (We can see again that Dalí's concern is always with credibility and so with a realism that he himself calls "categorical") "This is why, before he even begins shooting his film, Salvador Dalí will take care to immobilize, to nail his camera to the floor with nails like Jesus Christ on the cross. Too bad if the action moves out of the visual field! The audience will wait in anguish, exasperated, anxious, panting, stamping, in ecstasy, or better still, bored, for the action to come back into the field of the camera taking the picture." Noted in *Mes secrets cinématographiques* [My cinematographic secrets],[44] a piece published in 1954, this would be Andy Warhol's idea around ten years later, when he planted a camera in front of the sofa in the Factory and left it running, sometimes for a very long time, recording, *indiscriminately*, everything that happened. Not only did Dalí think of one of the forms of underground cinema, in other words the static shot, but he was also perfectly aware of what it was about: boredom induced by the impression that time is being stretched even when that time is real time ….

Warhol filmed people acting out scripts that are like psychodramas; he also filmed them eating, fucking and sleeping. This kind of morality cuts life up into slices of time rather than in relation to a scale of values and its first effect is to contrast the expression of people's thoughts and feelings with the concrete conditions of that expression, the prosaic elements that are then placed on the same level. Dalí uses and abuses this effect. His style may take flight into hyperbolic lyricism, yet the end of the paragraph will always be brought down by some remark that would be shared more by the fishermen of Port Lligat, from whom Dalí never really distanced himself, than by refined poetry-lovers. Of course his prosaic observations usually concern the organic life that reminds humanity of its true condition. Let us measure the distance, for example, between Breton's praise of the woman he loves: "My woman with log fire hair […]/My woman with buttocks of sandstone and asbestos/My woman with swan's back buttocks / My woman with spring buttocks/With a gladiolus cunt",[45] and the enthusiasm of Dalí who has just met Gala and is rejoicing at the idea that "in my own bedroom there might now be a real woman with breasts, pubic hair, gums …".

56 (VSD) Where the former describes the body using animal, vegetable and min-

eral metaphors, the latter suggests a fantasy and sexual anxiety (the assimilation of coitus with devouring) in the most fully embodied evocation possible.

Even in love scenes, Dalí places himself far from the romantic background of Surrealism. He declared himself "anti-feeling" on several occasions. This is easy to believe when we read the account of his first kiss with Gala. It begins with a notification: "In my whole life I had never yet *made love*". (VSD) He goes on, "I kissed her lips, which opened. I had never before kissed like that, deeply, and I didn't know you could do it. […] And that first kiss, in which our teeth knocked against each other, our tongues entwined, was only the start of that hunger that would drive us to bite and eat down into the deepest depths of ourselves. […]

I pushed Gala's head back, pulling it by the hair, and hysterically commanded: 'Tell me now what it is that you want me to do to you. But tell me slowly, looking into my eyes, with the crudest, most fiercely obscene words capable of making us both the most ashamed!"

Dalí has to repeat his request several times: "What-is-it-that-you-want-me-to-do-to-you?"

Eventually Gala replies, "I want you to make me die!"

In an erotic context the word "die" has a crude connotation. But at this point in the text, it resonates for the reader with another of its meanings since, a few pages earlier, the new lover has described walking above the sea and the temptation he felt to hurl his companion on to the rocks below. In his concern for truth, the author does not spare us the terrible ambivalence that may be contained within a feeling of love. As an aware Freudian he knows that the response to a violent desire for possession can be a violent desire for destruction. Idealization is out of the question, even in the early moments of a love affair. Just as the static camera records non-action as much as action, so the narrative notes an emotion and the impulse that instantly denies it, without any further soul-searching, one is tempted to say.

Starting from different psychological data, a scene from Dalí's novel suggests an analogous example of loving tipping over into an attempt at murder. This time it is Solange who responds to Grandsailles's provocation with a hearty laugh. Grandsailles throws himself at her, almost suffocates her by burying her

face in a pillow and even cuts her gums with his "large gold ring". This is a very concrete detail for a dramatic moment, which, from the point of view of the narrator's systematically documentary approach, deserves neither more nor less attention than the sound made by Solange when she "lazily" stretches out her legs on Grandsailles' bed: "and the bones in her knees cracked one after the other with the same sound and at the same moment that the vine stumps … were beginning to kindle and crackle in the fireplace". (HF p. 46) The impulses of the body are sometimes blocked when the same body proves dysfunctional in some small way. Betka, another heroine of *Hidden Faces*, goes into the dressing room of three acrobat brothers. One expects a fairly hot scene, sadly postponed by a disruptive element. A cherry stone is stuck under the door, preventing the acrobats from closing it, despite their vigorous efforts. At any rate we are already worried about Betka, who has eaten too many cherries (the stone fell from her handkerchief), and at that moment has "a slight attack of colic".

Touching with the eyes

When a human being who is past the age of potty training continues to be interested in the potty's contents, does this favour the development of the scopic drive in that individual? Does the visual examination of things that have returned to the state of undifferentiated matter develop the ability to make out the tiniest details, the slightest nuances? Dalí's personality provides an excellent opportunity to ask these questions. Retaining all his curiosity for something that everyone, or almost everyone else, rejects and conceals leads him to transgress a taboo – minor certainly, but a taboo all the same. This transgression is reduced when it is made by the eyes only, not the hand; it is easier to satisfy such inclinations by touching with the eyes than by really touching. During a stay in Italy, which was not as agreeable as it should have been because civil war had broken out in Spain and Dalí was having an attack of hypochondria, every time he went to the toilet, where he took the time to examine his stools "scrupulously", he found himself "obsessed by a huge lump of snot stuck to the white majolica of the wall" (VSD). A lump of snot is almost more disgusting than a turd

and we have to believe that it diverted his attention. "At first I pretended not to see it, by looking elsewhere, but more and more it made its presence felt. This lump of snot was definitely an exhibitionist. It clung to the majolica with, dare I say it, a kind of coquetry and it became impossible not to see it. Moreover it was fairly clean snot, of a pretty, slightly greenish pearl grey, browner in the middle. It came to a point and lifted off the wall as though to invite someone to do something. Six days went by without my being able to fight against my obsession. On the seventh I took action." What follows is terrifying: Dalí makes his finger bleed scraping it off, thinks he is infected with tetanus, imagines his hand has already been amputated; the civil war slides into the background, until he realises that what he had taken for a lump of snot "was in fact nothing more than a drop of dried glue, fallen no doubt when the majolica was being tiled." From this story we shall note that during the very long period in which he resisted his desire to touch, Dalí minutely studied the false snot in all its particularities of shape and colour.

A childhood memory of a rotting hedgehog calls up the same impulses. At the back of a hen-house Salvador finds a hedgehog that he had been playing with in the preceding days, now dead and swarming with vermin. "Despite my repulsion, I moved closer still, fascinated by this ball of filth. I needed to see it from very, very close to." (VSD) Then comes the "desire to touch", which the boy satisfies, from a distance, by turning the hedgehog over with the forked end of a crutch he has found in an attic. Of this crutch Dalí concludes, "the benevolent fetish became a symbol of death". The lesson of both this and the preceding story is surely that contact brings a risk of contamination by, and even proximity to, death. Similarly, *Le Mythe tragique de l'Angélus de Millet* reveals that coupling, the closest form of contact, causes the male to be devoured by the female. And fear of contact would surely favour the development of a purely visual approach as a highly satisfying and safer substitute.

In the manifesto text that is *L'Âne pourri* [The rotten donkey] (1930, MPC 38), Dalí raises the question, "And we do not know whether, behind the three great simulacra, shit, blood and putrefaction, the *desired* 'land of treasures' might not precisely be hiding". All things considered, it is still human excrement that

hides the most treasures. We know that Dalí believed in the Freudian equivalence of gold and shit. He could never meet a high society lady covered in jewels without admiring her for being really covered in excrement. There is another equivalence, that between pictorial matter and faecal matter: "After the birth of the Dauphin in the French court, the excrement of the heir to the throne would be collected before the highest in the Kingdom and the greatest artists summoned to take inspiration from the palette of royal shit. The entire court would dress in Dauphin-poo colours. […] Moreover the excremental palette is infinitely rich, going from grey to green and from the ochres to brown, see Chardin in particular." (UC p. 19) In April 1930 – difficult days during which, in addition to worries about Gala's health and financial uncertainties, Dalí was forbidden to go to Cadaqués, whence his father had him more or less driven out by the police – the couple were staying in Torremolinos, near Malaga. Their evening walks along the beaches were one of the pleasures of their stay, as long as they were careful "not to crush the admirable turds that the fishermen used to leave in provocative little heaps. […] I would watch with interest as these excrements emerged from the hard, white buttocks of the fishermen and moulded themselves into perfect spirals."(UC pp. 105–06) The turd already appears as a jewel set with precious stones: "As for the fishermen's excrements, they were always clean and incrusted with a few Muscat seeds as undigested and fresh as they'd been before they were swallowed." (VSD)

One cannot look on all these marvels with impunity! Visual people – let's not yet mention voyeurs – are necessarily afraid of losing their sight. The faculty of seeing a great many – too many – things might well lead to their being punished, in other words, being made blind. Here I'm stating the ultimate consequence of something felt by all those with an extremely developed sense of sight. Everything that their gaze captures, simply in a reflex sweeping of their surroundings, exposes such people to being considered a spy. If they tell others what they have seen, they will be suspected of some malign intent. The greatest power accorded to tyrants, greater even than physical control, it is the ability to see everything. Alternatively the paying of such exaggerated attention to everything that presents itself will be regarded as madness, the madness of one

who is assailed by everything with no ability to sort elements and put them into hierarchies. But though Dalí boasted of being "polymorphously perverse", he was not really a tyrant, and when he defends himself against accusations of madness, we have to believe him. He does as people do when they have a gift that exceeds what is normally accepted by the community and they don't want it to lead to their exclusion: he compensates for his gift with a fantasy of mutilation. To Pauwels Dalí says, "After my manifesto against the blind, for a long time I was afraid for my sight. I was haunted by the idea that I was going to pour corrosive drops into my eyes. [...] I had to treat myself for conjunctivitis, and I was completely obsessed, reading the label a hundred times before picking up the dropper." It was important not to confuse the Optrex bottle with some other container! The cover of the Italian edition of *The Secret Life* (1949) shows the author's bloodstained face wearing an eye-patch **fig. 12**. A portrait by Halsman (1956) returns to this idea, but this time the patch shows the image of an eye-shaped jewel, designed by Dalí. The anxiety reaches its height in the famous, unbearable image of *Un Chien andalou*, in which an eye is sliced with a razor. Parinaud links this allusion to a sadistic act: "I thought I'd lost my sight after hitting a blind man". Such viciousness explains perfectly why the one who has committed it fears that the same will happen to him, but it can also explain a fear whose motive is far more irrational. To see everything is to appropriate a priv-

12 Cover of *La mia vita segreta* (*My Secret Life,* Italian edition), Milan (Longanesi), 1949

ilege that belongs to God, and God may well punish someone he sees as taking his place.

However, there is one difference between the almighty gaze of God and the uncommonly effective gaze of his servant. God sees everything because he looks down, whereas the man whom nothing escapes, who sees at once the beauty spot and the entire body, stays on the surface of the visible as a blind man's fingers feel a page of Braille or as a lover makes his body into a coat for the body he loves. God sees from on high, while human eyes are irremediably compromised within the sensory world. The history of art has long noted the complicity of sight and touch or, to put it in moral terms, the perversion of the optical by the haptical. In the preface to an exhibition on this theme, Gérard Simon has explained that the Arab scientist Ibn al-Haytam, who was the first to identify light reflected by objects as the agent of visual perception, was also the one who recognised the role of the experience and memories recorded by all our other modes of perception, starting with touch, as a complement to the impression received at the back of the eye. We recognise a rough surface visually because we associate the fine irregularity of its lighting with our memory of having touched such a surface. Simon adds that Cimabue and Giotto, founders of a pictorial tradition that creates the illusion of depth and places a value on the qualities of flesh, may perhaps have been aware of Ibn al-Haytam's treatise, which was widely available in the West in the second half of the twelfth century.[46]

Before being the – modest – heir to Renaissance painting, in his first Surrealist period Dalí made important collage works with crushed sea-shells, cork and sand in the manner of André Masson, before adopting the unified manner that enabled him to suggest his famous soft forms more successfully. We should recall that Dalí linked the "divisionism" of *The Lacemaker* to Vermeer's use of canvas with a rough grain. In Pauwels, Dalí announces that he will describe his passion for Gala "staring from a tiny point on her woman's body, a beauty spot". This beauty spot is located on her left earlobe towards which, "ceaselessly, [his] fingers voluptuously move". The beauty spot is the point of departure for a methodical exploration, made, he tells Parinaud, "with the minute detail of a physician and archaeologist. [...] I could have drawn a map of her body". By the

time he was making these confidences, he had apparently overcome the apprehension noted many years before in his *Diary*: "It's thanks to the fear of touching Gala's face that I will eventually know how to paint!"

Visual obsessive

Little Salvador began paying loving attention to the visible world very early. He detected the presence of a microscopic insect under leaves in the garden, making them move; a pictorial riddle-hunter moving through the forest undergrowth, he found more rabbits than strictly necessary. Better than this, he developed "a strange power, that of seeing through walls". In reality, fixing his attention on parts of the landscape that he could see through the classroom window, he acquired "the power of a waking dreamer unlike any other". (UC p. 28) And he reinvented Leonardo da Vinci's famous method counselling the observation of walls covered in dirty marks. "Leaning over my desk, I stared at the walls whose peeling paint and cracks formed allegorical figures and characters." (JGA) Drawing on his vast store of visual memory, his imagination enabled him to go beyond the foreground immediately in front of the school desk or outside the window. It even enabled him to see through skin. The novice painter had been somewhat off-colour in the French capital, which he had not yet managed to conquer, but back in his native land he returned to a health he describes as "'transparent' for it was exactly as if I had 'seen' through my own body the perfect functioning of all the viscous little mechanisms of my once more flourishing anatomy." (VSD) Given the point at which it is recounted in *Secret Life*, this cure came shortly after Dalí had painted *The Invisible Man*, which itself reveals more of the viscous little mechanisms of psychology.

After Dalí's meeting with Gala it was no longer just God who was likely to be keeping an eye on him. Dalí lent his own power to his chosen woman. The fantasized memory of a certain little Galutchka, "with an unbearable gaze" (VSD), is recorded as a premonitory anecdote: "Every time that my eyes turned towards her, I noticed that she was staring at me intensely. So intensely that the back of the thick-set nurse [against which little Dalí was pressed] was growing

thinner by the moment, as though an actual window had just opened in it."
(This nurse surely inspired that of *Sevrage du meuble-aliment* [Weaning of the
cabinet-food-item] of 1934). Later Dalí borrows Éluard's description of Gala's
"wall-piercing" gaze. It was this gaze of almost terrifying intensity, pho-
tographed by Max Ernst (who was also her lover), that the poet put on the cover
of his first collection, *La Femme Visible* **fig.13**. And it is this same glacial gaze that
pierces the surface of *The Endless Enigma* **fig.14**. At the far right of the painting,
sliding in from outside, Gala's three-quarter face appears, eyes fixed on the
viewer after having perhaps been watching over the painter, while the viewer's
eye, following that of the painter himself, becomes lost in multiplicity of this im-
age that is doubtless the most complex of all Dalí's work.

Endowed with the power to see through walls, but aware of being watched
by an identical power, one thinks only of seeing through another wall. A man
whose piercing sight enables him to see forbidden things is obliged to turn his
eyes in another direction, where they once again alight on forbidden things,
things that can be touched only by the eyes – and herein lies the full ambiguity,
the source of the guilt that makes him believe he is being watched. And so he
embarks on compulsive exploration; he becomes a visual obsessive.

Before entering the Dalínian labyrinth, I had investigated a few other ob-
sessives of this kind and it was almost certainly they, as much as a slight personal

64

13 Cover of *La Femme visible*
(with the eyes of Gala), Paris (Éditions
surréalistes), 1930

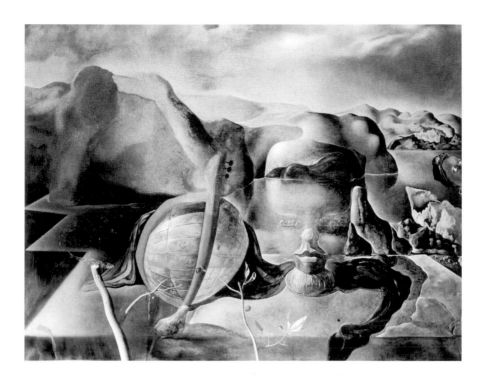

inclination towards scatological treasures, that led me to Dalí's door. Working on Richard Hamilton and Alain Jacquet, I realised that, on the one hand, both minutely scrutinize the images that they work with and, on the other, both produce series of images that are closely interrelated, of which one could be a detail from another, or the same scene reproduced from a different point of view. This way of proceeding produces labyrinthine works: from one picture to another, the viewer has the sensation of entering a space, moving around in it, sinking into it. Hamilton who, in parallel with his artistic work, had a career as a designer, designed themed exhibitions such as *Growth and Form* in 1951, which have remained famous because their apparently labyrinthine layout paradoxically did not get in the way of their educational intentions. *An Exhibit 1* and *An Exhibit 2*, of 1957 and 1959 respectively, retained only the modules from these exhibitions, stripped of all documentation, through which visitors were invited to wander.

65

14 *The Endless Enigma,* 1938, oil on canvas, 114.3 x 144 cm
Museo Nacional Reina Sofia, Madrid, Dalí bequest to the
Spanish state

Hamilton and Jacquet used the processes of photographic reproduction. In 1964 Jacquet began using photographs as a basis for silk-screen prints that emphasized the patterns created by four-colour reproduction. The image is formed from a multitude of dots and sometimes parallel lines, so that in order to see the whole thing one needs to look from the right distance, as with an Impressionist painting. Jacquet exploited the effects obtained by looking from a greater or lesser distance and produced different versions of some of his images, as though the viewer were getting closer to them, or moving further away. Many of the pictures consist of more or less enlarged details from *Le Déjeuner sur l'herbe*, a reworking of Manet's painting that is in every sense a masterpiece. One of these views is such a close-up that its dots become the large marks of an abstract composition. Hamilton's *People* (1965–66) takes a similar approach. Starting from a postcard of bathers on a beach, the artist has repeatedly zoomed in on one part of the photograph until it becomes almost impossible to decode. There are several versions of *People*, in which the photographic enlargement is heightened with oil, or gouache, or has added collages. One version, *People multiple*, combines different stages of this penetration into the texture of the image.

In the same years, Dalí's interest in pointillism led him to imitate the patterns of photographic reproduction in *Portrait of my Dead Brother* (1963) and *The Sun and Dalí* (1965). In the former the dots are molecules which, in some places, agglutinate to form small figures and, in others, become cherries, one of Dalí's

66

15 Study for portrait of Gala, 1939, chalk on paper,
33.5 x 22.5 cm
Fundació Gala-Salvador Dalí, Figueres

16 *Gala looking at the Mediterranean Sea which at twenty metres' distance transforms itself into a portrait of Abraham Lincoln – Homage to Rothko* (1st version), 1974–75, oil on photographic paper, 445 × 350 cm
Fundació Gala-Salvador Dalí, Figueres

favourite motifs. In the latter painting the dots imitate the perforations of a stencil. Ten years later Dalí, never slow to take an interest in technological progress, moved from the patterns of offset reproduction to digitization with *Gala looking at the Mediterranean Sea which at twenty metres' distance turns into a portrait of Abraham Lincoln*, an image made in collaboration with a cyberneticist, Leon D. Harmon. There are two versions of this work, one subtitled *Homage to Rothko* **fig.16**, the other a monumental piece 4.5 metres tall. From a medium distance viewers see the nude Gala from behind, surrounded by a few other images; from further away they realise that this figure is part of a chessboard that forms the face of Lincoln. Jacquet similarly worked with computer-generated images to make portraits whose digital treatment obliges viewers to take a few steps back in order to recognize the sitter.

In being led to examine figures and objects so closely that they explode into a multitude of particles, we pass to the other side of the surface, through the stitches of the fabric, virtually entering the imaginary spaces established by the artists. The coming and going that we are obliged to carry out by works ex-

17 Alain Jacquet, *La Madone des cocotiers* [Madonna of the coconut trees], 1979–81, oil on canvas, 190.5 x 145 cm

ploiting the breakdown and construction of the image later gave way to wanderings through labyrinthine works. Throughout the 1980s, again starting from a prototype, in this case *The First Breakfast* (1972–78), Jacquet explored an image of the earth as revealed by the first cosmonauts. Starting from this single image, he used different framing, enlargements, the enlargement of details, reversal of the point of view and anamorphosis to obtain dozens of new images, each 'vision' more fantastical than the last. From these interpretations of the Earth's relief and the configuration of the continents emerge women's faces and bodies and an entire bestiary. Jacquet's method, which involves concentrating on an image until one sees other images emerging out of it, is not unlike the paranoiac-critical method. A detail of *The First Breakfast* gives rise to a dark-skinned Madonna, and a detail of the Madonna picture produces a strange dog sniffing a skull **fig.17**. Because each time the process involves focusing on one part of the picture which, once interpreted and enlarged, provides the motif for a new picture, we can say that the gaze penetrates ever more deeply into the substance of the visible, from which it releases the fantasy.

18 Richard Hamilton, *Lobby,* 1985–87, oil on canvas, 175 × 250 cm
Private collection

Hamilton's logic is less dream-like, but places more emphasis on the sensation of vertigo. *Lobby* ^{fig. 18} is a painting of 1985–87 based on a postcard showing a hotel lobby. It depicts pillars covered in mirrors, a staircase and a counter at the back. A vase in the foreground, exactly on the lower edge of the painting, gives viewers the sense that they are in the lobby. *Europa Hotel* (1986–91) ^{fig. 19} is a view of the same lobby, to which the painter has added a couple leaning against a sofa. The viewers turned visitors are supposed to have moved slightly to the left: indeed the right side of a cabinet located on the far left is now hidden. After this Hamilton made an installation consisting of a life-size reproduction of the space of *Lobby*. On entering it, for real this time, viewer-visitors discovered both the painting itself, hanging on the wall, and the reflection of the painting in the mirror-covered pillars that had been reconstructed. Hamilton reworked this type of *mise en abîme* on several occasions. In 1997, for Documenta 10 in Kassel, he reconstructed the space of the Anthony d'Offay gallery in London. In it he presented large cibachromes showing the actual gallery walls, on which, using inlays, he had virtually hung his own works. And these works

19 Richard Hamilton, *Europa Hotel,* 1986–91, oil on canvas, 100 × 100 cm
Private collection

20 *Gala and Millet's Angelus preceding the imminent arrival
of the conical anamorphoses,* 1933, oil on panel, 24 × 18.8 cm
The National Gallery of Canada, Ottawa

were themselves interior views of his house in which could be seen, placed here and there, other, older, works of his.

Luis Romero was invited to Dalí's studio when the painter was starting work on *Le Hallucinogenic Torero* (1968–70) and took this work as his starting point for a long exploration of Dalí's entire oeuvre. The *Torero* is a very large work (four metres by three), and it is a kind of masterpiece, in the old sense. Romero methodically identified all the elements in it that echoed other works by the master, starting with the boy in a sailor suit in the lower right-hand corner, a place he had earlier occupied in *The Spectre of Sex Appeal* of 1934. This was a self-portrait of Dalí "at the age of six", which appears in many other paintings. Symmetrically on the left, the copy of a work by Juan Gris signifies that Dalí was not denying his cubist beginnings. The huge face of the torero is skilfully drawn by the shadows of a succession of Venus de Milos, none of which have drawers but with, for those seen from behind, a kind of window opening through their torsos, like the seated 'nurse' in *Sevrage du meuble-aliment*. Other meteorites fired out from the exploding core of Dalí's work include roses that might come from *Bloody Roses* of 1930 or from *The Virgin of Guadaloupe* of 1959, a structure of coloured dots in perspective, like the spheres of *Galatea with Spheres* of 1952 and the bust of Voltaire, one of the most striking dual images, reinterpreted after the *Slave Market with the Appearance of the Invisible Bust of Voltaire* of 1940, in which the philosopher's face is formed by a group comprising a figure in oriental dress and two duennas in ruffs. Romero identifies many more obsessions, and wrote an entire book about them.[47]

Viewers can walk in Dalí's footsteps as he wanders through the landscapes that inspired him throughout his life. From painting to painting they will learn to recognise the fragmented rocks of Cap Creus and the gentle slopes of Port Lligat, although the painter sometimes liked to reverse their relationship. Walking around these features, they can take their bearings from the isolated tower behind the terraced hill of the bay of Port Lligat or the Cucurucuc, a triangular rock in the bay of Cadaqués. Fetish furniture items and objects, elements of the set that Dalí transported from work to work, become familiar and expected, like the cypresses near the well in front of the house at Port Lligat, or incon-

gruous, like the crutch, bean and bedside cabinet. As the *Hallucinogenic Torero* demonstrates, Dalí quotes himself; when, in the transition from the 1920s to the 1930s, he placed rectangular plinths in his landscapes, some had a side showing the reproduction of an earlier work or one of its details, such as *Chair de poule inaugurale* [Inaugural goose flesh] (1928), which recurs in slightly simpler form in *Surrealist Object indicating instant memory* (1932). Sometimes in these pieces Dalí used collage; we could say that in this he was prefiguring the technique of embedding, as understood today in the language of computer technology.

Let's assume that we can consider in succession two small paintings executed two years apart but bathed in the same ochre light, *Gala and Millet's Angelus preceding the imminent arrival of the conical anamorphoses* (1935) **fig.20**, and *Gala's Angelus* (1935) **fig.21**, followed by the stereoscopic piece of 1972–73, *Dalí seen from behind painting Gala from behind eternalized by six virtual corneas provisionally reflected by six real mirrors* **fig.22**. In the first painting, we see Gala in the background through a door, her slightly undersized figure very small in relation to the rest of the scene, dressed in her beautiful brocade jacket. She is facing the horrible

73

21 *Gala's Angelus,* 1935, oil on panel, 32 x 26 cm
The Museum of Modern Art, New York

figure in the foreground, who looks like Lenin. Above the door, appropriately framed, is Millet's painting. In the second picture we go behind Gala, still dressed in the same jacket. Here she is being looked at, not by Lenin, but by herself, sitting on the handcart from the *Angelus*, and this time the picture is hanging behind her double's head. It has also been modified since, instead of standing, the peasants are now seated on … handcarts. The stereoscopic pieces meanwhile reinterpret the arrangement as follows: Dalí is seen from behind between Gala seen from behind and us. She is now wearing a sailor top similar to the one worn by Dalí at the age of six. Gala is still staring, but this time not at her double, or at her own refection in the mirror in front of her, but at Dalí's face, which the mirror also reflects. The framed couple is therefore no longer the couple of *The Angelus*, but Dalí and Gala. The circulation between the 'six corneas' is as follows: the viewer's eye is caught in a movement between four heads, leading to Dalí's eyes resting intensely on Gala, which can be seen shining in the mirror, while Gala is trying to catch his eyes. Other optical experiments dating from the same period cite Velázquez's *Las Meniñas*, an illustrious precursor in the use of mirrors in painting.

Like tracking shots that take us through a series of rooms, the space of one picture opens on to another space, and sometimes on to the space of another painting. Throughout the history of art mirrors have always been the tools most

74

22 *Dalí seen from behind painting Gala seen from behind eternalized by six virtual corneas provisionally reflected by six true mirrors* (unfinished), 1972–73, two elements of a stereoscopic device, left and right eye, each oil on canvas, 60 x 60 cm
Fundació Gala-Salvador Dalí, Figueres

suited to this *mise en abîme*. One of Hamilton's most significant works is *Interior 1* (in Hamilton's usual style, there are of course two versions of *Interior*), which provides a highly complex representation of a sitting room, using collages and seen from different, interpenetrating points of view. A real mirror is set into the piece, bringing the space in which the viewer stands into the interior shown in the painting. In the different two and three-dimensional versions of *Lobby*, the mirrors at once fragment and double the space.

In Dalí's most famous paintings, we find stretches of water as limpid as mirrors (*Metamorphosis of Narcissus*, *Swans reflecting Elephants* (1937)). Meanwhile the stereoscopic works, such as *Dalí seen from behind painting Gala from behind*, require a real mirror. This enables the viewer's eye to form a single image from the two panels painted with the same scene from two very slightly different points of view, giving the illusion of depth. It could be said that the process here is the opposite of that at work in the paintings with double images, since the eye synthesizes the two rather than dissociating them. At any rate the picture truly exists only in the viewer's head. In the writings reflective surfaces have well-defined functions. We remember that Grandsailles's "scrutinizing eyes" inspect his guests in their reflections in the silver tableware. In an even more concentrated image, two drops of sweat on Solange's naked skin reflect the velvet of the armrests of the chair she is sitting in.

The narrative of *Rêverie* turns on a large mirror. The narrator, who goes through phases of very consciously organizing his fantasy and then giving himself up to it with complete abandon, decides at one point "to imagine the scene of Dulita's sexual initiation reflected in the great mirror in Dulita's room, which adjoins the dining-room." (MPC) I shall try to give the briefest possible description of the mechanism that Dalí spends pages elaborating. The initiation is to take place outside the protagonists' house, near a fountain surrounded by cypresses, and the narrator stands by the window to watch the scene. The cypresses hide the fountain, so he invents a fire that has burnt them down. But, as this narrator is a masturbator who needs to defer his pleasure, another obstacle, a wall, must also be destroyed by the fire. This is still not enough, as the fountain, located "on the far left", *can't* anyway be seen from the dining-room win-

dow. It is then that the narrator imagines a large mirror in the next room to reflect its image. As he says himself, this has "the advantage of a certain complication". I would add that, throughout this reverie, the action is always announced by a representation, whether written or visual, in a manner that is utterly Sadean (as is the initiation carried out by older women, the mother and the prostitute):[48] the narrator conveys his instructions to the women in writing; at the start of the girl's initiation she is presented with an album of pornographic postcards. The specular loop is locked shut.

Even for very simple pleasures, Dalí is not satisfied with direct vision. His bedroom overlooks the bay of Port Lligat, but he likes to lie on his bed, which is perpendicular to the window, and enjoy the view reflected in the open pane. The *Fifty Secrets of Magic Craftsmanship* include "The secret of learning to paint models the other way round using a mirror". For a long time, until Impressionism plunged them into nature and the avant-gardes took them into the street, painters used to use instruments such as the *camera obscura*, the *camera lucida* and Dürer's tracing device – which Dalí reproduced as illustrations for *Fifty Secrets* – enabling them to work directly from a specular image. The presence of mirrors in paintings (particularly in the work of Vermeer, which Dalí so admired) and also of windows and other images framed or embedded within the picture shows that painters have always seen the world as already like a picture **fig. 23**. The shadows cast on the walls of the primitive cave are part of the found-

76

23 *Retrospective utilization of aranarium,*
illustration for *The Fifty Secrets of Magic
Craftsmanship*, 1948, Chinese ink on paper,
30 x 22 cm
Private collection

ing myth of art. Similarly shadow plays and other magic lanterns are part of the legend of painters' childhoods. An eccentric old professor would work an optical theatre for the young Dalí. Alone in his room with the shutters closed, the boy would watch the shadow play projected on to the ceiling by rays of light. The painting called *The Old Age of William Tell*, a response to banishment by his father which Dalí painted at the time when his family ties were coming undone in the very early 1930s, shows a distant echo of these original impressions in the form of a lion that is merely a shadow cast on a sheet.

Painters grow up with a lens grafted on to their eyes. Dalí talks about "the magnifying glass [that he] placed over the world and which is called eye". (UC p. 144) We can note the things his young eyes observed through the classroom window when he was supposed to be listening to his teachers, and which would later provide food for his thought and his painting, starting with the cypresses over which he followed "the march of shadows and light [...] just before

77

24 *Impressions of Africa*, 1938, oil on canvas, 91.5 x 117.5 cm
Museum Boymans Van Beuningen, Rotterdam

sunset". (VSD) These reappear at Dulita's initiation, which takes place beneath cypresses, in "the light of the sinking sun". (MPC 42) Once night had fallen and the lights had gone on in the corridor leading to the classroom, the distracted schoolboy would look through a window in the door at a reproduction of Millet's *Angelus* hanging outside. Similarly it was at the age of nine that Dalí began to be obsessed by Vermeer's *Lacemaker* "of which a reproduction hung in [his] father's study and was visible from the open door". (MPC 67) His curiosity was not only directed towards reproductions of works of art. *The Secret Life* records a stratagem Dalí devised in order to catch a glimpse of a peasant-woman's breasts, framed by a window. The distant Gala of *Gala and Millet's Angelus* is seen through a door frame while her face is seen in the reflection of a painted mirror seen, if need be, in a real mirror in *Dalí seen from behind paint-*

25 *Solar Table,* 1936, oil on panel, 60 x 46 cm
Museum Boymans Van Beuningen, Rotterdam

ing Gala from behind. In this optical labyrinth in which the eye is sent from one surface to the next, we should note that the painter stands behind the opaque surface of his painting, where the synthesis of visions will take place. In the work in question, we are faced with the dark mass of his back, seen against the light in the foreground. In another, earlier painting, *Impressions of Africa* (1938), he positions us facing him, with a canvas on an easel between us **fig. 24**. His pose, arm outstretched and hand open, seems to show us our place, as though he were telling us not to move because the distance or the pose is right. His gesture also holds us at a distance. The fact that we feel we are walking through his world, and he is pretending to position us in his model's place, does not mean we can join the painter. He keeps his distance, between the screen of mirrors and that of the canvas, and he will not be part of the action. By definition, the observer always remains outside the scene he observes.

Bodies that mirror each other and the ductility of spaces may encourage an assiduous visitor to Dalí's painting to dive into it as into an endless dream, particularly given the constant recurrence of impressions of *déjà vu*, which make one doubt one's own memories. We are often moved or disturbed to find ourselves recognizing faces and settings in writings or paintings produced in different periods. We can make out the boy of *The Spectre of Sex Appeal* **fig. 27** in the lower right corner of *Solar Table* (1936) **fig. 25**, against the light, because of his position

79

26 The bay of Port Lligat

as spectator, except that here he has grown up, he's almost a youth. Moreover the same boy reappears in the boat of *The Astral-paranoid Image* (1934), turning towards a little girl who, in her pose and facial expression, recalls the Gala of *Gala and Millet's Angelus*. We find the boy in outline again, in 1941–42, in a landscape that is at the same time a face with the eyes of Garcia Lorca and, in 1944, in a bookplate drawn for the collector and writer Maurice Sandoz. In 1950 it is no doubt the same curious boy, still in the same corner but seen from closer-to and naked, in the wonderful painting whose title is almost a poem: *Moi-même à l'âge de six ans, quand je croyais être petite fille, en train de soulever avec une extrême précaution la peau de la mer pour observer un chien dormant à l'ombre de l'eau* ^{fig. 46} [Myself at the age of six, when I thought I was a little girl, lifting the skin of the sea, with extreme care, to observe a dog sleeping in the shadow of the water]. Turning round in the light, the child has changed sex. Nor can one fail to see a link between the Fountain of the Log, where the two women of the *Rêverie* take young Dulita, and the Found Fountain where, in a "false memory" from *The Secret Life*, Salvador "glimpses from behind" (inevitably) the little girl he dreams of kissing and whom he nicknames (even more inevitably) Galutchka. In the picture, the horribly Oedipal scene of *William Tell* (1930) takes place by a fountain, as does the sacrilegious scene (an act of fellatio in front of a wafer of the host) in the picture of the same year precisely called *The Fountain*.

Dalí gave concrete form to the spaces of dreams on several occasions – if imperfectly because of the limitations imposed by the commissioners of the works and before the art world had invented the categories of environmental art and installation. Two examples are his sets for *Spellbound* and the sitting room in the theatre-museum of Figueres – with sofa, wallpaper, fireplace, clock on the mantelpiece and pictures on the wall, all of them very real – that reconstructs the face of Mae West from a gouache of 1934–35. The latter stretches the space under viewers' feet because they cannot enjoy the hospitality of the sitting room; instead, in order to understand what they are seeing, they must move back from it, climb on to a small platform and place their eyes at a precise point opposite the arrangement, as they would to look at an anamorphic image.

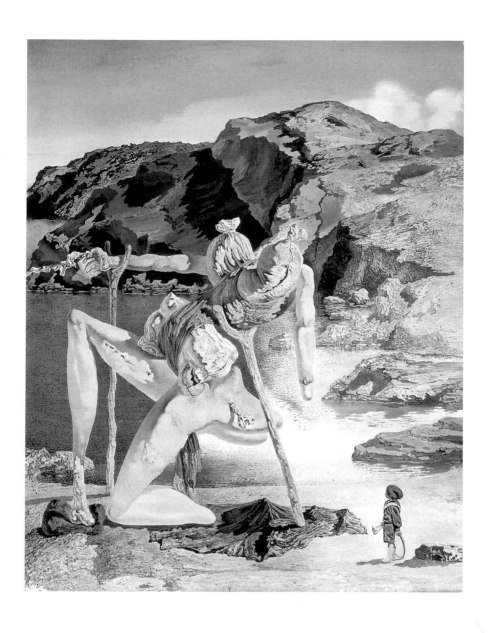

27 *The Spectre of Sex Appeal,* 1934, oil on panel, 18 × 14 cm
Fundació Gala-Salvador Dalí, Figueres

The arse-hole, and other vanishing points

Like the subject of this book, I shall get straight to the point: if we are endowed with two eyes, it is to see what one of Courbet's paintings refers to precisely as *L'Origine du monde* [The origin of the world] – in other words, the key to a woman's crotch, a key which, for some, also gives access to the pleat at the far end of the buttocks. For this reason, the attention of individuals in whom the scopic drive is particularly developed will tend to be drawn spontaneously to the discreet or hidden element that others have not been able to discover. They will see things that do not show themselves – the microscopic insect hidden under the leaves, the cotton reel abandoned in the gutter, the forgotten bottle of Optrex on the corner of the bathtub – and which are in fact signposts indicating the path to the "origin".

To the extent that the master himself has spoken of his painting as "a hand-made photograph in colour", we can apply to him the observation made by Alain Fleischer: "The essence of photography is to be a trace, an inscription by contact, and so a forcible entry of touch into the visible, which is then offered to the eye; once touched, this visible folds in on itself, locks itself away forever behind the wall of time at the speed of light. So it is in pornography, the representation through contact of contact between bodies, […] of the opening of one to the other, of the penetration of the one by the other, that photography finds its absolute."[49] This is the ultimate function of the human eye, to reach that which is normally hidden from it – and which the hand cannot so easily grasp. A novel by Jacques Henric[50] – the man whose life I share – is an allegory of this paradox. Its protagonist is a film-maker who fails to get the simple shot of a hand. In the end the corpse of a woman is found with a camera lens forced up between her legs. The police come to arrest the man. It's a tragic story because, with this desperate act, the character has short-circuited the process of producing the image.

The visual hunt may last a long time; it may be diverted down many labyrinthine paths for the sake of convention and decency or, better, to defer the satisfaction of desire; nevertheless, what the visual organ endlessly seeks to attain is the sexual organ and its surroundings, and indeed the secretions that

escape from that region. The opening of chapter six of *The Secret Life* perfectly defines the nodal point that holds all this together. Having just bathed, the adolescent pulls a long, brand new hair from his pubis and, as his thoughts take flight, makes it into a ring, puts it to his mouth and, with the saliva that sticks to it, makes it into a kind of monocle through which the beach seems to him iridescent. Continuing the game, he then pierces this saliva "membrane" with the end of another hair and sees in this "all the enigma of virginity". The manuscript contains a detail that was not kept in the published version: the pierced membrane falls in a drop – of sperm, I would add – on his belly.[51]

The other artists I have referred to provide further evidence: Jacquet's "Visions" based on the image of the earth seen from space culminate in his monumental work, almost seven metres wide, *La Vérité sortant du puits* [Truth coming out of the well], which depicts an imminent coitus. Among other things they also include a tondo, *Après-midi à la grande chatte* [Big cat afternoon], which shows a generous vulva opening over the full height of a hemisphere.

Examining popular images – postcards showing bunches of flowers or humorous scenes praising the (undoubtedly laxative) "effects of Miers waters", Hamilton transposes and completes them logically in his painting. The bucolic scenes and bouquets are decorated with a roll of toilet paper (the kind one assumes to be rose-scented) and even, metonymy aside, a turd. He also uses advertisements in which a young woman is photographed crouching to show how elastic her tights are. In Hamilton's version, she retains this position, but with her trousers down, and we can perfectly well see why. It turns out that Hamilton, who owns a house in Cadaqués, also made a series of sunsets, again taken from postcards, in which the church, "central characteristic of the little town"[52] and Dalinian emblem, is covered by an enormous turd like an eiderdown.

The artist who was not afraid to embark on his career by painting shit-spattered underpants was not going to deprive himself of dealing with scatological themes, in either writings or drawings. His entangled bodies of 1930–32 include the magnificent frontispiece to *La Femme* **fig. 28** reminiscent of a drawing by Dürer (whose signature Dalí sometimes liked to imitate), notably his strange *Desperate man* of 1516. They illustrate to the letter the lines already cited from

28 Frontispiece of *La Femme visible,* Paris (Éditions surréalistes), 1930

Le Grand Masturbateur: [...] the man who eats/the incommensurable/turd/that the woman/shits/with love/into his mouth". (MPC 39) The same artist becomes "the first painter of arses in the history of painting" and offers to our admiration images of rumps whose meaning becomes more and more precise. The ideal position for a woman to present her rear is leaning her elbows on a balustrade, *framed* by a window or glass door, in the position adopted by Gala in *Gala looking at the Mediterranean Sea*. In 1925 Dalí asked his sister Ana Maria to pose: in *Figure at a window* **fig. 29** she contemplates the bay of Cadaqués while we admire her bottom, whose roundness creates the divide between light and shadow. *Young Virgin self-sodomized by the horns of her own chastity* **fig. 30** of 1954 is a stripped down, exploded version of the same scene: the body is naked, probably inspired by a pornographic photograph, and, as the painter was then full of theories about the virtues of rhinoceros horn, the model's buttocks and thighs are coming apart and taking the shape of horns, in a movement in which two of these stumps are preparing to part the crack of the arse. Of 1960, *Déesse s'appuyant sur son coude – Le Continuum à quatre fesses ou Cinq cornes de rhinoceros formant une vierge ou Naissance d'une divinité* [Goddess resting on her elbow – Four-buttocked continuum or Five rhinoceros horns forming a virgin or Birth of a divinity] is a close-up of the conjunction of these thighs/buttocks/horns that shape, between them, a narrow space into which slides... a nail, perhaps symbolic of Christ, certainly a piercing object. Compared to the earlier visions, this is almost abstract, but not, however, as pure as that of the immaculate twin bottoms – four buttocks – barely marked by the hole of the anus, "moulded" in a sheet of embossed paper as part of the object-book *Dix Recettes d'immortalité* [Ten recipes for immortality] (1973).

Even before he made the *Young Virgin self-sodomized* appear at her window, Dalí had already talked about a "four-buttocked continuum". The concept is put forward in the *Journal* in August 1952, in support of Dalí's certitude, now proved, he says, by science, that "space is finite". Very pleased to be rid of the romanticism of his adolescence, which had seen him crushed by the endlessness of the cosmos, beneath the celestial vault Dalí now feels an "emotion that has the perfect form of a four-buttocked continuum, the very tenderness and

flesh of the Universe". The vault is the concave, immeasurable, but nonetheless finite imprint of an arse and, though finite, as attested by the many trompe-l'oeil patches to be seen in *Déesse s'appuyant sur son coude*, it has a hole (in French *trou*, which you should pronounce *trrrrou*) – the arsehole.[53] I will just point out in passing that, in its arrangement and meaning Jacquet's *La Vérité sortant du puits* **fig. 31**, mentioned above, is the giant-sized younger sister of *Young Virgin self-sodomized*, featuring the same high-angle view of buttocks but making them look even wider, viewers being supposed to raise their eyes from the bottom of the well towards the heavenly vault, and the same assumption of hermaphroditism, since in Jacquet's vision the male member seems to be coming out of the thigh of the female figure.

The "emotion" Dalí felt at his discovery was "so indefinable" that he decided to have a mould made of it. And as, for him, everything is verified in his most immediate surroundings, a high-born lady whom he received in his gar-

29 *Figure at a window (Girl standing at a window)*, 1925,
oil on canvas, 103 x 75 cm
Museo Nacional Reina Sofia, Madrid, Dalí bequest to the
Spanish state

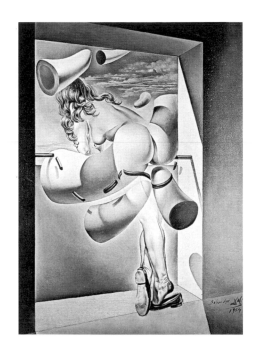

den presented, on turning her back to him, "exactly two of the buttocks of [his] continuum". "Would she allow me to photograph her? She agrees perfectly naturally, unfastens her dress and while leaning over the low wall to chat to friends on the terrace below and suspecting nothing, offers me her buttocks to allow me to juxtapose the mould and the very flesh of the mould." (JDG) Personally I'm unable to verify the relationship between the world and the form of the human behind in physical terms, but from the psychological point of view, I think this anecdote has relevance. One might think that secretly to offer one's arse to lechery while the rest of one's body remains on public display would distract one's attention from the things going on around one. But no! Having myself experienced such a situation, I know that, far from becoming blind to or separate from what is happening before your eyes, your perception of it is heightened tenfold. Perhaps you feel a need to compensate for revealing what you can't yourself see and to compete in visual appetite with the voyeur behind you. When you be-

30 *Young Virgin auto-sodomized by the horns of her own chastity*, 1954, oil on canvas, 40.5 x 30.5 cm
Playboy Collection, Los Angeles

come excited the invisible part of yourself turns into a devourer that demands to feed as much as possible on everything visible. The pleasure comes from drawing everything visible into the funnels of your eyes and having it pass through you into the dark passage. When the invisible is revealed in a strictly exclusive fashion to a single observer, it swells with all that can be seen and shared with others. This could not have escaped Dalí's notice.

"Woman: an extremely fine waist and lots of arse is perfect. Breasts, of no interest at all." (PSD) Dalí's penchant for bottoms continues unchanged. As does his fondness for testicles, which he likes to represent with an insistent, circular pencil line that highlights their roundness. "Of all the beauties of the human body, it is the balls that have the greatest effect on me. [...] But I hate the ones that hang, like beggars' sacks. I must have them gathered, compact, round and hard like a double seashell." (PSD) Or like a pair of cherries, that masculine symbol given up to voracious feminine lust and analysed at length in *Le Mythe tragique.*

88

31 Alain Jacquet, *La Verité sortant du puits* [Truth emerging from the well], 1983, synthetic resin and oil on canvas, 396 × 670 cm

Anyone who still doubts that heightened visual attention necessarily causes images to explode into a multitude of particles, and thus, now the surface of the visible has become permeable, reaches things one is normally forbidden to see, will be persuaded by the irrefutable proof offered by *The Sistine Madonna*. This is a large painting of 1958 in which one small element, a cherry hanging from a thread, is highlighted **fig. 32**.

The painting was made according to the principle of photographic enlargement, which enlarges the dots of the printed reproduction. Dalí used a detail from a photograph of Pope John XXIII published in *Paris-Match* – the pontiff's ear. One has to view the painting from the right distance for it to stop being a carpet of white dots on a grey background and become the image of an ear nearly two metres high. From somewhere in between viewers can also see, in the hollow of the ear, a ghostly reproduction of Raphael's *Sistine Madonna*. However,

89

32 *The Sistine Madonna,* 1958, oil on canvas, 223 × 190 cm
(and detail of buttons and cherry)
The Museum of Modern Art, New York, H.J. Heinz Collection

they also find themselves looking closely at the surface, their attention drawn by two dots that are different from the rest, one red, the other almost black, on a small white rectangle. They realise that these two are a cherry and its shadow, both painted in trompe l'oeil, in other words using a technique that is at once the antithesis and the ideal of the photographic technique that the rest of the painting claims to imitate. In addition to the sexual symbolism of the cherry and its double, a drawing made quickly for Romero's book establishes an equivalence between buttons and cherries. While the teenage Dalí imagined placing his easel in front of a "tufted cherry tree laden with cherries",[54] he later regarded some buttons as equally worthy motifs. In the period when he was examining the portrait of John XXIII, he was also looking closely at another photograph, taken on some official occasion, where we see him with Matisse. What Dalí himself saw in this photograph was a button on Matisse's flies **fig. 33**. From this Dalí drew the implacable conclusion that the reason the button could be seen so clearly was that the flies were not properly fastened. Ten years later, in relation to the button fastening the collar of the *Torero hallucinogène*, Dalí insisted that he "was inspired by that of the flies of Matisse, the famous painter of seaweed. It is the fly button of the French bourgeoisie, who have always forgotten to button them."[55] Cherries float not far from the Torero's collar button, causing Luis Romero to compare this picture with *The Sistine Madonna*. It must be said that when one looks at the reproductions placed side by side in the pages of his book, there is a striking similarity between the pattern of *The Sistine Madonna* and Matisse's houndstooth check trousers, seen in close-up, with their woven chequered pattern.

I hope the reader has followed me thus far (I did warn that the links between images would lead the mind into a maze). While waiting to transform a fly button into a collar button, Dalí placed a cherry and its double on the image of a virginal ear. These details are made to stand out by the *trompe l'oeil*, which gives the impression that they are placed slightly in front of the surface, as though advancing towards the viewer's eye, just like the fly button, which at once caught Dalí's eye. And in the same way that Dalí must then have brought his face close to the photograph, and notably to Matisse's flies, in order to check whether his

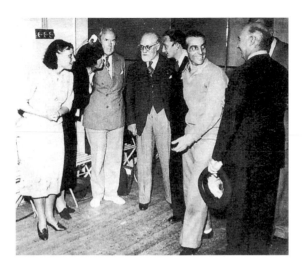

intuition was correct, so viewers who were just about to admire a Virgin find they have been caught in the trap set by the pattern of dots, their noses almost touching a cherry. In such circumstances, is it more seemly to look closely at a cherry than a man's flies?

"A clear spring of masturbation"

Because the scopic passion commands that we keep looking further, our activity must be sustained, made to last; because it demands precision, it mobilizes our full attention; because it requires us to avoid all distractions, all obstacles, it tends to be performed alone. This solitude only adds to the sense of guilt already felt at having gone so far, beyond, it is assumed, what is permitted. In all these things it is not unrelated to masturbation.

Reading the book by the philosopher and historian Ian Hacking on *Mad Travelers*,[56] I was struck by the fact that, in several of the cases he studied, including the main case of a man called Albert, the wanderings of the "mad traveller" were preceded by periods of intense masturbation. Ian Hacking's intention is to prove that some behaviours are identified as symptoms of illness or madness only when this is encouraged by the scientific, cultural or social con-

33 Matisse, Dalí, Léonide Massine, Lord Berner and others,
about 1958, with detail of Matisse's flybutton

text. The late nineteenth century thus witnessed an "epidemic" of wandering, explained in the first instance by the fact that doctors had devised criteria to diagnose this illness. When the criteria fell into disuse, the pathology disappeared. Given my own preoccupations, I have to say that what I most remember from reading this book is that, after his masturbatory period, the wanderer sets off on the road, sometimes travelling a very long way (some crossed Europe; Albert, who lived in Bordeaux, went as far as North Africa). Their wanderings could be described as random, but it would be more correct to say that they let themselves be guided by their perceptions; Albert heard someone shouting the name of a city, so he went there. What did he retain from his travels? Only the "fine landscapes he saw and [the] monuments he admired".[57] During his peregrinations he forgot who he was. On his return home he forgot his misadventures, including the fact that he had been in prison, and remembered only "fine landscapes" and "monuments". So I wondered whether these travellers might have converted their compulsion to masturbate into an "ambulatory automatism" (to borrow medical terminology), because, by always going further into the landscape, they were physically prolonging the mental exploration which masturbation had led them to undertake. Perhaps this was a way of suspending the reprehensible activity of masturbation without leaving the dream behind. It seems to me that one can make a comparison between masturbators who prolong their pleasure with more and more mental images – all the happier to defer satisfaction of their desire because, being alone, they can't turn fantasy into reality – and recidivist wanderers who go from one landscape to another but never reach their goal.

One could also suggest that these "mad travellers" of modest social origins might, with a little more culture and money, have swelled the ranks of the nomadic connoisseurs of art, of whom there were a great many in the same period and to whom Hacking also refers. Proust well described the visual insatiability of these connoisseurs, their incapacity ever to be satisfied, and in my view they shared this incapacity with masturbators who, no matter how detailed their hallucinations, can never embrace them. Dalí did not stray far from the circuit formed by Port Lligat, Paris and New York, but his endless exploration of the

visible world and its mirages made him a great mental traveller. He advanced through the labyrinth of his multiple images as Albert walked the roads, responding to perceived signals and sometimes embarking on this search for visual satisfaction under pressure of masturbation. "The mortal activity of these new images can still, in parallel to other surrealist activities, contribute to the ruin of reality, to the advantage of all that brings us back to the clear springs of masturbation, exhibitionism, crime, love." (MPC)

The most effective source of masturbatory activity is seeing: seeing more, from closer, as completely as possible, even if the images are only mental. So much so that Freud wondered whether masturbation could exist without conscious fantasy.[58] Jean-Jacques Rousseau called it a "vice for vivid imaginations".[59] Not only does Dalí associate onanism with his fantasies, as in *Rêverie*, but in *The Secret Life* he suggests that, during a period in which he gave himself over intensely to "that solitary pleasure sweeter than honey", he really did have a hallucination. He assures us that the phenomenon occurred only once. Later he had the means to, as it were, "manufacture" hallucinations. He organized evenings during which, he says, "I direct, I dictate poses down to the smallest details" (PSD). He describes the extremely complex arrangements to which he subjects those who are willing to go along with them; they are *tableaux vivants* reminiscent of a Sadean theatre, except that Dalí's sadism is not at all extreme – it is more mental and to do with frustration. His definition of eroticism is fundamentally voyeuristic: "Eroticism starts with the third person." (This definition can be generalized, so necessary is the conscious or unconscious presence of an imaginary or real 'third person' in a relationship of love, including those of the most conventional kind.)

Masturbators may watch with open eyes, or at least one open eye, like voyeurs who may or may not impose their gaze by force but who are always excluded from the action and prefer to watch through an element that frames the exciting scene (half-open door, window, keyhole); they may be pornography connoisseurs flicking through a magazine or watching a video, but always, whether alone or in company, increasingly focused on the rising pleasure; or they may watch their erotic dreams with eyes closed. Whatever the case, mas-

turbators need images. More than a relation of cause and effect there is surely a structural analogy between visual greed and masturbatory activity. When the latter is stigmatized it is always said to be "frantic", "ferocious", to "exhaust the strength" of those who indulge in it, who are themselves more "insatiable" than libertines, etc. I know that in France whole generations were threatened with deafness if they committed this sin. In Spain young perpetrators of the vice were liable to go blind, and in Switzerland too, since, in his highly documented book on *La Sexualité de Narcisse*,[60] Sarane Alexandrian cites the case of the nineteenth-century Genevan poet Frédéric Amiel, who, having a problem with his eyes, became more anxious when his doctor told him, "Every instance of pollution is a dagger for your eyes". To save himself from such misfortune, the young Dalí invented a means of protection: drawing. "I learned to draw with the fervour and attention of my entire being, made ten times stronger by the need to wipe away my guilt at having done 'that'." (VSD) To the point where, in accordance with a well-known psychic process, "I very soon came to associate the pleasure of my masturbation with that of drawing". (UC)

The history of literature does not abound with accounts of masturbation but, when they do exist, their authors have almost always linked them to the faculty of imagination. Crossing the countryside to join the woman who welcomed him tenderly but was forbidden to him as a lover, Rousseau relates, "As I walked I dreamed of the woman I was going to see, the caresses with which she would welcome me, the kiss waiting for me on my arrival. Just this kiss […] heated my blood to such a point that my head became troubled, I was dazzled to the point of blindness. […] Aware of the danger I sought, as I left, to distract myself and think about something else. I had not gone twenty steps before the same memories […] returned to assail me and I could not free myself from them, and however I had gone about it I do not think that I could ever have managed to make that journey alone with impunity." In other words, without having been guilty of pollution.[61] This passage emphasizes that the solitude of the daydreaming walker is entirely relative. In his prologue, Sarane Alexandrian cites at length an extract from Michel Leiris's *L'Afrique fantôme* [Phantom Africa]: "Desire to write an essay on masturbation. How, despite the description

'solitary vice' that it is often given, masturbation has an eminently social character, because it is always accompanied by representations of a hallucinatory nature. That the figures who come to surround the man on the point or in the course of masturbating are entirely imaginary, or that they are (as I think is most frequent) formed of a single memory or an amalgamation of several memories, it is out of the question for the masturbator ever to be satisfied with himself. He needs the external support of this or these partners." This company is also evoked by René Crevel in *Mon corps et moi* [My body and me]: "I hesitated to make an appointment with myself because, if I sentenced myself to an evening of solitude I knew that, after reading something in particular, when the time came to go to bed, there would be fifteen or twenty full minutes of posing in front of the mirror with the sole end of imagining some other presence".[62]

In his essay *Solitary Sex*,[63] the historian Thomas Laqueur offers an unexpected argument to support the correspondence between masturbation and imagination. It would be wrong to accuse religion of being the most repressive authority. In fact "masturbation, as a serious matter of sexual morality, is a modern phenomenon; it is the product of the profane Enlightenment." In reality it was when scientific and medical conceptions began to prevail that masturbation appeared to rational minds as being "against nature, in the sense that it [is] artificial, born of the imagination and desires dissociated from the natural needs of the body." If solitary sex became reprehensible, this was because it is "rooted in the imagination but not in reality."

Following an order at once thematic and chronological across several civilizations, Sarane Alexandrian cites a profusion of examples and quotations from both practitioners and censors, revealing the masturbator's dependency on images. So we learn that "With closed eyes the yogi [who practices tantric yoga] sometimes visualizes Kumari squatting with parted thighs to show him her delectable sex". Kumari is the goddess who represents all sixteen-year-old girls. "But he may also visualize the goddess Kali appearing to him naked with her four arms and three eyes (one in the middle of her forehead), sticking out her tongue." The tongue is a sign of devastating sensuality. Also, "the initiate who masturbates imagining Kali reaches the extremes of desire."

It is not a goddess that sets Leiris fantasizing when he is in Africa but more ordinarily – for lack of them – a blonde: "I perceive extremely acutely the shape of her buttocks and the taste of her skin." One sixteenth-century Franciscan monk thought the sin of voluntary pollution should be counted twice on the grounds that it involved a mental representation, making the crime more serious. It seems he had a point. In the eighteenth century the scientific argument began to prevail over that of religion: masturbation was bad for health. Doctor Tissot identified all the forms of exhaustion it caused, among the first of which, according to Alexandrian's summary, were "the efforts of imagination [it demands] which weaken the faculties of the soul."

The most interesting case for our purposes here is that of the English painter Austin O. Spare. He is part of the long tradition of onanism mixed with esotericism, an idea he developed in 1913 in a book called *The Book of Pleasure*. Of this Alexandrian says, "In the method using coitus or masturbation as a magnetic charge, desire must be clearly present in the mind during the act and stated out loud at the point of orgasm. Spare's innovation was to replace this practice by that of the seals. A seal is made representing the desire to be realised, it is visualized until it is assimilated in the depths of the unconscious, after which one thinks no more about it. Organically it becomes a modifier of destiny. Coitus and masturbation ensure that the seal is assimilated and projected into the future. To justify this process, Spare developed a theory of the unconscious that is said to have impressed Freud and been ahead of C.G. Jung and his concept of the collective unconscious. For Spare the unconscious is made of superimposed strata, including all the strata of our previous lives: it is the deepest layer of the unconscious, that of our prehistoric life, which has the greatest life force." Alexandrian also reveals that, a little before Dalí, Spare was a great masturbator who "anticipated his 'paranoiac-critical method' in his creations (and masturbation)". According to this theory, as in many other examples cited, the stimulation of the sexual organs is so closely linked to an intense effort of imagination that the metaphorical sense that the notion of masturbation has acquired is easy to understand.

Although the following example is too good not to be a reconstruction, Dalí's description of his teenage masturbation makes it possible to link the

visions that accompanied it with the multiple-images principle of critical para-
noia. "As a teenager I masturbated a lot in the attic, watching the sun sink over
the bell-tower of Figueres. Then I saw that this bell-tower was like that of San
Narciso's in Gerona. Later I discovered an analogy with that of Delft. So that
to obtain pleasure I now had to assemble these three bell-towers in sublime su-
perimposition on my retinal field." (PSD) Another virtuoso of metaphor, Mar-
cel Proust, whom Dalí knew how to read, also remembered his early mastur-
bation, and his narrative has striking similarities with that of Dalí. In drafts for
the first pages of *A la recherche du temps perdu* [In search of lost time], Proust de-
scribes how, at the age of twelve, he locked himself in the lavatory at the top of
the house. "Up there [under the rafters of the house] I was entirely alone [...].
The exploration I then made in myself in search of a pleasure that was unknown
to me would not have afforded me more emotion, more fear, if I had been prac-
tising a surgical operation on my own marrow and brain. I thought I was going
to die at any moment. But I did not care. My mind, exalted by pleasure, was
well aware that it was bigger and more powerful than the world I could see in
the distance through the window [...]. I felt the powerful glance in my pupils car-
rying, like simple reflections with no reality, the beautiful curving hills that rose
like breasts on either side of the river."[64] Disturbed by the sun, Proust draws
the curtain and concludes with a typically paranoid exclamation addressed to
it: "Move over, lad, so I can get on with it". Since for many people access to
pleasure depends on the recreation of the conditions in which it was first felt,
we can deduce from the examples of Proust and Dalí that a young masturbator
whom chance has made to benefit from such sights becomes a demanding
voyeur.

 As reported by Dalí, it's a difficult exercise. "Unfortunately it didn't work! [...]
Such difficulties paralysed pleasure, which, for me, is linked to a great many
satellite satisfactions. I must have available, in thought, all the wonderful things
I have seen and experienced: a particular light, a particular shadow, a particular
form, a particular colour. This is why, for me, everything is based on the moiré
that combines the hierarchical mobility of the eye, and thus of painting, with the
supreme delights of the mind without which there is no real carnal pleasure." 97

Of course Alexandrian gives Dalí a major place in his book, reporting in particular another phrase from the conversations with Pauwels: "What I'm looking for is not orgasm, it's the vision capable of producing orgasm."

It is quite possible that the greatest pleasure lies in the proliferation of visions that make it possible to delay orgasm. *The Secret Life* describes Dalí's unhappy early days in Paris. He visits brothels, never touching a girl, but discovering enough "unlikely" props to feed his erotic daydreams for the rest of his life. He tries to pick up women at pavement café tables and on the bus, choosing the ugliest to give himself the best possible chance. But it doesn't work. "So? Where is that bag you were going to put all of Paris into? What an animal you are! Not even the ugly ones!" The day ends in the solitude of his hotel room. "In front of the wardrobe mirror I performed the solitary sacrifice which I tried to *prolong as long as possible* in order to *recall one by one* the images glimpsed during the day and to force them to come and show me what I had so much desired from each of them." (My emphasis). The observations of Leiris and Crevel are verified, the masturbator is not alone when he sets about satisfying himself, and the vision of partners is superimposed on his own reflection in the mirror.

Readers who have had the curiosity to glance at their own images in the mirror at moments when their hands are active at crotch height will know that the sight is not particularly aesthetic. (Anyone who has not had this curiosity can refer to Egon Schiele's *Self-portrait masturbating* of 1911). The concentration and tension required by the act (often more continuous than coitus) lead to grimaces or to a kind of paralysis of the face – and indeed part of the body – that are more accentuated than when pleasure comes through exchange with another person. Might not this unappealing vision of oneself be part of the pleasure? One takes pleasure in imagining another who is desired and the sensual relationship one might have with that person, but a whiff of masochism is enough, I think, to make one take even greater pleasure in the uncoverable distance between this idealized representation and the reality reflected in the mirror, which appears intermittently and is, it must be said, fairly abject. The most ironic written self-portrait of all is *The Secret Life*, almost contemporary with another satirical self-portrait, painted this time, the *Soft Self-portrait with grilled lard* of 1941. In it

Dalí continually gives himself a cold shower. He concludes passages of self-glorification, often already too superlative not to be suspect, with some fall, in every sense of the word, that covers him in ridicule. In the final pages he contemplates himself naked in the mirror – a narcissistic and sometimes masturbatory position – and praises his arms, legs, torso "which are the same as those of the glorious youth [that he] was." He stresses that he has "sought the Sky. And what is the sky? […] The sky is precisely at the centre of the chest of the man who has Faith." In this way Dalí ends his self-portrait – but he adds a postscript: "At the present moment I still do not have Faith and I'm afraid I will die without Sky." To end one's autobiography on a PS is certainly in itself an act of derision.

A few pages earlier the "glorious youth", now a student in Madrid, wants to be attractive to women and so goes to a barber's with the intention of having his long hair cut. "I looked at myself in the mirror and seemed to see a king on his throne, a white napkin over his shoulders like an ermine cape." In the next paragraph the "king" is at the bar in the Ritz, meditating on life's passing, looking at what he thinks is his first grey hair, which has fallen into his second cocktail glass. An elegant woman watches him for a long time. He wants to take out the hair, which is in fact a crack in the glass, gives himself a nasty cut and, with a bleeding hand, makes himself a doll out of his handkerchiefs. All this before the eyes of the woman and the barman, who must have taken him for "a provincial know-nothing washed up there." (VSD). Much of the book combines this humorous masochism with the story of a quest for a woman who remains unattainable, from a disdainful little girl in his childhood to an elegant woman later in Madrid. "And what is an elegant woman? It is a woman who despises you …." (VSD) In the end one woman, Gala, allows herself to be kissed. But what happens immediately after the kiss? The lover restrains himself from throwing her into the abyss. Thank God, he settles for walking her back to the station. And rubs his hands on his return to his studio, exclaiming, "Alone at last!" No sooner has the hero managed to unite himself with a woman than his one thought is to be alone again and to start *The Great Masturbator.*

We don't find out why Gala wants Dalí to make her "die". She refuses to reveal her underlying motives. "Only one person in this book will be flayed alive

and that will be me. I'm not doing it out of sadism, or masochism, but out of narcissism." We are within our rights to think that the narcissism of the "polymorphous pervert" is tinted with both sadism and masochism. And to regard the entire story as a good illustration of the mechanism according to which a woman is desirable only to the extent that she keeps the man at a distance (her scorn satisfying his masochism), or else that he keeps her at a distance (sadistic desire for murder), in other words, to the extent that she allows him to remain alone, to "flay himself alive". This is a sensual flaying. At the bottom of the etching he made as an illustration for Georges Hugnet's book *Onan* **fig. 34**,[65] Dalí wrote, "'Espasmo-grafifisme' obtained with the left hand while with my right – I masturbate until I bleed, down to the Bone to the helices of the calyx¡"

In the wake of the success of *The Secret Life* in the United States in 1942, Dalí wrote *Hidden Faces* **fig. 35** the following year. Written very quickly in dalinian French, this "true novel", to use the description chosen by its author, was translated into English – not without difficulty – by Haakon Chevalier, who had already translated Dalí's autobiography. In French we still have only a translation

34 Illustration with inscription by Dalí for Georges Hugnet,
Onan, Paris (Éditions surréalistes), 1934

from the English.[66] We can at least appreciate its remarkable dramatic structure. "It reads," says Haakon Chevalier, "like a novel of manners, its stylized characters reliving scenes bathed in an atmosphere of romantic decadence reminiscent of Barbey d'Aurevilly, Villiers de L'Isle-Adam and Huysmans."[67] Against a background of fallen aristocracy, Parisian high society, war in Europe and heroic deeds of combat and resistance, the plot cuts back and forth between five main characters: Count Hervé de Grandsailles, the proud owner of an estate diminished by debts and mortgages, Solange de Cléda, a high-born lady, Veronica Stevens, a rich young American, her poor Polish friend Betka and John Randolph, known as Baba, an airman with many exploits to his name. Grandsailles obliges the stoical Solange to put off the consummation of their love for years; Veronica and Betka both fall in love with Baba, whose injured face is hidden by a mask; Veronica marries Grandsailles thinking she is marrying Baba without his mask; Solange dies before Grandsailles makes up his mind to unite himself with her.

Dalí presents this novel as the illustration of "cledalism", a passion that should take its place in the inventory of psychic life alongside sadism and masochism. "Sadism may be defined as pleasure experienced through pain inflicted on the object; Masochism, as pleasure experienced through pain sub- 101

35 Cover of *Visages cachés*, Paris (Stock), 1973

mitted to by the object. Clédalism is pleasure and pain sublimated in an all-transcending identification with the object."[68] [HF p. XII]

I shall return later to the character of Solange, destroyed by renunciation imposed on her by her platonic lover, a woman flayed alive who renounces the flesh so completely that it kills her. As for Grandsailles, in addition to the sharp sight that I have already mentioned, he shares with his creator a true talent for the psychological torture of others, and the fear, despite his name, of proving impotent. He also shares the practice of masturbation accompanied by reveries. At length and sadistically Grandsailles undertakes to explain to Solange the ritual on which his philosophy of love is based. First introduced to each other completely naked and after months of abstinence of the flesh, the two lovers are required to have no physical contact at all. This prohibition is extended to other meetings, at which they appear ever more fully clothed. In the end, "if the charm works, orgasm occurs simultaneously in both lovers, without their having communicated with each other except by the expressions on their faces." This is a way of making love that is very much inspired by the courtly tradition and Dalí recognises that his own eroticism "is not unconnected to the old Cathar influence, the mystique of the troubadours and courtly love, the pleasures of non-consummation, the spiritualization of the act through privation, the rise of the energies of orgasm to the brain …". (PSD) The only "night of love" that Grandsailles grants Solange fits this model: she comes at one-thirty in the morning to lie naked on his bed, while he remains hidden in the darkness.[69] She leaves at two, as she came, and, looking at the sheets she has barely crumpled, Grandsailles, as honest as Dalí would have been, observes to himself, "In fact this all goes together, with the recurrence of my complex of impotence." (HF p. 148)

At the age of fifteen, while finding that "too much literature" was added to love, Dalí nevertheless showed himself sufficiently gifted to complicate his relationship with his girlfriend at his leisure. First came this sacrificial confession: "I am in love with Carme, but I've never told anyone, it's a secret I wanted to keep forever, for eternity, I wanted to suffer from it alone, it was my only selfishness!" (JGA) This is followed a few lines later by another, perverse confes-

sion, "I've seen what a cynic I am. I'm not in love with Carme. However, I pretended to be." This Carme herself does seem to have been pretty much in love, since she communicates her love to Salvador indirectly. He pretends not to understand. A few months later he does try to kiss her, but she resists out of modesty. These are the kind of manoeuvres that adolescents readily make but, at the age of thirty-seven, Dalí has not forgotten them while writing *The Secret Life*, in which he claims to have imposed a "five-year plan" on a girl he went out with in his youth. "I cynically graduated the frequency of our meetings, our topics of conversation, my own lies about the inventions that I claimed to make [...] when I felt she was 'ready', I began to demand sacrifices." The poor girl was put in a state "verging on mysticism". She was ripe to become a Solange de Cléda. As Dalí did not hide from himself his own fear of being impotent, it is not too much of an interpretative liberty to say that this fear "all goes together" with both the girlfriend that he strings along and the elegant woman who despises him. For a man who is so afraid he will not rise to the task that he fantasizes women as praying mantises, it is very convenient to keep them at a distance or be rejected by them. Cledalism theorizes this behaviour. Much later, when Dalí had overcome his fear, he was even able to justify this distancing by finding it an anchor in popular culture, in a rationalization fairly typical of the paranoid approach: "The girls of Ampurdan still sing to boys who beset them, 'Plenty of looking, but no touching!'" (PSD)

"Plenty of looking" has the two-fold advantage of preserving one from the dangers of contact and providing images for the reveries of those who, consequently, must satisfy themselves. An impertinent remark from Grandsailles's governess leaves us with no doubts: the count soils his sheets. And the further he moves from Solange, the greater the role of images. Idle on the liner taking him from Casablanca to Buenos Aires, Grandsailles is "relentlessly assailed by hallucinating and tenacious evocations of his libido". (HF p. 205) Of course the image that insistently presents itself is that of Solange de Cleda. Now he feels remorse and senses the degree to which she has taken "root at last in [his] heart". Now, with eyes closed, "with an unaccustomed, hyperaethesized visual acuteness, he saw cavalcades and triumphs similar to those described in *Hypnerotomachia*

Poliphili and painted by Piero della Francesca. If he wished to examine a fragment of one of his imaginings at leasure he had only to tighten the muscles of his eyelids." (HF p. 208) Grandsailles's reverie is dizzyingly detailed and Dalí has fun corrupting his character's refined taste with lubricious drives. Grandsailles immediately sees "the curling lines of blessed turpitudes drawn as sharply as in a sculpture by Carpeaux …. He could even distinguish through the veils over their bodies the various shades of salmon-pink on the tips of the breasts of dancing nymphs." (HF p. 208)

There are some advantages in responding to sensory excitation in solitude. One can control the rise of one's pleasure to the nearest quarter of a second and make it last by multiplying the images on which it feeds; similarly once can go back and forth among these images to the nearest millimetre, thus holding off the arrival of orgasm. On this point Dalí is perfectly explicit. First he reveals the way in which this practice incorporates the mechanism it is, in a way, replacing, and how one can even take pleasure in it. The distancing that underlies the pleasure of the voyeur or pervert similarly structures the pleasure of the masturbator. For those who prefer to remain at a distance from the object of their desire, masturbation not only realises that distance but also enables one to obtain pleasure from spacing out the times when the object is evoked by the imagination. One passage reveals the chain in which a feeling of guilt demands that the young Dalí delay the time when he starts again, then how the waiting increases the pleasure until it becomes a constitutive factor and so is understood and controlled. "A psychic technique enabled me to do 'it' at ever more widely spaced intervals. Now I no longer pretended that it was the last time. On the contrary, I promised myself I would do 'it' on Sunday. The idea of the pleasure to come calmed my erotic longings and I took sensual pleasure in waiting for Sunday. The longer I waited, the better 'it' was." (VSD) The masturbator, who alone sets the rules that govern his pleasure, arranges them precisely to suit his desire alone.

The complete portrait indicates that the masturbating voyeur is an obsessive. There are so many images that only a few can be selected, but these are explored into their farthest corners. "As I become more impoverished in images,

those that remain grow fabulously sharp." (PSD). Grandsailles is a maniac who polishes his shoes twice a day, sets out the ritual of his meetings with Solange leaving absolutely no room for the unexpected and, in his masturbatory hallucinations, evokes details from his collection of works of art that have not escaped his subtle connoisseur's eye. Thus Solange appears to him on a chariot whose bronze chains remind him of those of a Louis XVI clock, "one of his most recent acquisitions". Similarly, at the start of *Rêverie*, we are in the presence of an aesthete who is preparing to think about a masterpiece of German Romantic painting. In the meantime he hesitates at length over which notebook to use for taking notes. We should remember that this aesthete must also rid himself of an obsessive desire to urinate; we should add that the memory of a crust of bread left aside during a meal further delays the start of his thinking. He goes back to the kitchen to get it, intending to take out the crumb, a quintessentially maniacal action. He pummels it with one hand, plays at putting it up one nostril and expelling it again, while he takes his penis in the other hand. At last the show can begin! One of the narrative's fine artifices is that the erotic reverie begins after a digression evoking Vermeer's *The Letter* and the curtain it depicts. The curtain seems to be rising on the long series of paintings I have far too briefly summarized above. In the last lines we seem to understand that the masturbator does not attain his ends since he has been supplanted by the obsessive within him: the reverie stops when Dalí realises that he is in the process of noting it down "with the greatest scruples". (MPC 42) Any experienced disciple of Onan knows that the detail of visions during masturbation sometimes demands such concentration that it lessens the erotic tension and that the hallucination must then be reconstructed from the beginning. An authentic masturbator must have the focus of a civil servant – or a lawyer. Dalí claimed that in this he was the true son of his lawyer father and he talked of masturbation as a "discipline". (UC) The observation of images is associated with the observation of the practice. A literary paragon of this discipline is surely the hero of Roger Nimier's novel *Les Épées* [The Swords], who keeps a day-by-day account in a notebook of how many times he has masturbated and for how long.

Solitude

The masturbator may well evoke a beautiful blonde in the heart of Africa or a theory of nymphs on a liner sailing to America; he may have a head full of representations of his partners; nevertheless, wherever he is physically, he is most often alone. His nature is similar to that of the voyeur: he can take pleasure in this solitude. Solitude is first of all socially imposed. Confusedly knowing that "it" is forbidden, the teenager hides to indulge in it. Associated with sensuality, isolation becomes a pleasure in itself. *The Secret Life* contains countless occurrences of the word "alone", always of a jubilatory nature. "I kept telling myself, 'Just me alone! Just me alone!' [...] However, I ensured I was always in love – but in such a way that I was destined never to meet the object of my desire." In relation to the girlfriend he strings along, "I knew that I didn't love her, she knew that I didn't love her, I knew that she knew that I didn't love her, she knew that I knew that she knew that I didn't love her. My solitude remained intact." And let us recall the exclamation "Alone at last!" after Gala's departure, after they had just fallen into each other's arms.

Should we believe in this aspiration to solitude when we know all about the master's life in society and the court that surrounded him at his house in Port Lligat (where there was, however, no guest room), or in his suite at the Hotel Meurice, Paris? Yes, because nothing is sweeter than the sense of one's own solitude when surrounded by many people. Dalí discovered this very early, in the classroom when he was practising looking through walls. At that time he developed the power to "isolate [himself] completely", a faculty that went hand in hand with an unbelievable capacity for dissimulation. He adds "I reached an almost permanent absence during lessons." (UC). This "capacity for dissimulation" favoured the development of a multifaceted personality. The daydreaming schoolboy might have looked like a good child, paying attention to his lessons, and it is to be supposed that with a bit of practice he was even able to answer the teacher's questions while keeping part of his mind wandering. Explaining his behaviour as an adult, Dalí goes on, "I am capable of projecting myself into my little inner cinema [...] I free myself through a secret exit from the attempts to encircle my soul." (UC) Those who love solitude are not nec-

essarily hermits. On the contrary, they may live in the world and keep it happy by matching their faces to the person they're talking to. The more you lend yourself to the caprices of the curious, journalists and photographers, the better your face meets the expectations of those who address you, and the more you will be left in peace (I mean the peace to pursue the task that you have set yourself of course, the main one). This is the chameleon's mode of protection: matching one's appearance to the ambient colour. As a child Dalí observed small animals of this kind. His extravagance, like that of Warhol later, was a way of conforming to the unavowed madness of others, of taking it on and releasing them from it, while releasing himself from them. I like to think that, while his friends were still joking about the latest get-up they'd seen him in or his most recent prank, Dalí had the satisfaction of locking himself away in his studio. Surely this is also how we should understand his answer to Chancel, that he earned money in order to work, rather than working in order to earn money.[70] While some take offence at seeing a great painter act the clown to advertise a brand of chocolate or Alka-Seltzer, the great painter acquires the means to build a security wall that enables him to carry through what is developing in the solitude of his studio.

Dalí liked to describe parties at which he acted as the master of erotic ceremonies. In the spirit of cledalism, in other words pleasure in endless waiting and frustration, he included the parties that failed owing to the impossibility of finding taxis in Paris on a rainy night, or because a rather complicated position caused one of the participants to fall out of bed. The situation becomes ridiculous. We should not call these parties orgies – Dalí says they weren't – let us call them dramatizations. The man who has people call him "the Divine Dalí" in reference to the Divine Marquis (de Sade)[71] chooses the participants for their beauty and claims to excite their desire, but he also sends them into a panic, as he says, by deferring the realisation of that desire. With the same passion for detail as the marquis, he dictates positions which, as in de Sade's novels, are *tableaux* in the theatrical sense of the word. Simply put, like the masturbator, he arranges the protagonists of his fantasies at will. Many of de Sade's characters behave like this. The story is cruel because we are told that the masturbator re-

alises his fantasies, the most murderous included, by having them acted out by real people. Because Dalí's sadism is essentially mental, and his approach is to ward off the violence inherent to the sexual drive by sublimating rather than describing it, he claims to have had the idea of rewriting *The 120 Days of Sodom* so that vice is converted into virtue and orgasm into ecstasy, making it "the saga of chastity, abstinence and spiritual perfection." (PSD)

One might wonder, in relation to the parties whose failure Dalí seemed so to enjoy, what advantage there is in gathering together real people who will always be less docile and less agile than virtual characters. "I'm going to confess something to you," said Dalí to Pauwels, having described the parties in great detail, "[…] my delirious imagination is enough for me and ultimately I don't need anything or anyone." Except that he still needed to check that he didn't actually need anyone and got all the more pleasure from this aptitude for self-satisfaction because it was felt among other people and opened the door through which he escaped them. We know that the delight experienced in the base activity of bringing one's face as close as possible to a mirror and squeezing out the blackheads has been identified as a substitute for masturbation. Dalí used it as a metaphor to explain the "aerodynamic appearance of 'object-creatures'", the title of an article published in *Minotaure*: "It is fine and extremely satisfying, particularly after several clumsy, fruitless compressions, to reach the appropriate, definitive one which unleashes the serene exit of the foreign body, contained in the flesh of your own nose or in that of the person who stoically gives themselves up to this act; an act which, as I have insinuated, is the most involving, fascinating and irresistible of all." (MPC) The masturbator caught and besieged by a group, even a group in his power, who then voluptuously expels himself from that group, is surely comparable to the blackhead squeezed out of the pore that contained it.

In these gatherings of which we shall say, to avoid employing a word that would displease Dalí, that the exchanges between people had a sexual aim, the person in whom the sight organ is dominant, and who submits his sexual pleasure to it, automatically takes the place of the observer. He mentally removes himself from the scene he is observing: he is a voyeur and willingly adopts a

position that is either distanced from the others or, on the contrary as in Dalí's case, that of the organizer, the person whose point of view dominates the scene. The sensation one feels by placing oneself at a distance is reinforced by the very nature of the scenes offered to the eye, which can be perceived as unreal; the voyeur may be led to look on situations and actions that he could barely have believed capable of realisation – for example, a young woman leaning back so far that her lips brush those of the young man behind her, "in one of those un-believable positions from Hindu frescos". (PSD) They can even go beyond the imagination, and at this point the observer withdraws from reality itself, with the impression left by certain dreams so strange that they seem foreign to us when in fact they spring from our deepest desires. To put it in more general terms, the paradox is that an orgy can be the hyper-dream of one who enjoys solitary pleasures.

In the Bay

On repeated occasions Dalí chose to set a scene, written or painted, by a fountain. In mythology Narcissus squatted down by a fountain to slake his thirst. He is often represented in that position and Dalí, no doubt remembering the painting by Caravaggio[72] – which is, if not a double image, at least a doubled image – maintains this tradition. In the doubled image that is the *Metamorphosis of Narcissus*, the figure is particularly bent over, curled up like a shell. In "Intrauterine memories", the second chapter of *The Secret Life*, Dalí describes the position he adopts before falling asleep as one of being curled up (*recroquevillement*) or, "more precisely, 'shelled up' (*"recoquillement"*)". "Before sleep I lie 'shelled up' in the embryonic pose. [...] My back strives to stick to the imaginary placenta of the sheets which I try to mould over my behind." The Narcissus he depicts adopts the same foetal position. The year after writing "Intrauterine memories" Dalí was photographed by Halsman completely naked and, by means of montage, curled up in an egg.

The oceanic feeling

The theme of the birth trauma (Dalí cites Otto Rank) and the return to the paradise of the mother's belly, potentially during sleep "through which we gain access to precious parcels of our lost paradise" (VSD), is a *leitmotiv* of Dalí's imagination. To some extent Dalí interprets the metamorphosis of Narcissus as a second birth: the flower Narcissus becomes blooms with an egg that cracks. In the painting *Geopolitical Child observing the Birth of the New Man* (1943), a man is struggling to get out of a kind of soft, egg-shaped world map. Meanwhile the pavilion of the Dream of Venus, built for the New York World's Fair of 1939, invited visitors to enter a highly suggestive cave **fig. 36**. They had to cross the threshold between two gigantic female legs and make their way to, among other things, a room called the "wet room". It is very possible that this Venus was an inspiration for Niki de Saint-Phalle's *Hon*, her penetrable woman at the Stockholm museum **fig. 37**.[73]

36 The façade of the pavilion for the New York World's Fair, 1939, *The Dream of Venus* (to the right, the entrance between the legs), photograph by Eric Schaal
Fundació Gala-Salvador Dalí, Figueres

Similarly the Ovocipede, the transparent plastic ball with a diameter of 1.2 metres in which Dalí "landed" in New York in late 1959, heralded the various pods designed by artists in the 1960s and 1970s. Their emergence was favoured by that of so-called inflatable structures, perhaps because air, fundamental to life, was regarded as doing good (this was before people started worrying about pollution). I'm thinking of maternal utopias such as Piero Manzoni's egg-shaped *Placentarium* (1961) and Bernard Quentin's giant reclining body of a woman, *Venus of Chicago* (1974–75).

In the first pages of this book, I said that the house at Port Lligat, now managed by the Fundació Gala-Salvador Dalí, is so welcoming that one could happily move in. At least I could. It has something of the maternal refuge about it. Without wishing to draw my reader into an introspection as long and as detailed as Dalí's own in *Le Mythe tragique de l'Angélus de Millet*, I should like to describe the echo that – as I now understand – my visit found in me. Many years

37 Niki de Saint-Phalle, *Hon,* 1966
Moderna Museet, Stockholm

before doing the Figueres, Cadaqués, Port Lligat, Pubol circuit,[74] Jacques and I stayed at a hotel at Belle-Isle. Though of course the colour of the sky is not the same in Brittany as on the Catalan coast,[75] it is possible to make comparisons between the two places. The hotel in Belle-Isle is more or less in the middle of the cove of Goulphar just as Dalí's house is in the centre of the bay of Port Lligat. In both places the water seems all the closer because the habitable space is confined. Our room in the Goulphar manor house was comfortable but small, under the eaves as I remember. It is well known that the Port Lligat house comprises a collection of connected fishermen's huts, bought and redesigned over a number of years. If the mental complexity into which we are led by Dalí's work has been compared to a labyrinth, the house is its three-dimensional expression and the giant eggs on the roof are the signs of its protective function. The rooms are never large and can moreover be visited only in small groups. You have to pass along very narrow corridors, some of which are like secret passages; you go up a few steps, then down again. Almost hidden, because you have to go through

38 The Port Lligat house with eggs on the roof
Fundació Gala-Salvador Dalí, Figueres

Gala's bathroom to get to it, is an oval room around which runs a padded bench covered in cushions **fig. 39**. This is the belly of the house.

During our stay in Belle-Isle we both had a lot of work to do. Each of us had to read the proofs of a book that was about to come out and we swapped tasks. In my case it was a book on Yves Klein, which I had started, by chance, in the days following my mother's suicide a few months before. The days spent between my tiny improvised work-table in the hotel room and the stretch of dark ocean were a moment of complete happiness. By withdrawing from time, my mother had cut me off from the dreamed element of my own future. She had annihilated a part of my own self – at least that was how it felt. In the hollow of the bay of Goulphar – and in the name Goulphar it's impossible not to hear an act of ingurgitation – I was reborn in a space that was doubly enclosed: first by the surrounding rocks and the walls of the room and secondly by the depth of the ocean. Without looking for it I found a sense of absolute well-being in keeping with the external conditions of my life with Jacques, which the horizon seemed

39 The oval salon of the Port Lligat house, with Dalí
in an embroidered suit

to match, perhaps giving me back unfolding time. Of course I was reconciling myself with my dead mother. I went back into the closed, protecting belly without walls. In a book which, as I shall show, has guided me greatly in my understanding of the work of Dalí, *The Hidden Order of Art*, Anton Ehrenzweig describes this paradoxical space: "In psychoanalytic terms, the sense of unlimited extension is closely associated with fantasies of the womb. The womb, in itself, is perhaps the most constraining symbol of a restraint inducing claustrophobia. And yet, in the child's fantasies, the womb extends to contain the whole universe."[76]

Ehrenzweig describes this "sense of unlimited extension" as "oceanic", borrowing a term that Freud applied to mystical experience. This sense of being one with the universe can be felt during a moment of regression, in the fantasy of return to the mother's belly, but it is also related to what the author calls the "dedifferentiation" stage of the creative process. In Ehrenzweig's view artists are more likely than other people to experience moments of suspended consciousness in which all distinctions and boundaries are abolished, including those between themselves and their surroundings. At these moments they are totally available, open to all possibilities, to the infinite, before making the choices that will lead them to create their work. This dedifferentiation usually operates at the deepest level of the unconscious, but when it is perceived by consciousness it can give rise to a feeling of ecstasy.

A description of this oceanic feeling opens another book, Catherine Millot's *Abîmes ordinaires* [Ordinary abysses], to which I was particularly receptive because the almost total similarity of its author's name to mine added another knot to my tie to Dalí's *L'Angélus de Millet*. Like Ehrenzweig, who uses the examples of many artists who were his contemporaries, including Jackson Pollock and Bridget Riley, Catherine Millot evokes similar accounts by Arthur Koestler and Henri Michaux. But she also records personal experiences: driving along a road taking her to a new life (a job she had never done before in a new city), she miraculously escaped having a car accident. "Mysteriously, in the following days, all my anxieties disappeared, I was overcome by an unknown sense of freedom, as though I had paid a debt of life. I was filled with a great emptiness. It began

with the sky as though an invisible lid had been lifted, revealing a bottomless hole. […] Then the emptiness spread, expanding the world and opening it up in every direction."[77]

The aftermath of a drama in which one has come close to death or a great misfortune has left one feeling annihilated can be experienced as a rebirth. Catherine Millot adds a nuance: "It was as though […] I had died on the road and was now living a supplementary life. Should I speak of rebirth? It was rather a second life, free and unencumbered, granted as a grace."

From the threat of cannibalism …

Although Dalí never gives in to pathos in his descriptions of the traumas he experienced, we can imagine which events were sources of suffering for him: the death of his mother when he was seventeen, his father's rejection of him and, presumably, during the period of war and exile in the United States, the impossibility of going back to the landscapes of his childhood, of the plain of the Ampurdan. He freed himself from his painful past, as any artist or writer must, by making art. America, where he wrote *The Secret Life*, was of course a country favourable to such an undertaking. "New skin, a new land!" he wrote in the final pages, straight after the lines, "[…] with my vice […] of doing the contrary of what others do, I thought that it was more intelligent to begin by writing my memoirs, and to live them afterwards. To live! To liquidate half of life in order to live the other half enriched by experience, freed from the chains of the past. For this it was necessary for me to kill my past without pity or scruple, I had to rid myself of my old skin." Also in these memoirs he announces that his imminent rebirth would be dated the very day after the day of their publication. Moreover the final words, just before the epilogue, are: "Instead of Reaction or Revolution, RENAISSANCE!" (SL p. 398)

In order for rebirth to occur, there had to be a burial. Using the work of the pioneers of psychoanalysis while also reading poets, Ehrenzweig imagines one of the very first, pre-Oedipal states of the child's development, when the mother appears terrifying, threatening to devour the child out of love. This image is

that of the Great Mother illustrated in mythology by, among others, Agave, the mother who tears her son limb from limb and then, having recovered from her madness, puts the broken body back together again to bury it. Ehrenzweig links the conceptions of the poet Robert Graves to this model: "In his view [...] the Apollonian poet avoids the dangers of the abyss where the real muse, the dangerous White Goddess, awaits him. The real threat that she represents lies in her triple aspect, her lack of differentiation between life, love and death. Her love for the poet will thus precipitate his death: the poet, in adoring her, provokes his own death to find love and rebirth in its place, or else [...] he desires life in death." The oceanic feeling is ambivalent, like that of vertigo. While the plenitude one feels in the presence of immensity can lead to a kind of ecstasy, this does not remove the terror of being swallowed up by that immensity. However beneficial my contemplation of the ocean from the window in Belle-Isle may have been, I would never have put a toe in the water, incapable as I have always been of learning to swim, in other words of stretching out my body over an abyss, too weighted by my attraction to that abyss. Unlike me Dalí liked to swim, but I note that during his first Atlantic crossing by sea, he was seized by "a real terror of the oceanic space". (VSD)

The theme of rebirth – understood in part as a reparation of the birth trauma – is one pole of Dalí's work; that of immersion, being swallowed up, devoured, is another. One of his "real" childhood memories concerns his drawing sessions in a laundry transformed into a studio. On very hot days, Dalí remembered, he would put a board that served as a table over the cement washing trough, fill it with water warmed by the sun, take off his clothes and work up to his waist in water, which helped to "revive the intrauterine pleasures within [him]." (VSD) In the same pages we find "fried eggs without a plate", which abound in his painting, and enable him to visualize the soft, viscous substance in which the embryo is bathed. Further on comes the description of a sack of very hot maize seeds which the boy voluptuously tips over himself having, once again, taken his trousers off, and the singular epicurean ritual in which, every morning, he would pour a little sticky milky coffee over himself. To this we can add the children's games, including the game Dalí calls the "cave game", similar to 'sardines', in

which several people are packed into a cupboard (CDD), and, substituting for a fantasy to which I shall return and which consists of imagining oneself dead, eaten by worms, the episode in which the painter works covered in a swarm of large flies attracted by a very fresh fish whose scales he is copying. (JDG)

But it is certainly in *Le Mythe tragique de l'Angélus de Millet* that this obsession is elaborated. Dalí is not lying when he highlights his fear of grasshoppers – it first appears in the journal he kept in his teenage years – and the woman's contemplative attitude reminds him of a grasshopper's folded legs and, worse, of a praying mantis – the female that devours the male after coupling. This also reminds him that as a child he used to wonder if the female kangaroo (which adopts the same pose) had eaten the baby she carried in her pouch. His interpretation is reinforced by the figure of the man (the son) who, faced with the "annihilatory power" of the phallic mother, is concealing an erection behind his hat. In the end Dalí admits that, "the submersion of the figure of *L'Angelus*, in other words *me* in the maternal milk, can be interpreted ... only as the expression of being absorbed, annihilated, eaten by the mother". A fantasy comes to mind: the picture is soaked in a bucket of warm milk, but slips longitudinally, so that Dalí no longer knows "whether the submerged figure was the man or the woman"![78] (MTA)

Later Dalí found a way to verify his thesis still further. When the book was published, twenty-two years after it was written, it was preceded by a prologue in which the author explains that x-ray analysis of the painting has revealed in the meantime that Jean-François Millet had initially painted a child's coffin at the feet of the figures but then, fearing that he would make the public ill at ease, "is thought to have buried the dead son under a layer of paint representing earth." (MTA) *L'Amour* [Love], an astoundingly exhaustive piece in *La Femme visible*, had earlier linked all the themes we have just cited: "Nothing could be more surprising than the scrupulous documentation of sleeping positions, particularly after love, as they are always those of annihilation or intrauterine curvature, particularly when adopted by happy people who fall asleep in the passionate, cosmic position of 69 or in that of the praying mantis devouring the male".[79]

The 69 position supposes an exchange between lovers involving their mouths. There are so many representations or suggestions of fellatio in the paintings from the early 1930s that although, as is said in *Le Mythe tragique*, Gala's love brings about "the psychic cure" of "the terror of the act of love", it is reasonable to think that this was partly because she was able to prove that the man survives being taken into the woman's mouth. (Nevertheless Dalí continued to think that Gala looked like the lion of Metro Goldwin Mayer (JDG).) We can cite *The Great Masturbator* of course, *Tour du plaisir* [Tower of pleasure] and *The Fountain* (1930), or the drawing *Des douceurs fines pour les enfants* [Exquisite sweetness for children], 1931. The boy compares his penis to those of his friends and worries whether it's smaller than theirs (UC); then, as a young man, he suffers from an impotence complex combined with the unconscious belief that coitus has "almost immediately fatal consequences" (MTA) (all fears related to that of castration, which psychoanalysis would link to the fear of losing one's eyes); then, having finally established a relationship with a woman, he paints and draws enormous phalluses as objects of woman's oral lust, for example in *Drawing done intentionally for Gala*, 1932. Ultimately he objectifies his obsessions by rehabilitating *La Beauté terrifiante et comestible de l'architecture Modern Style* (The terrible and edible beauty of Modern architecture) – an incongruous aesthetic position in the context of Surrealism. In this piece published in *Minotaure*, Dalí maintains that houses in the modern style can be assimilated to cakes, because they are "the first and only erotizable buildings, whose existence verifies a 'formation' that is urgent and so necessary to the lover's imagination: being able as really as possible to eat the object of desire." (MPC 46)

The least one can say is that Dalí did not hide the fact that his obsessions remained firmly rooted in the earliest stages of infantile development. Among his regressive temptations, the anal nature of some of which we know, others take him even further back, to a nostalgia for the oral phase. He often mentions the "sensual pleasures of sucking with the mouth, the upper lip sucking the pillow" (UC) just before falling asleep. Throughout his writings we are told as much about what the author has in his stomach as what his double takes in or throws up, as in the hallucinatory scene from his student life in which he revisits a two-

day orgy: "It was all in there, reheated rabbit, two shaved armpits, mouth, eyes and reheated rabbit again, anarchy, anchovies, absolute monarchy, clams, vermouth, bile, bile, bile, clams, reheated rabbit, bile, armpits, bile, bile ...". (VSD) Our hero's eyes were bigger than his stomach. He should have known that, when faced with an overabundant table, as we are before the one we love, we should content ourselves with devouring with our eyes. After this Dalí's visual appetite played its role as a substitute for cannibal fantasies to perfection.

The word "cannibal" reappears endlessly. Unsatisfied love proves to be "as ferociously cannibalistic in feelings as the praying mantis devouring her male during coupling" (VSD); because he loves extracting bone marrow and adores woodcocks that have been left to hang, Dalí rejoices in his "cannibal appetites" (UC), and so on. A great many of his paintings and drawings have cannibalism as a theme, including the monstrous couple eating each other in *Autumn Cannibalism* (1936). Generally speaking these works are regarded in the light of the Spanish Civil War but, as has rightly been noted, they do illustrate Dalí's conception of human nature, of which the cannibalism of war is only one aspect.[80]

Yves Klein pretended to launch himself into the air; he also mimed his own burial. On several occasions he had himself photographed lying on one of his works, a horizontal monogold apparently floating slightly off the floor, on which are placed, as on a gravestone, plastic roses and a blue sponge crown. The work is called *Ci-gît l'espace* [Here lies space]. It dates from 1960, in other words the year of *Saut dans le vide* [Leap into the void]. Little has been said about it, although one of the photographs I mention, taken shortly before the artist's death, might have made a subject for romantic speeches – but it's also true that its kitsch aspect might have deterred connoisseurs of the void and of monochrome works. For my part I saw in it the self-irony with which great artists often accompany their most extreme propositions, in order to prevent any single interpretation. Yves Klein seems to be saying, I appropriate space, I fly away ... but crash! I may also end up lower than the earth.[81] Today I also see this work and the way it was staged it in the light of Ehrenzweig's theses. Opening oneself to the infinite and being buried in the belly of the mother, the bowels of the earth, are aspects of the same movement.[82] It's easy to imagine that an artist who ex-

tends his field of creation to a dizzying degree, aware of the risks he runs (and these risks, for Yves Klein, were also physical), should ward off his resulting anxiety by representing his own end. To borrow the terms used by Ehrenzweig in relation to Graves, the artist "avoids the abyss" by precipitating his own death, but, because he is doing it in a representation, in a game, a work, it is with the hope of a "rebirth".

The poet Federico García Lorca also used to act out death. At the end of evenings with friends he sometimes lay down on a divan and, in the position of a corpse, would describe in detail how he was laid in his coffin and what chaos the hearse encountered on the road to the cemetery. "He would dance a kind of horizontal ballet representing the jerking movements of his body during burial, as the coffin descended a steep slope in Grenada." (JDG) He would describe everything down to the decomposition of his corpse. When he had succeeded in plunging everyone into a state of anxiety, he would sit up, very joyful: "He had managed to revive a little",[83] notes Luis Romero with a sad irony. This ritual must have impressed Dalí profoundly. He described it again when Ian Gibson met him in 1986 for one of his last interviews, when he was already very ill and had difficulty speaking.[84] In particular he appropriated it when, in 1973, he chose to start *The Unspeakable Confessions* with the chapter, "How to live with death": "My supreme game is to imagine myself dead, devoured by worms. I close my eyes and, with incredible details of absolute, scatological precision, I see myself being slowly eaten and digested by an infernal swarm of large, greenish maggots gorging themselves on my flesh." (UC p. 11) There follows a paragraph about this feast, described from the point of view of the sacrificial victim. The chapter concludes with the words: "Death is the thing I am most afraid of, and the resurrection of the flesh, a great Spanish theme, is the one that it is hardest for me to accept, from the point of view of ... life." (UC p. 22)

... to phoenixology

So Dalí liked to suggest ways of accessing immortality that relied not so

much on any religious conception as on scientific facts – very freely interpreted

it must be said – such as the discovery of DNA. In 1973 he made the object-book *Dix Recettes d'immortalité* [Ten recipes for immortality]. But he was at his most convincing inventing a new discipline called phoenixology (which Cocteau would recall when making *The Testament of Orpheus*), even though, here too, there are few methodological certainties to be found. At any rate phoenixology allowed him to write the most moving pages of the *Diary of a Genius*, which are those describing the suicide of René Crevel. There has been a great deal of interest in the unconsummated love between Dalí and Lorca.[85] The friendship described in the pages on Crevel is equally worthy of attention **fig. 40**.

Like all the physical descriptions Dalí gives of people, that of René Crevel is implacably synthetic, but coloured with tenderness. "He was endowed with the morphology of an embryo, or more precisely still, with the morphology of the bud of a fern just before opening [...]. You must have observed the gruff-looking face, like that of a bad angel, deaf and Beethovenian, in the curl of a fern bud. If you haven't thought of it yet, do so now, carefully, and you will know ex-

40 René Crevel and Dalí in Port Lligat, 1931 (?)

actly what the puffy, backward baby face of dear René Crevel looked like." Of course the poet was predestined by his name. "Crevel was called René, which could very well come from the past participle of the verb *renaître*, 'to be reborn'. At the same time, he had kept Crevel as his surname, which suggested the act of *se crever*, to die, or as the philologist-philosophers would say, 'the vital urge to die." But his embryo's face saved him for a while. "Phoenixology teaches us living beings the marvellous chances we have to become immortal in the course of this very terrestial life – and this is as a result of the secret possibilities we possess of rediscovering our embryonic state and thus being able to be perpetually reborn from our own ashes, like the Phoenix." Because Crevel's whole life alternated between stays in sanatoria and intense periods of literary and political activism, "Nobody has so often 'perished' *('crevé')*, nobidy has so often been 'reborn' *('rené')* as our René Crevel". (DG pp. 77–78)

Dalí was, if not predestined, at least predisposed to conceive of this notion of phoenixology by an event that occurred before his birth. His elder brother, born in 1901, died nine months before he was born. His parents, with the same thoughtless sorrow as those of Vincent Van Gogh, gave him the same first name. Dalí partially disguised this fact, claiming in *The Secret Life* that this brother had died three years before he was born and at the age of seven. These shifts of chronology conceal the fact that the gap between the death of the elder brother and the birth of the younger suggests that the latter was conceived as a replacement for the missing boy. At the age of nearly seventy Dalí was still fulminating against his father: "His eye on me addressed my double as much as myself. In his eyes I was only half of myself, a creature too many. My soul twisted with pain and rage beneath this laser that endlessly rifled through it looking for the other one that was no longer there." (UC p. 23) How, in such conditions can one refuse to be merely a double and "reconquer [one's] rights to life"? (UC p. 24) By denying that one was conceived by the same means, by engendering oneself, which is the goal of his work's frenzied autobiographism – and, in doing so, overturning the natural order. "Moses [to whom Dalí initially compared his father] gradually divested himself of his beard of authority and Jupiter of his thunderbolt. Only William Tell was left: the man whose success

depended on the heroism and stoicism of his son." (UC p. 30) The son begets the father. And we have to acknowledge that, if Salvador Dalí Cusí (the father) still exists for us, it is because Salvador Felipe Jacinto Dalí Domènech (the son) brings his features back to life by painting his portrait (and not only lending him those of William Tell).

As a child Salvador Dalí Domènech chose to do his business in the most unexpected places in the house (such as the drawing-room carpet or a shoe box) and sent all the family into a panic, hunting for it. If Ehrenzweig had known about this "poo ceremony", would he have interpreted it as an extension of the stage of free anal dissemination, the first anal phase? Would he, considering the work rather than the biographical reconstruction, have gone back to even more primitive phases of the child's development? He writes, "At the anal level, the White Goddess takes on the powers of both parents. Her aggression also increases and the threat of castration gives way to the threat of death. [...] In the end the divine child himself absorbs the creative powers of both his parents. He incorporates the mother's womb; he carries himself, expels himself and buries himself in a single act, a manic-oceanic act which his extreme indifferentiation makes it hard to visualize." It would seem that Dalí is the paragon of Ehrenzweig's theory. Dalí manages to go beyond the threat of castration and death exerted by the praying mantis; he states, "Salvador Dalí was invented in a belly created by Salvador Dalí. I am at once my father, mother and me, and perhaps a little divine" (UC) – indeed he liked to have himself called "the divine Dalí" and created double images whose extreme indifferentiation makes boundaries hard to visualize.

Scanning

We can look at many other dalinian themes through Ehrenzweig's lens. Dreams and the fading of consciousness in the moment before sleep favour access to the dedifferentiation phase. Ehrenzweig explains, "When the semi-paralysis that affects rational thought is felt as the destruction of the self and even as death, these reveries can appear self-destructive." In *L'Amour* Dalí writes,

"Sleeping is a way of dying or at least of dying to reality, better still it is the death of reality, but reality dies in love as in dreams. The life of man is entirely occupied by the bloody osmoses of dreams and love." The notion of osmosis is not very far from that of dedifferentiation.

Ehrenzweig gives the description "twilight" to these reveries halfway between waking and sleep. By erasing the outlines of things, be they concrete, mental or even moral, twilight is the time that most lends itself to dedifferentiation. The most transgressive scenes of *Rêverie* are permitted because they unfold in a twilight setting and the dreamer indulges in them during a siesta, another moment when consciousness fades. But most importantly twilight is the time of the Angelus. "It is with Millet's *Angelus* that I associate all the pre-twilight and twilight memories of my childhood, regarding them as the most delirious, in other words (commonly speaking) poetic. [...] Most frequently, at the end of summer days, I would leave the streets of the town and go to the fields to listen to the sounds of insects and plunge into infinite reveries." (MTA) This predilection for evening walks is confirmed in the *Journal d'un génie adolescent*.

Dalí returns to it in *Le Mythe tragique*. In the course of these walks, he says, he would declaim poems of his own composition in which he would lament that civilization had ruined the world's virgin state, "thus ruining the ideal that led [him] towards a pure, integral pantheism going back to the origins of the universe". Nostalgia for a virgin state of the world is one of the great modern themes. Partisans of the avant-gardes have long made this observation, which destroys the notion of progress in art since, at the height of civilization, artists aspire to return to the lost paradise. Yves Klein, to mention only him, proposes Air Architecture as a solution. Uniquely "constructed" using the natural substances of air, water and fire, with all machinery hidden under the ground, it would return the earth's surface to its original state, and man to an Eden in which he would live naked.

The oceanic experience and effect of dedifferentiation it engenders lead to a pantheistic feeling. We have seen that this experience is like a return to the space of the womb, paradoxically perceived as an infinite space, and that dedifferentiation can go so far as to break down the bounds of the self. Remember-

ing that Freud spoke of the oceanic feeling as characteristic of religious experience, Ehrenzweig goes on, "For the mystic has the feeling of being one with the universe, and sees his individual existence as a drop of water lost in the ocean". Koestler's experience, mentioned by Catherine Millot, combines the "horror of the trauma with a blessed dissolution in the Whole". Meanwhile Klein, unusually, sees going beyond the self in terms of collaboration between artists – in which he was involved on several occasions – and whose consequence is that "the thinking man is no longer the centre of the universe but the universe is the centre of the man". He adds, "We shall then know 'prestige' in comparison to the 'vertigo' of before. Thus we shall become men of the air, we shall know the upward force of attraction, towards space, towards nowhere and everywhere at once; having thus mastered the earthly force of attraction we shall literally levitate in complete physical and spiritual freedom."[86] Ehrenzweig goes on, "For the mystic has the feeling of being one with the universe, and sees his individual existence as a drop of water lost in the ocean." This widely shared aspiration towards the infinite is summed up in Jacques Lacan's words, cited, not without humour, by Catherine Millot: "The infinite, to every man, whatever he wants or does, the infinite means something to him, something fundamental, it reminds him of something. It's where he comes from."

We know that Dalí's eye passed through obstacles, and that it was not for nothing that he was interested in the multidirectional vision of flies. The articles of 1929, collected under the title *Documentaire* [Documentary], record all kinds of visual information without distinguishing the most distant from the closest, nor objects that have a role from those that are part of the backdrop. From the time of his interest in Impressionism and then in Vermeer, Dalí seems to have seen matter as porous, formed of discrete elements, always capable of being passed through, or at least looked through. He found confirmation of this in the theory of the atom which, during what is known as his "mystic" period, led him to paint scenes in which no one element touches another, such as the two versions of *The Madonna of Port Lligat* (1949 and 1950), and exploded images such as the Raphaelesque heads of the early 1950s. This functioning of the eye is akin to what Ehrenzweig refers to as "scanning", a word that was cer-

tainly used less in his day than it is in ours. "At the conscious level, the constraint of the *Gestalt* causes us to divide the field of vision into significant 'figures' and an insignificant 'background'. And yet, if anything is impossible for the artist, it is precisely to divide the plane of the picture into significant and insignificant areas. […] A true artist will see, with the psychoanalyst, that nothing produced by the human mind can be regarded as insignificant or accidental." The "true artist" goes into a state close to that of dedifferentiation that "does not deny reality […] that transforms it according to structural principles that work at deeper levels. […] The artist who wants to try to make a profoundly original work must not base it on conventional distinctions between 'good' and 'bad', but should prefer deeper, undifferentiated modes of perception that will enable him to grasp the whole, indivisible structure of the work of art […] and it is the scanning of the total structure that provides the artist with means to reevaluate details." Dalí exploited the full potential of this method of scanning, or integral sweeping, not only of the painted image but of his whole visual field. In the space of the painting itself, double images arise when certain parts of the "background" come forward and, by combining in different ways with other elements, form different "significant figures". To give a simple example, taken from *Endless Enigma*, the boat and all the small details of the landscape (no larger than an empty cotton reel that has fallen to the ground and rolled near a pavement …) that we see if we look at the painting as a seaside scene 'disappear' to leave 'empty spaces', in other words to give way to a 'background' under the upper part of a bowl, then 'reappear', assimilated to eyes, to turn the bowl into a face.

At the risk of surprising my reader, I would say that monochrome painting, including that of Yves Klein of course, is also a product of dedifferentiation. In a different formal register, I agree. But double and monochrome images are responses to the same desire. Both suggest infinity, through endless reversibility where double images are concerned, through extension of the field of colour for monochromes. Both abolish frontiers and deny contradictions.[87]

Revolutions in revolution

The ultramarine ultimately chosen by Klein as the exclusive colour of his monochromes is a shade with a power of radiation such that it does not easily accept a neighbouring colour. Dalí had already noted this, since the thirty-seventh of his *50 secrets magiques*, "revealed" in a publication of 1948, is "that of the incompatibility of ultramarine with other colours". Ultramarine has a tendency to dissolve the edges of the painting; it is a means of access to those "zones of immaterial pictorial sensitivity" defined by Klein; it is a springboard to the infinite that used to fascinate him in his youth as he lay on the beach to look at the azure sky. In October 1960, in front of Harry Shunk's camera, Klein leaped into the sky **fig. 41**. Did he, at that moment, have the "feeling of unlimited extension" that Ehrenzweig describes? Just as his colour escapes its outlines and spreads in all directions, so Yves the monochrome is no longer subject to the law of gravity. At least for the click of a camera.

129

41 Yves Klein, *"Un homme dans l'espace! Le peintre de l'espace se jette dans le vide!"* [A man in space! The painter of space throws himself into the void!], photomontage by Harry Shunk, 1960

In *The Madonna of Port Lligat*, particularly the first version, the bodies of the Virgin and Child open to the infinity of sky and sea; an azure point can even be seen splitting the Virgin's skull. Figures and objects levitate, as they do in *Leda atomica* (1947–49) **fig. 42**. The pendant to this *Leda* is a photograph by Halsman, *Dalí atomicus* (1948) **fig. 43**. While Klein and Shunk relied on the help and strength of the judo experts who caught the modern Icarus in a stretched tarpaulin, Dalí and Halsman benefited from the patience of the photographer's wife and assistants during the eight hours that the photographic session lasted, not to mention the good will of the cats, who were, it's true, amply rewarded with sardines in oil. But here is the result: two easels, a chair and Dalí leave the ground and cross the paths of three cats, one of which seems to being carried along by a jet of water.[88] A few years later Dalí and Halsman tried again with a photograph in which the artist is seen from a high angle, arms and legs spread

42 *Leda atomica*, 1949, oil on canvas, 61.1 x 45 cm
Fundació Gala-Salvador Dalí, Figueres

wide, supposedly rising into the air. The image was used on the cover of the American edition of the *Diary of a Genius* **fig. 44** and was copied twice, in the centre and at the top of the large painting of 1965, *Perpignan Station*. At this time Dalí was thinking about anti-gravity; he visited Dr Pagès, who lived in Perpignan, and had patented a gravity-defying "cosmic engine".

This dream of flight had begun in childhood, with its full ambivalence, even then. The laundry where Dalí set up his first studio was under the eaves. "'Up there!' Wonderful words! All my life has been dominated by these antagonisms: high and low. In my childhood I tried desperately to be high up." (VSD) One day he could stand it no longer. He climbed on the roof and felt vertigo for the first time. "There was nothing left between me and the void. I must have spent several minutes lying on my stomach with my eyes closed to resist its almost invincible attraction." The intrepid boy returned to his trough of warm water.

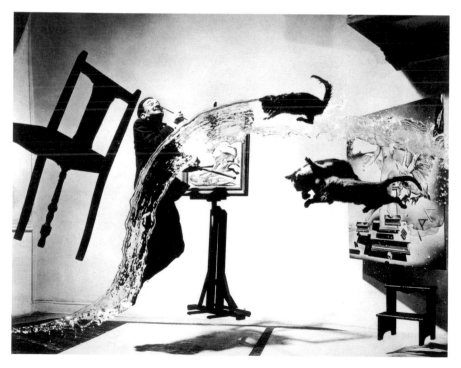

43 Philippe Halsman, *Dalí atomicus*, photograph, 1948

But a few pages earlier he has given us the key to this attraction. "Most of my readers will have felt the sensation of suddenly falling into the void, just at the point when sleep is going to take them over completely. Waking up with a start, your heart convulsively trembling, you don't always realise that this sensation of vertigo is a reminiscence of the expulsion of being born. [...] All those who throw themselves into the void have at bottom only one desire, to be reborn at any price." To this he adds, with a reference to Freud, that "flight is a symbol of erection". Annihilation in sleep, emptiness, rebirth and the promise of pleasure – we have not left the oceanic feeling.

Our view of things changes depending on whether they are seen from below or above. For a long time Dalí's philosophy left aside all conventional value systems and indeed the very principle of a value system. To the extent that "objective descriptions" of reality are as moving as poetry, "the words beautiful and ugly ceased to have any meaning". (MPC) Psychoanalysis had a part to play in this revelation. The finest feelings connect with the worst, so that, from the point of view of traditional morality, "Freud's mechanisms are very ugly." (MPC 37) In support of this statement Dalí provides the example of a woman who devotedly nursed her husband and fell ill herself when he recovered. Surely this was because unconsciously she wanted to be rid of him. The text I quote is that of a lecture given in Barcelona in 1930 on the "Moral Position of Surrealism", because "the surrealist revolution is above all a revolution of a moral order". A

44 Cover of the English-language edition
of *Diary of a Genius*, Garden City (Doubleday),1965

revolution whose consequence is that, in the eyes of the Surrealists, Sade "appears with the purity of a diamond". He may have looked that way to the Surrealists, but certainly not to Salvador Dalí senior, who found it hard to accept that his son could write, in the middle of a drawing, moreover suggesting the sacred heart of Jesus, "I sometimes spit on the portrait of my mother for fun". Not being familiar with Freudian dialectics, the lawyer could not understand that this in no way affected the affection felt by his son for his deceased mother.

To the "conventional distinctions between the 'good' and the 'bad'", which, according to Ehrenzweig, are removed during the process of dedifferentiation, we can add the distinctions between the true and the false, the real and the fake. Oppositions fade away. It has been said that this process can be characteristic of ecstasy. In 1933 *Minotaure* published a piece by Dalí, "Le phénomène de l'extase" [The phenomenon of ecstasy], in which he observes, "One might think that through ecstasy we would have access to a world as far from reality as that of the dream. – The repugnant can become desirable, affection cruelty, the ugly beautiful, faults qualities, qualities black miseries." (MPC 47) This process is also a stage in creation, which Dalí systematizes. His tendency to confuse the work and its creator makes this dedifferentiation an almost permanent state, his personal morality. We are warned in the early chapters of *The Secret Life*, which are devoted first to "false memories" and then to "true memories", given that "The difference between false and true ones is the same as for jewels: it is always the false ones that look the most real, the most brilliant". (SL p. 38) Anyway Dalí's "memory has welded the whole into such a homogeneous and indestructible mass that only a critically objective examination of certain events that are too absurd or clearly impossible obliges me to consider them as authentic false memories". (SL p. 39) In reality the paranoiac-critical method means that objective reality itself is a matter for caution. The images that materialize in paintings are as real as reality. Later the theory of the atom comes along and the reasoning is inverted: it is reality that ultimately has no more consistency than a falsity, no more unity than an image made from a fine net of points through which the eye passes. In both cases there is continuity rather than an opposition between reality and illusion. "Where is the real? All appearances are deceitful, the visible

surface is deceptive. I look at my hand. […] It is nerves, muscles, bones. Let us go deeper: it is molecules and acids. Further still: it is an impalpable waltz of electrons and neutrons. Further still: […] an immaterial nebula. Who can prove that my hand exists?" (PSD)

We might regret that the master was not always levitating among the nebulae. During the 1950s the need to live in Spain without being bothered led him to Franco's table. However, in his favour we can say that this was certainly a matter of opportunism and not political conviction, and also, as he justified it, fidelity to infidelity, the "congenital" spirit of treason. To Bosquet, who teased him about a decoration he had received from Franco, Dalí replied, "Let us illuminate my political positions. I have always been against any affiliation. […] I am the only surrealist who always refused to be part of any organization whatsoever. I was never a Stalinist, nor fooled by any association. Illustrious members of the Falange have solicited me; I never got involved." (ESD) And he ends, "If I accepted the Grand Cross of Isabella the Catholic from Franco's hands, it is because in Soviet Russia I was not awarded the Lenin prize. […] I would also accept a decoration from Mao Tse Tung."

In 1956 Dalí published *Les Cocus du vieil art moderne* [The cuckolds of the old modern art]. These were the years in which the New York School was asserting itself, in the city that Dalí had conquered a decade before. He did not show the affectionate attention to Jackson Pollock that he would later show to De Kooning; he referred to the drip technique as "bouillabaisse". Although I am moved by the harmony of this style of painting, I shall be Dalí's advocate. When judging him in this period one must keep all his work in mind and recognize that, owing to the fairly perverse disposition of its creator and his ability to go beyond contradictions, it absorbs and digests many contradictory developments of his day, more perhaps than it criticizes them; at the least in his eyes the differences between the ones and the others are often subtle.

As all those who scorn him well know, Dalí did better than to sing the praises of the modern style, he became keen on academic art. But what the contemptuous have not always understood is that Dalí defended the academic artists on the grounds that they made possible the emergence of the avant-gardes. "All that

is avant-garde arrived necessarily and unavoidably only as the murderous, fortifying debris of the 1900 explosion." (MPC 73) I am inclined to think that, beyond its ironic stance, this opinion was also forged in observation of the works and that, if our eyes were as good as Dalí's, we would tend to share it. "In Cubism or anecdotal Surrealism [the painter Edouard] Detaille,[89] with his microstructures, explodes in Cézanne. [...] Picasso's *Guernica* represents a retarded explosion of Carolus-Duran's *Murder of a Woman*."[90] (MPC 73) It remains the case that *Christ with rubbish* (1969), the improbable sculpture lying in the garden at Port Lligat, which could be taken for an Arte Povera installation and is made of heterogeneous objects, mostly gathered on the beach, comes shortly after the written *Hommage à Meissonier* [Homage to Meissonier].[91]

In criticizing abstraction what Dalí mostly had in mind was the heritage of Neoplasticism that had dominated the 1930s and 1940s. His mockery of Mondrian did not prevent him, where necessary, incorporating a few elements of Op art, as in *The Apotheosis of the Dollar* (1965), just as his swipes at Pollock did not stop him from undertaking several tachiste experiments. When he talks about Georges Mathieu, he says "my friend" (moreover he said the same of Malcolm Morley, then at the forefront of hyperrealism). But his favourite was Willem De Kooning, whom he wrote about in *Le Trois Cent Millionième Anniversaire de De Kooning* [De Kooning's three hundred millionth birthday], a masterpiece of poetry: "Let us watch this de Kooning, with his prematurely white hair making his great sleepwalker's movements, as though he was waiting in a dream to open bays of Biscay, to explode islands like pieces of orange or Parma violets, to tear continents from a cerulean blue split by oceans of Naples yellow [...] if by good or ill fortune, in the middle of this dionysian demiurge [...] the image of 'The Eternal Feminine' should appear [...] the least that might have happened to her would be that she should emerge (from all this chaos) wearing nothing but a little make-up." (MPC 75)

So, contrary to an opinion widespread in circles that are more politically and culturally correct than authentically dogmatic, Dalí did not fall behind the times after the Surrealist period. He may have praised Meissonier, but when it came to drawing up a "Comparative table of values according to dalinian analy-

sis",[92] Meissonier received o for genius while Picasso got 20 (compared to the 19 Dalí awarded himself). Dalí is a modern who remained modern in the middle of all his paradoxes and precisely because of these paradoxes. In the course of a lecture entitled *Picasso et moi* [Picasso and me], he had argued, "In 1951 the two most subversive things that could happen to an ex-surrealist were: firstly, to become a mystic and secondly, to know how to draw. These two models of rigour happened to me at the same time." (MPC 65) To Bosquet he maintained that, as a bourgeois who had betrayed his class origins to defend monarchy (another reason to praise Franco, who Dalí hoped would restore absolute monarchy), he was simultaneously an anarchist. But here I shall rest my case, since what better advocate could Dalí find than Pierre Naville? "From the purely surrealist point of view [...] the famous question 'who am I?' instantly invokes the answer: both obverse and reverse, as Dalí repeats that in pretending he speaks the truth, that in advocating the inquisition he demands the freedom to be rid of it, that in turning his wife into an image of the ascension of the Virgin Mary he proves that he wishes 'to be cretinized by the one I love', that in asking the Pope for permission to have a religious wedding to a Jewish divorcee without having Christian faith, he is theatrical, ceremonial, an actor; in short: I am 'at the antipodes from myself'."[93] Let us hope that soon Dalí will soon be given credit for his betrayal of the clichés of the avant-garde, which is also a fidelity to the rebellious spirit, just as, for a little while now, we have seen the rehabilitation of the Picabia of the kitsch, sexy nudes of the 1940s, the Picabia who declared, "Modern painting, modern literature, all the modern efforts of our valiant modern young people pushing the ploughshare into the sun rising on the horizon [...] – I don't give a shit about them."[94]

Leda, Dalí

Extending Anton Ehrenzweig's argument, it might be suggested that the greatest artists seek to 'hold' the dedifferentiation phase to the maximum, as we talk of 'holding a note', in other words maintaining their works in an undetermined state whose consequence is that their forms cannot always be entirely

identified and their meaning is never fixed. When Robert Rauschenberg claimed to stand on the border between art and life, or when Barnett Newman crossed vast canvases with a line that unified the plane instead of separating it into figure and background, weren't they trying to enable the viewer to perceive something akin to scanning and to leave the work open to multiple possibilities, including that of no longer existing? Open works, works in process and unstable forms render borders endlessly porous, break down barriers and maintain rather than resolve contradictions. So in this context it is no surprise to find the figure of the hermaphrodite re-emerging from time to time, however ancient the myth, as the sharpest metaphor for this indeterminacy. The mechanism of Marcel Duchamp's *The Bride stripped Bare by her Bachelors, even* is one of the most remarkable epiphanies, perfectly decoded by Jean Clair.[95] Framed by her glass door, the *Young Virgin self-sodomized* is not without similarities to the bride on her glass support, and a comparative study of the two pieces has yet to be made.[96] In relation to the artist's identification with his work, we should remember that some of Dalí's multiple personalities are feminine, just as Duchamp posed in *Rrose c'est la vie*. A great masturbator is somewhat predisposed towards sexual ambivalence and indeed mutation.

Masturbation exerts the capacity to move from one state to another, or even to adopt contrary or complementary positions simultaneously. Preparing to describe teenage masturbation sessions in front of a mirror, Pierre Guyotat writes, "What more brutally material sight can there be than that of a good-looking boy who, with his left [hand] wanks in the apparatus, his right hand writing. The confusion of that moment must be seen as one aspect of the contradictory impulse to be at once seen and voyeur (*seeing*), pimp and tart, *buyer* and *bought*, fucker and fucked."[97] The solitary pleasure is linked to two forms of abandonment: away from other people, temporarily abandoned by them or having abandoned them, one is all the more free to abandon all resistance to one's fantasies. Overwhelmed, carried by one's reverie, one comes close to an oceanic feeling. Sarane Alexandrian quotes Maneewan, wife of the Taoist master Mantak Chia, who states that "women who practise solitary pleasure are often impressed by the size of the inner space, by the communication of their bodies with the universe

and by their heightened sensitivity with others".[98] Perhaps the physical and spiritual exercises of Taoism help masturbation to acquire this quality. At the least masturbatory reveries enable us to remove many of the obstacles encountered in life, whether these arise in our relationships with others or are imposed on us by nature through our sexual identity. I have verified this in situations when I was filled with jealousy, which fosters a sense of being abandoned. I would indulge in long and frequent sessions of masturbation during which not only did I imagine participating in private moments between the couple that aroused my jealousy, but I would also take the man's place. For a while these sessions would leave me in a state of floating happiness, reconciled with the whole planet.

In his book entitled *Lorca-Dalí, el amor que no pudo ser*, Ian Gibson provides details of a scene Dalí described in his conversations with Bosquet, which took place in Madrid in the days when the poet and painter were students at the same academy **fig. 45**. Since Dalí persisted in turning down his advances, Lorca decided to make love in front of him with one of their young women friends. In his old age Dalí had not forgotten this episode and recalled that the girl, who was very

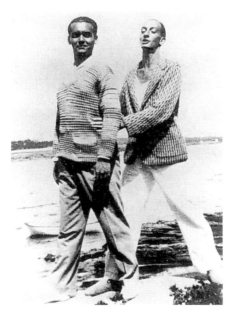

45 Dalí with Lorca

free in her behaviour, had an androgynous beauty. According to the account of the artist Maruja Mallo, who describes a little escapade she took part in, one day she and this girl borrowed Lorca and Dalí's jackets – which they wore as trousers – in order to pass as boys.[99] Gibson doesn't say what Dalí did while Lorca and the girl were making love. Nor do we know whether this scene fed fantasies. However, though true, it appears as the realisation of a fantasy whose broad outlines share something with my own reveries. In both cases there was a substitution of participants, overlaid with a substitution of sexes. Like masturbatory daydreams, experiences of this kind are one means by which we can experience our bisexuality without having to conceive of it fully, still less find it necessary to adopt it completely.[100]

The mysterious and delicate painting *Moi-même à l'âge de six ans, quand je croyais être petite fille, en train de soulever avec une extrême precaution la peau de la mer pour observer un chien dormant à l'ombre de l'eau* [Myself at the age of six, when I

139

46 *Myself at the age of six, when I believed I was a little girl, raising with very great care the skin of the sea in order to observe a dog sleeping in the shade,* 1950, oil on canvas, 27 x 34 cm
Private collection, Paris

believed I was a little girl, lifting the sea's skin with extreme caution to observe a dog sleeping in the shadow of the water] **fig. 46** is one of the most bare and at the same time most complex images in Dalí's work. Dalí as a little girl looks more like an angel whose body does not touch its shadow. In one hand he holds a shell, in the other the corner of the sea's skin. The dog is borrowed from *The Martyrdom of St Cucufat*, a sixteenth-century painting in the Museum of Catalan art, Barcelona.[101] The dark side of the sea's turned-back corner is the same shape as the knife used to kill the saint. The serenity of this image can be judged in the light of the combination of terror and shame expressed twenty years earlier in *Le Jeu lugubre* and the paintings that followed it, peopled with lions baring their canines and old men, always well endowed and equipped with scissors.

Since age makes us freer, particularly in self-expression, it is in the books of conversations that took place at the end of the 1960s and during the 1970s that Dalí is most explicit about sexual ambiguity and homosexuality (in Gibson's view Dalí must have known that Freud linked narcissism and homosexuality). I have provided a few quotations above. Before this time we must make do with clues that are few in number, but whose enigmatic form renders them striking. First is a bizarre game before a mirror: as a boy Dalí, who loved to dress up, donned a king's costume given him by an uncle. He put on the white wig, crown and ermine cape, but remained naked underneath, his penis hidden between his thighs "in order to look as much like a girl as possible" (VSD). The contrast between the description of the pre-pubescent, "feminized" body and the insignia of authority in which it is dressed is almost disturbing, as are, in everyday life, little girls dressed as ladies, old gentlemen whose wigs have slipped and the transvestites whose make-up and breasts fool no one. Whether we like them young or old, women by birth or by design, we always prefer to deal with people who have a unified physique. But, as countless photographs indicate, throughout his life Dalí retained a liking for dressing up, and as time went by he dared to wear increasingly grotesque costumes that were even more grotesque on an aging body. Photographs taken in 1975 by Marc Lacroix, when Dalí was an old man with a bare skull, recall the *Dalí drapé* [Dalí draped] series taken in 1933 by Man Ray, in which the painter is entirely enveloped in a white sheet and balances

a different object on his head in each image **fig.47**. However, in front of Lacroix's camera, the sheet, which turned the body into a kind of sculpture, has been replaced by a tunic of transparent net more appropriate to a nymph than the thin body we glimpse here **fig.48**.

The very last paintings of 1983 are certainly not masterpieces, but they are sufficiently strange to be worthy of attention and, particularly in relation to our concerns here, those entitled *Contorsion topologique de figure feminine* [Topological contortion of a feminine figure]. These show complex figures, apparently abstract at first glance, but in which fragments of human members appear. When I first saw them, these figures immediately reminded me of Alain Jacquet's sculptures made on the principle of the Möbius strip or Klein bottle (which is the three-dimensional shape made from two Möbius strips), such as *Mâ Coco* (1977) and *L'Acrobate* [The Acrobat] (1980) **fig.50**. Both strip and bottle are figures with only one surface. The reader will recall that I talked about Dalí's 141

atomized images and those of Jacquet as permeable surfaces that invite us to wonder what we would see by looking through them. The question becomes more complicated, or more interesting, if we think of a Möbius strip or a Klein bottle, whose surface has no underside. Everything that is inscribed on such a surface is part of a continuity. So it is not insignificant that Dalí spoke of one of these "feminine figures", precisely *Topological contortion of a feminine figure becoming a cello* **fig. 49**, as being also a self-portrait. The crooked fingers that seem to be disengaging themselves from this bent and folded figure – actions reminiscent of "the new man" trying to break out of his egg in the painting of 1943 – are said to represent "motor gripping due to illness".[102] Like most of the last paintings that bring back very old motifs, and although all the rest of this painting is done in grisaille, we can also recognize a curious red figure in the form of

49 *Topological contortion of a female figure in the process of becoming a cello,* 1983, oil on canvas, 60 × 73 cm Museo Nacional Reina Sofia, Madrid, Dalí bequest to the Spanish state

a crab, which is in fact one of four women in a picture painted fifty-five years earlier (!), *Four Fishermen's Wives in Cadaqués*. Like Alice, the little Salvador has passed through the looking-glass and, because he has aged a great deal, the contortions of his body are no longer those by which he hid his penis between his thighs. However the laws of topology ensure continuity between his masculine and feminine identities[103] – perhaps also continuity between him and the world, if we are to believe Catherine Millot's account: "The self and the world cease to be distinct, as though a continuity were established between inside and outside so that they formed a single space in which the self dissolved. Möbian figures, which Lacan used so often – the Möbius strip, the cross-cap, the Klein bottle – appeared to me then no longer as metaphors or abstractions, but as the most concrete reality."

50 Alain Jacquet, *L'Acrobate* [Acrobat] (large version), 1980,
gold leaf on synthetic resin, 52 × 64 × 67 cm

Halsman's *Dalí atomicus* is not the only pendant to *Leda atomica*. There is another, which is Dalí as Leda **fig.51**. This is also a photograph, taken at the same period, in the Port Lligat house. What drove Dalí to sit on the floor fully naked and take the place of Leda, with a stuffed swan (probably the one that served as a model for the painting) between his legs? His glance towards the camera has something shameless about it.

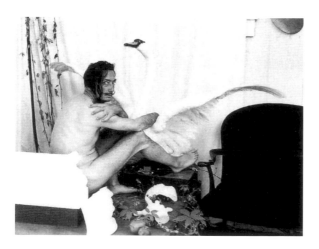

51 Dalí naked with a swan in Port Lligat, photograph, 1940s

"Narcissus, you're losing your body"

Given that Andy Warhol was preoccupied with appearances to the point of making them a foundation of his art, that he included self-image in this category and made no secret of his own narcissism nor the wounds it had suffered, I sometimes wondered why a man who incarnated the most sophisticated phase of civilization spent so much of his life going about with a tow-coloured wig on his head, mostly skew-whiff. I found the answer when in my turn I saw my own image appearing in newspapers and on television screens – to a lesser extent than Andy Warhol, of course, but, as he had himself predicted everyone would, I had my fifteen minutes of fame (and even a little more). I've never worn a wig but I have been dressed in hats that weren't my own; I have often had make-up applied – slapped on I could say; I have also been undressed or made to strike poses that, even with a good sense of balance, I could never have held for more than the few necessary seconds. I always went along with these whims willingly because I discovered almost at once that my narcissism was in no way affected. I can see myself looking dreadful or ridiculous on paper or screen and it leaves me completely cold, or at the most amused. This is not only because I reassure myself with the thought these are just images and the sight is less depressing for

those who get to know me in real life. Nor is it because any recognition is flattering, whatever opinion others may have of you. Much more than these things it is the sensation of no longer being circumscribed within yourself but, on the contrary, existing ever more in the eyes of others and, because there are a lot of them, enjoying a much more open, unstable existence. You feel so light, relieved, unburdened of your own persona because so many others each carry a little piece of you. I can vouch for the fact that one may even be tempted to give oneself up entirely to their very different and sometimes contradictory points of view, to be nothing more than a multitude of reflections that no longer have a referent. Do you think I am beautiful, ugly, strong, or weak? Please, go ahead. Make me weigh no more than a diffracted ray of light.

This state, which does not require any prior fading of consciousness – because on the contrary it demands hyper-attention to the dispersed traces of yourself – makes you feel you are escaping your limits, with a simultaneous feeling of annihilation in that escape that is akin to the oceanic feeling.

In Dalí uniform

This is how I understand Warhol's wig, like the accoutrements Dalí imposed on a body that, judging from the photographs taken at the seaside in the 1920s and 1930s, did not deserve such ill treatment. He acquired the habit very young: "Dressing up was one of the greatest passions of my childhood." (SL, p. 69) However it continued to an age when one wants to be attractive. During the famous summer of 1929, he writes, "I tried on my sister's ear-rings several times. I liked them on myself, but decided they would be a nuisance for the swim. Nevertheless I put on my pearl necklace. I made up my mind to get myself up very elaborately for the Eluards. [...] Definitely giving up attempting to paint any more, I took my finest shirt and cut it irregularly at the bottom, making it so short that it did not quite reach my navel. After which, putting it on me, I began to tear it artfully: one hole, baring my left shoulder, another, the black hairs on my chest, and a large square tear on the left side exposing my nipple that was nearly black. [...] But the most difficult problem was the trunks, which struck

me as too sporty. [...] Then I had the idea of turning them inside out. They were lined in white cotton, which was discoloured with rust stains from the oxidation of my belt." (SL, pp. 227–28). Continuing with his preparations, the aesthete was careful to match his colours and dyed his armpits with laundry blue. "The effect was very fine for a moment, but immediately my sweat caused this make-up to begin to run". (SL, p. 228) He needed red! By giving himself a really close shave, Dalí soon had blood-stained armpits. Perfume lent the final touch: a mix of fish glue, goat droppings and aspic oil, cooked up on the studio heater. "Miracle of miracles! – the 'exact' odour of the ram which I was seeking emerged as if by a veritable magic operation. I let the whole thing jell, and when it was cold I took a fragment of the paste that I had made and rubbed my whole body with it." (SL, p. 229) If even a very small part of this description is true, it must be said that Gala, who fell under his spell, was a woman truly lacking any kind of prejudice.

Wearing a striped suit or enveloped in a heavy overcoat, Dalí was the epitome of elegance. But he also dressed in a great many disguises that are all the harder to enumerate because they sometimes defy language. Can we describe as a helmet the headgear shaped like half an egg, surmounted by two little celluloid babies representing Castor and Pollux and a flashing light that lit up the genius's head during a lecture he gave at the École Polytechnique, Paris, in 1961 **fig. 52**? And, splendid though it may be, the embroidered satin body-suit worn over white cotton stockings is surely a clown's outfit.

"I am always dressed in Dalí uniform." (DG, p. 53) But what kind of uniform is never the same? Dalí was invited to Arturo Lopez's yacht: "I am the same being as that adolescent who was once so ashamed he did not dare cross the street or the terrace to his parents house. [...] Today we were photographed in super-disguise. Arturo had on a Persian costume. [...] I, the ultra-exhibitionist, wore turquoise Turkish trousers and carried an archbishop's mitre." (DG, p. 96) Dalí was affected, like Warhol (and the author of these words) by a natural shyness. His propensity to manufacture his own image was intended to make up for this shyness. Someone who finds it hard to accept their own person disguises it with masks. My idea is that when one observes that others have seized on this image 147

and inevitably distorted it, one can, instead of trying to maintain it, on the contrary speed up the process and conform to the distortions. This corrects any shyness more successfully. There is no need to be ashamed of oneself since it is other people who largely decide what one is.

Fèlix Fanés presents the *Journal d'un génie adolescent* as "the first phase of a project that kept getting larger [...] a valuable counterpoint that enables us to measure just how far the Dalí who was close to reality was from the other, more distant, complex and constructed Dalí, the result of an extraordinary effort of elaboration."[104] This is valid as long as we recognize that it was not so much a construction as a *millefeuille* and that this *millefeuille* is no further from reality than the boy who noted his early impressions in school exercise books.

The photograph of Dalí as Leda **fig. 51** is a good key to understanding the particular way his personality was crafted. First of all it shows that disguise can involve taking off all one's clothes. Disguise simultaneously conceals and uncovers. Clearly, in this case, uncovering reveals the feminine aspect of the person. To this we can add that Leda was the mother of two sets of twins, both consisting of a girl and a boy: Castor and Clytemnestra and Pollux and Helen. We know that Dalí was interested in Castor and Pollux. Ian Gibson notes that Gala's real name was Helen and that Dalí thought of himself as Gala's twin. Going back to Ehrenzweig and his conception of the "divine child", Dalí is both Leda the mother and the child – and the child's double. In the 1930s he began to sign his paintings "Gala-Salvador Dalí". The last words of the *Métamorphose de Narcisse* are "when this head bursts, / it will be the flower, / the new Narcissus, / Gala – / my narcissus". (MPC 60)

Hidden Faces offers other doublings, another *millefeuille*. In their love affairs the protagonists constantly replace one partner with another through the magic of fantasy or perversion, including at times when they want to be their own partners. "I don't like myself at all, but I would like to find someone exactly like me, whom I could adore", declares Veronica, whose narcissism via another person is no less a form of narcissism. This is handy, because her friend Betka thinks that she looks strikingly like Baba. In fact, as we recall, Veronica falls in love

with Baba, whose injured face is hidden by a mask, then marries Grandsailles

thinking he is Baba. So, in order not to give way to his love for Solange, Grand-sailles marries Veronica, but when he possesses her he has Solange in mind. Meanwhile Solange gives herself to Angerville in a moment of ecstasy in which she thinks it is Grandsailles who has come to visit her …. For anyone who doubts that the pleasures of the flesh are governed less by the flesh itself than by the sometimes tortuous twists of the mind, *Hidden Faces* is a demonstration particularly well padded with what Grandsailles calls "mortal sin by represen-tation. We might have guessed: *The Great Masturbator* has a gigantic head and a dream to match (the couple emerging from the back of his neck) and a body reduced almost to nothing.

But the splitting and doubling that interests us most here is that of Dalí in his two main characters. As we have seen, Dalí makes Grandsailles carry his fear of being impotent, his flight from the consummation of love, his perverse tal-ent for stringing others along and a few obsessional traits. Moreover he stated

149

52 Dalí with a helmet crowned with Castor and Pollux, worn during his lecture "Gala acidodesossiribonucleica" given at the École Poly-technique, Paris, 1961

that the name Cléda was a contraction of *clé-Dalí*, the key to Dalí. Cledalism, "a particular and majestic form of eroticism" (PSD), seems to explain one of Dalí's psychic dispositions. However, he claims that this passion "is in complete contrast to [his] passionate love for Gala". "I am", he goes on, "at Gala's feet, in a state of absolute submission and spirituality, whereas cledalism is a passion of demiurgical domination." (PSD) But when Dalí describes this desire for domination, he launches into the story of the parties at which, as master of ceremonies, he drove the desire and frustration of the participants he had invited to their limits.

In reality, submission and spirituality define the character of Solange de Cléda, while the desire to dominate is that of her beloved and spiritual torturer Grandsailles. Dalí is by turns, or at the same time, the one who dominates and the one who submits – the one who sets the rules and defers the sexual act (Grandsailles) and the one who accepts this deferral because it enables her body to separate from her soul (Solange). We can imagine that this tactic was useful in Dalí's relationship with García Lorca – as it was with the "Niña" whose amorous expectation the adolescent Dalí spun out before dropping her when he went off to study in Madrid.

We remember the place occupied by the ideal of St Sebastian in Dalí's relationship with García Lorca. Jean-Louis Gaillemin highlights this in explaining the methods Dalí used to defend himself against his attraction to the poet. In these years of effervescence, this ideal was associated with the adoption of a "sensual spirituality" – the expression comes from a letter from Dalí to García Lorca – with the unavowed aim of avoiding, as Gaillemin writes, "being submerged by the forces of Eros".[105] St Sebastian is an example of complete indifference to the body's situation. Similarly we might think of St Lucy, whom the two friends also mention. Did they know the legend according to which Lucy was a virgin whom the love of Christ rendered indifferent to the hideous tortures inflicted on her body? To the tyrant who threatens to have her taken to a brothel, *The Golden Legend* has her reply, "The body is corrupted only if the spirit consents; if you have me raped against my will, the chastity that will earn me my crown will be redoubled. You can never force my will to consent."[106]

Conversely deprived of carnal relations by the moral tyrant Grandsailles, Solange de Cléda is nevertheless driven to the same separation of body and mind. She remains faithful to her love for the count by treating her body as if it was someone else's. Even before her passion for Grandsailles becomes a Passion, Dalí gets her ready: "Beginning an imaginative life apart, Solange was preparing to pursue the realization of the unique miracle of caring for the physical person of her anatomy as an independent being. Thus, while she delivered her spirit to her passion, she provisionally lent the inexhaustible biological resources of her body to the studied mouldings of masseurs, beauticians, surgeons, dressmakers and ballet teachers." (HF, pp. 78–79)

The portrait is enhanced by subtle observation of the circles in which the author moved. In *The Secret Life* he defines the "elegant" woman as tyrannized by her jewellery and her dresses, with nothing but disdain for her body. A few lines of the *Métamorphose de Narcisse* had already warned us: "Narcissus, you are losing your body,/carried off and confounded by the ancient reflection of your disappearance,/your body struck by death/goes down to the topaz precipice with the yellow debris of love". And when the count drastically reduces the frequency of their chaste meetings, there begins "without truce or pity, the torture of separating her soul from her body so that the torments of the one should not encroach upon and wilt the intact beauty of the other". (HF, p. 156)

Dalí had had this feminine type in mind for a long time. In *Les Nouvelles Couleurs du sex-appeal spectral* [The new colours of the spectral sex-appeal], a piece written in 1934, he predicts that "all the new sexual attractiveness of women will come from the possible use of their spectral capacities and resources, in other words from their possibility of luminous, carnal dissociation, decomposition." (MPC 48) The fundamentals of what could be termed a similarly divided aesthetics are put in place. Presenting an exhibition of drawings by García Lorca, Dalí sums up the possibilities of painting as follows: "The Italian metaphysical movement started from the spiritual reality, a consequence of the physical miracle and its aspects grouped on an immaterial plane; all this formed a new *spectral* reality, in order to attain maximal, almost erotic creativity in touch./The cubists, on the other hand, starting from this sensual- 151

idealistic touch, found a pure, new form of spirituality./Lorca is one of those who have reached this new form of miracle by following the paths of the greatest incredulity. He does not even believe in his own hands, unless it be to turn one-legged physiological and abstract tables." (MPC 3)

The dematerialization of art and the artist

To a large degree the aesthetic system Dalí developed turns on this separation between the mental and all that is accessible to the senses. Years after writing the preface for García Lorca, Dalí no longer believed in his own hand: "Who can prove to me that my hand exists?" (PSD) The entire perceptible world is suspect and, despite the absolute priority given to visual perception, it is no more trustworthy than touch since "what is visible on the surface is merely fake". (PSD) Critical paranoia proves this; the visible world is not the objective world that penetrates the brain via the optic nerve, it is on the contrary the result of mental elaborations, "associations and delirious interpretations" which the subject "objectifies" (I'm using the terms Dalí uses in his definition of the phenomenon).

It is hardly surprising that such a mental conception of art should lead the man who mocked "old modern art" and abstraction to ideas that heralded … conceptual art. For example, what are the "anamorphic psycho-atmospheric objects" mentioned in a written piece from 1933? (MPC 43) They are objects obtained using initial objects placed in a completely darkened room. People who are not those who placed them there go and touch these objects, still in darkness, and describe their elements out loud. These elements are then reconstructed by different people again, according to the descriptions, after which yet other people reassemble them, still working in the dark. I'm leaving out the complicated arrangements enabling these assemblages to be photographed. The object is then destroyed and its photograph plunged into a mass of molten iron.

An anecdote reveals Dalí as a forerunner of the aesthetics of communication theorized by Fred Forest, one of the founders of sociological art. In 1961 Dalí worked on a ballet staged by Maurice Béjart at the Fenice theatre, Venice. As

the two men were unable to meet to discuss the design, Dalí spoke to Béjart on the phone. He told him to find a good television set and to watch a Spanish programme to be broadcast the next day on which he would be interviewed. Béjart followed these instructions and on the screen he did indeed see Dalí, who paid no attention to the journalist's questions, but spoke directly to Béjart and, helped by a demonstration involving a pot of soapy water, explained what he wanted. End of "interview". Béjart had received the message: Ludmilla Tcherina was to dance on a set of soap bubbles.[107] A year earlier, in response to an invitation from the International Annual Conference on Visual Communications, rather than making the trip Dalí had sent a video made with Halsman's help. Entitled *Chaos and Creation*, this is the recording of a lecture-cum-happening in which some pigs and a young woman in her underwear gambolled around in a structure supposedly reproducing the outlines of a painting by Mondrian, which also contained a motorcycle and was filled to the brim with maize seeds, echoing a sensual childhood memory. It is regarded as one of the first artistic uses of the new medium.

From virtual presence to transportation by means of Hertzian waves, the advantages offered by the new technologies could hardly escape a great masturbator. The projection and multiplication of his image were bound to satisfy his narcissism. But this projection is also a way of escaping oneself, a projection outside the body. Where is Dalí most present? In the Barcelona television studio where he is physically present, or at his one-to-one meeting with Béjart in Venice? Sarane Alexandrian relates the example of a ritual of Tibetan tantrism during which the monk sits in the lotus position, having drunk special liquor, "forgets his body [...] to see himself" and mentally has sexual union with a woman. He again refers to Austin O. Spare, who favoured "the 'death posture', lying on one's back, eyes closed [...] a position provoking a 'loss of all awareness of the body, a phenomenon which may conversely be experienced as a feeling of bodily omnipresence'." We know that masturbators are familiar with this kind of splitting. Their pleasure is not derived solely from the sensations given to them by their bodies; in their fantasies they also gain pleasure from being able to watch their bodies as spectators, and sometimes to regard them as quite

other, having taken on a different face and a different sex, or at least a different complexion, a different age. Lying on his divan in the "death posture", the masturbator-narrator of *Rêverie* notes, "I see myself as I am now, but clearly older. I have, moreover, let my beard grow after the old memory I have of a lithograph of Monte Cristo." (MPC 42) Also, "I see myself from behind, in the dining room ...". In front of the television camera does the artist see himself from behind or from the front, with Béjart, in the Fenice?

The gift of ubiquity that masturbators are led to exert, the ease with which they imagine themselves in different postures and different roles, make them a privileged guest in the media world. Their adaptability works wonders there. It goes against social constraints and just as much against relationships of love, whose aim is to give you a fixed place, to lock you up in a monolithic personality (otherwise you will be criticized for not 'sticking to' your role or that what you have just said or done "isn't like you"). Narcissus as a media presence escapes these pitfalls through his versatility, and still more easily so if he is a masturbator.

In Dalí's case, critical paranoia ensures continuity between the various manifestations of the person. If the same logic applies to these as to the whole of the visible world, the Dalí(s) seen through camera lenses are no less real than the Dalí(s) known to his chauffeur, cook, secretary and close friends. This suggests that the divisions that split any subject do not have to be experienced as conflicts, or repressed elements, and some people are able to open floodgates that allow the unconscious to flow back into the conscious. Painting, writing, performance and also, it must be said, the social theatre that surrounds all the arts offer a prime terrain for such things to rise to the surface.

It may seem surprising that Dalí should make a public show of revelations that would be unthinkable in more restricted circles of life in society and that he should feel more at ease unveiling his most secret traits in this way. As I have said, maturity may have encouraged Dalí to acknowledge homosexual leanings, but it is also very possible that it was easier to admit to them in a book with a print run of thousands than looking a close friend in the eye. If we carried out a survey of those whom the moralistic accuse of indecency, from porn stars to

artists and authors who reveal their inner selves, I'm sure many would confirm this paradox. Of course they would maintain, more or less hypocritically, that they never put forward images of themselves and that they are playing a game of hide-and-seek. But the real reason is that these people have raised a moral barrier that is not the one generally assumed, and which gives them access to a great happiness: they know there's no point trying to carry the weight of one's being all by oneself. It's so heavy that no one has ever been known to bear it alone. They have also understood and accepted the absolute pointlessness of sharing it with those close to them because the latter will not fail to unload some of their own burdens in exchange. But to unload some of this weight on to the greatest possible number, on to strangers whose own weight on both the social and emotional scales is unknown, offers happiness comparable only to that of an assumption.

Body subject to coercion

There is a mechanism with which masturbators are very familiar, which consists of pressing chosen parts of the body while they create mental representations, so that their bodies are converted into images. It's striking to note that the author who multiplies images of himself from one page to the next simultaneously describes his body as being often hindered, or meeting an obstacle. The feet of the man preparing to write *Diary of Genius* are, let us remember, squeezed by patent leather shoes. While not being obliged to take this information literally, we might think that Dalí was fairly receptive to the particular pleasure that consists in verifying the existence of one's body through pain. (When the pain is as sharp as that of toes imprisoned in undersized shoes may be, it is moreover called "exquisite".) His taste for these small tortures may have emerged very early, since a "false memory" from *The Secret Life*, which can be assumed to correspond to a real trauma, describes the boy who cannot take off his sailor top alone almost suffocating when he tries.

In the end the body often encounters a hard surface or bumps into another body. During their visit to Torremolinos, Dalí and Gala had a bed "so hard that

the mattresses seemed, instead of wool, to contain pieces of dry bread. It was uncomfortable to sleep on, but afterwards one body was completely covered with gentle bruises and aches which, when one gets used to them, become extremely agreeable, for then one perceives that one has a body, and that one is naked." (SL, p. 275) One of the events that unleashed the delirious obsession with Millet's *Angelus* was the author's collision with the fisherman coming the other way. Dalí felt "all the inevitability of the shock" (MTA) the more strongly because it took place in the middle of a field and he had seen the fisherman coming from far off.

The Secret Life begins with a curious, fairly general bit of reasoning: "We know today that form is always the product of an inquisitorial process of matter – the specific reaction of matter when subjected to the terrible coercion of space choking it on all sides, pressing and squeezing it out, producing the swellings that burst from its life to the exact limits of the rigorous contours of its own originality of reaction." (SL, p. 2) I would like to paraphrase: the "polymorphously perverse" Dalí we are dealing with is surely the result of an inquisitorial process of his consciousness, the reaction of that consciousness to a coercion of the social space, of the others who encircle him on all sides and force him to express himself in swellings that overflow his own life and are nothing but the imaginative proliferation of critical paranoia. A space that subjects "matter" to pressure, to "coercion", which makes this matter "burst" […] to the limits […] of reaction", is surely understood as masturbatory. In the "aerodynamic appearance of 'object-creatures'" mentioned above in relation to the pleasure procured by the extraction of blackheads, we read, "Space has become that good, colossally enticing meat, voracious and personal, that constantly presses its disinterested, soft enthusiasm against the fine smoothness of 'foreign bodies'." (MPC 51) Let us expand the comparison we have already established between squeezing blackheads and masturbation and between the released blackhead, the "smooth, precious larva" and the masturbator himself, who voluntarily removes himself from a group of sensualists. It is the whole person, body and imagination together, that feels expelled from a larger social group, in other words as an evacuation – for his greater satisfaction. Dalí has related his

first journey in the Paris Metro, which left him with the memory of "the horrible oppression of the *Métro*." (SL, p. 210) He nonetheless took advantage: "Having reached the surface, I remained crazed for a long time, gathering my spirits. I had the impression that I had been vomited by a monstrous anus after being tumultuously brewed by an intestine. I did not know where I was; as though spat out on to unknown land, a pointless little excrement. [...] And, a miracle! [...] This shock was a beneficial revelation. One must at every opportunity use the subterranean paths of action and thought, erase the traces, appear suddenly and irrelevantly, endlessly conquer oneself, never hesitate to sodomize one's soul so that it will be reborn purer and stronger than ever."

If we link the story of this experience to other dalinian themes, we find those of birth – expulsion from the maternal body – and rebirth – through which one escapes the determinisms of life. We find stifling paternal love, "delivered like a sledgehammer blow" (UC, p. 23) and solitary rebellion: already rejected by his father, Dalí would find a way to be excluded from Surrealism by Breton, the man who, by his own admission, played the role of his new father.[108] But we can settle for taking the story literally. The others (the crowds in the metro, the birth family, the intellectual family) treat the individual like shit; also the individual disguises himself ("erase the traces"), causes scandals ("appear suddenly and irrelevantly") and hardens his character ("endlessly conquer oneself" etc.) And gives the group as good as he gets: "I remember mentioning the possibility of leaving the excrement of major personalities to posterity."[109] (MPC 69) More precisely, in relation to relations with the Surrealists, "Shit scared them. Shit and arseholes. Yet, what was more human, and more needful of transcending! From that moment, I know I would keep on obsessing them with what they most dreaded. And when I invented Surrealist objects, I had the deep inner fulfilment of knowing, while the group went into ecstasies over their operation, that these objects very exactly reproduced the contradictions of a rectal sphincter at work, so that what they were thus admiring was their own fear."*[UC, p. 113]

Let us retain this association between excrement and rebirth as a guiding schema. An individual can think of himself as a reject from the social body and be sufficiently materialist to accept that he is not only metaphorically but liter-

ally constituted of corruptible matter ("My shit is an integral part of myself" [UC, p. 114]); in the best case, he will work to haul himself out of this state, forging his soul so that "it will be reborn purer and stronger"; it is not enough for him to be born, a body expelled by another body; he must be reborn, in other words invent himself, and through this invention no longer be the product of a body but of an imagination. That said, the products of the imagination do not remain in the immaterial order forever and can be embodied in objects that are their reflections or traces, and which will in their turn have the status of residue, rubbish. We find the model for this cycle in the lives of some saints, those who are said to have allowed their bodies to rot, for example through contact with a filthy bed (the tyrant has St Lucy's body sprinkled with urine), while their souls rose up to God, indifferent to physical suffering. Of course this did not prevent the subsequent establishment of a trade in their relics.

Everything about Dalí

The break with Surrealism was consummated in 1939. The last issue of *Minotaure* included an article by Breton entitled "The most recent trends in surrealist painting" in which, convinced that Dalí had made racist comments, he wrote, "I do not know which doors such a statement can open for its author [...] but I know which doors it closes to him". The following year, seeing him moving in the high society circles of New York, Breton named Dalí *Avida Dollars*.

In 1941 the Museum of Modern Art, New York, presented joint retrospectives of Miró and Dalí. Dalí was only thirty-seven and he was already a celebrity. In late 1934 he had drawn illustrations for a very wide circulation magazine, *The American Weekly* **fig. 53**. Some of these made a little story in juxtaposed vignettes, like cartoon strips. In December 1936 his portrait by Man Ray made the cover of *Time*. In 1939 he began working for *Vogue*. A great consumer of the press, Dalí was also a prolific supplier to it. Not satisfied with getting himself talked about in the cultural pages or obligingly feeding the sensationalist machine, he provided articles and designed layouts and covers (for *Esquire*, *Click* and many others, including the *TV Guide*). Félix Fanès notes that in Spain in 1929

Dalí contributed to a wide circulation newspaper, *La Publicitat*, and at the same time to a magazine with a very select readership, *L'Amic de le Arts*.[110] The United States offered him a massively expanded media arena. In exile from 1940 to 1948 and separated from the collective activities of the avant-garde, but an excellent sailor on the rising tide of the mass media, Dalí drew the essential lines of his character. The moustache, which he had worn as a fine brush until 1939, began to divide and turn upwards under the influence of the American climate. In all honesty this was not the best period for Dalí's painting. On the other hand it did see the publication of *The Secret Life of Salvador Dalí*, then of *Hidden Faces*, a novel which, despite its title, highlights and reveals different facets of its author and the connections between them. *Diary of a Genius*, however brilliant, penetrating and sometimes touching in the first part (1952), does not have the density of the American writings, nor of the *Mythe tragique de l'Angélus de Millet*. Meanwhile the books of interviews mostly repeat the content of the autobiographies, adding details to some episodes and enhancing them, but also making them more confused.

159

53 Illustrations for *The American Weekly,* 1935, pencil and ink drawing on paper, 54.6 x 40 cm
The Menil Collection, Houston

For those who insist on trying to grasp the essence of the ungraspable indi-
vidual, the two issues of *Dalí News* offer an excellent … substitute. The title is
of course a reference to the *Daily News*. Subtitled "Monarch of the Dailies", *Dalí
News* sadly had only two editions, in November 1945 and November 1947. Each
publication accompanied an exhibition of Dalí's work at the Bignou Gallery,
New York. *Dalí News* really is a good newspaper! Everything is there on its four
large format pages, from studies to society gossip, jokes and last minute items in
brief, comic strips, advertisements and "predictions" instead of an astrology col-
umn. Of course its one writer is also its one object of curiosity. The headline of
the first edition **fig. 54** announces: "Extra! Dalí triumphs in apotheose of Home-
rus" (*sic;* referring to the title of a painting in the exhibition), that of the second
consists entirely of the names of Truman, Marshall, Picasso and Dalí, printed in
enormous letters. We can read accounts of Dalí's exhibitions and books and a pre-
view of good bits from the *Fifty Secrets of Magic Craftsmanship*. Even when the star
does nothing at all, this is food for an article, actually two articles ("Dalí in re-

160

54 Page of *Dalí News,* 20 November 1945
Fundació Gala-Salvador Dalí, Figueres

pose", "Dalí still resting"). Beyond the amusement occasioned by this celebration of self, we should note the subtle shifts of tone that, as always with Dalí, enliven these pages. On the ballet *Mad Tristan*, which he had presented the previous year, we can read the exchange of letters between the *New York Times* and the artist, arguing over whether or not Dalí is an iconoclast. The question is left hanging because, either way, as the article concludes, it's better to be uncertain about being an iconoclast than about "being a war criminal". A hook on the front page sends us directly to page four, on the pretext that it contains an article "censored" by Dalí: in reality this is a piece of society gossip describing guests at a private view whose names have all been carefully blanked out. Again on the first page is the reproduction of a detail from a painting on show in the exhibition, *Idylle atomique et uranique mélancolique*, a vision stimulated by the shock Dalí felt when he heard about the dropping of the bomb on Hiroshima; the last page has a box advertisement praising the virtues of Dalinal, an antidote to melancholy, which cures depression, disgust with life and many other ills. And, as nothing escapes this paper's investigations, the article "Exhibitionism" offers hints to autograph hunters who want to pursue the most "eccentric" and "hystero-narcissistic" of Surrealists. They are told how to recognize him by his clothes and what his daily movements are, including on rainy days.

I know of two other examples of auto-monographic newspapers. Yves Klein's *Dimanche 27 novembre*, called "the one-day newspaper", and Braco Dimitrijevic's *The Post Historic Times*. Like the *Dalí News*, both are printed on a single sheet folded in the format of a daily paper and comprising a range of illustrated articles of different lengths and pieces in boxes. The former is Klein's contribution to the Festival d'art d'avant-garde of 1960. It documents a theatrical performance running from midnight to midnight on that 27 November; people come and go as usual and the stage is everywhere. The newspaper describes all the steps that led the artist to this piece. Among other things, we find the photograph of the leap into the void **fig. 55** under the headline "A man in space!". Dimitrijevic meanwhile distributed *The Post Historic Times* **fig. 56** in Venice in 1993, while he was also presenting an exhibition, *Citizens of Sarajevo*, at the Biennale. Owing to the international context his titles are sometimes in English, sometimes

161

55 Yves Klein, *Dimanche 27 novembre 1960,* "The one-day newspaper"

in French. The editorial announces that the newspaper will appear irregularly and only when required by news events. Apparently these relate mainly, but not solely, to the intense activity of the artist.

The "literature" page offers three pieces of fiction, including the following: a brilliant railway track-layer finds a way to cut the rails into the right lengths so that when a train passes over them they play Beethoven's ninth symphony. Sadly he dies long before a particularly attentive, music-loving traveller hears the music. The genius will remain forever unknown. This example illustrates Dimitrijevic's philosophy, according to which the entire official history of art consists of misunderstandings, overlaid by missed opportunities; a subjective history would re-evaluate unknown masterpieces, which would then enter into a dialogue with the pieces now in museums. In a way he is relativizing his own work. One of his best-known actions consisted moreover of stopping an anonymous passer-by in the street, taking their photograph and exhibiting this por-

There are no mistakes in history.
The whole of history
is a mistake.

The Post Historic Times

Anno Post Historicum XXIV PARIS, LONDON, NEW YORK N° 1

Editorial

Louvre is my studio, street is my museum.

trait enlarged to a height of several metres on the façade of a building, as though it were a hoarding advertising an exhibition by a famous artist.

In 1960 I was an anonymous little girl, but I can claim to have played a part in a piece by Yves Klein, as can every human being who was alive on that Sunday 27 November. Putting your signature to an entire day of human history as you would claim authorship of a play may be regarded as megalomaniacal, and the same can be said of claiming to overturn the hierarchies of the history of art, as it can of publishing an edition of a newspaper entirely devoted to yourself. However a short piece in the "one-day newspaper" makes us qualify this statement: "When I have at last become like a statue through the exacerbation of my ego which has led me to this ultimate sclerosis […] then and only then will I at last be able to set this statue up and come out of myself into the crowd to go and see the world. No one will notice anything because they will all be looking at the statue and I will be able to go about, free at last". There is a punchline: "It's

163

56 Braco Dimitrijevic, *The Post Historic Times*, 1993

then that I shall realise my eternal dream: to become a newspaper reporter!" To sum up, this means that beyond the heightened glorification of oneself lies a keen attention to others. It is possible that Yves Klein, who had mimed flight and put his signature to the infinite, had read Charles Baudelaire's *Painter of Modern Life*: "The crowd is his domain, as the air is the bird's. [...] For the perfect *flaneur*, for the passionate observer, it is an immense pleasure to take up residence in numbers, in undulation, in movement, in the fleeting and the infinite."[111] And perhaps Dalí had read it as well. "To see the world, to be at the centre of the world and to remain hidden from the world, herein lie some of the lesser pleasures of these independent, passionately impartial spirits, which language can define only clumsily."

This is one of the metamorphoses of Narcissus. The statue is a decoy. The person it celebrates is elsewhere, having melted into the crowd.

These artists are curious demiurge's apprentices. In their own inoffensive way they appropriate the world and its inhabitants. On the basis of an entirely arbitrary selection Dimitrijevic publicly displays the faces of people who have certainly not asked to be singled out for such treatment; Klein recruits billions of involuntary actors and makes their actions his own. Throughout his career Dalí liked to subjugate and manipulate those around him; he strutted and stamped before a "fascinated crowd", "hailed by thousands of photographers' flashes" (JDG), and did his best to siphon off as much media attention as he could, imitating journalists' methods where necessary. While the *Dalí News*, *Dimanche 27 novembre* and *The Post Historic Times* were produced with humour and obvious parodic intent, in their egocentrism they sought to re-establish the central position of the artist, whom modernity had pushed to the margins of society. However, it would be wrong to regard this egocentrism as moving in a centripetal direction only. Its movement is also centrifugal. Megalomaniacs doubtless fall into different categories, but the ones I'm describing here developed a fairly contradictory form. They worked to erect their own statues using the tools and materials of their day – cameras and newspaper – but these are unstable supports that can be broken and scattered like sandcastles in the wind.

Meanwhile, when the baudelarian artists mingled with the crowds on the grand

boulevards, they saw opening before them what would soon be called information superhighways.

If Dalí had been a sculptor wanting to portray himself as a hero, would he have created a war hero like Grandsailles, who takes the identity of another war hero, Baba, whose face has been hidden by a mask? If he had wanted to portray himself as a saint, would he have chosen Solange de Cléda, an aristocratic saint whose physical being is annihilated and transcended by her unchanging love? These portrayals would not have given us a fixed image of the artist, since our eyes would have automatically shifted to another image, like the exploring, paranoiac-critical eyes of Dalí. We might have regarded him more benevolently than the critics of the clown who excited the media, but we should not have defined him any more clearly.

If we find it so hard to define Dalí's personality, it is because the painter is an eye and this eye goes everywhere, lights on everything. It sticks to reality and deliberately allows itself to be taken in by appearances; just as the fried egg without a plate viscously spreads across objects it encounters, it espouses the visible world rather than seeking its own identity in what would then be an encounter with the world. Critical paranoia is a method of objectification that regards introspection as a possible but far from obligatory means of elucidation after the event; its aim is not self-knowledge. In "Digest of a critical history of the cinema", his preface to *Babaouo*, Dalí called "contemporary cinema" a "psychological dustbin", signifying that he did not regard either his painting or his writing as such. Once again I would compare mental wandering with physical wandering: of "Albert's obsessional and uncontrollable travels" Ian Hacking says that "they systematically lack any goal: they are not so much voyages of discovery as attempts to eliminate the self".[112]

"Surrounded by countless people who murmur my name and call me 'maître', I am about to inaugurate the exhibition of my one hundred illustrations of the *Divine Comedy* at the Galliera museum." (DG, p. 189)

Here is Baudelaire again on the subject of the modern painter: "His passion and his profession is to *wed the crowd*". And again, "So, the man in love with universal life dives into the crowd as into a vast reservoir of electricity. He can

also be compared to a mirror as vast as the crowd itself, to a kaleidoscope endowed with consciousness which, each time it moves, depicts the multiple life and shifting grace of all the elements of life. He is a *me* hungry for *not-me*."[113]

A *me* hungry for *not-me*. People who obey their eyes completely, who follow them faithfully every time they are drawn to something, are certainly not inward-looking, even if they are narcissistic, and even when what they think is part of the external world is partly an externalization of their inner worlds. Critical paranoia gives them a relationship of osmosis with the world; they know the oceanic state that dissolves the boundaries between the me and the not-me, and that state is one of a great availability, including a readiness to accept the eyes of others turned towards them. To the doctor who questions him the friendly Albert replies, "I'm 26. I know this because you told me so."[114] Because friends call him "Divine Dalí", Dalí adopts the name, and he is also Avida Dollars because Breton told him so.

The curse of the ex-adoptive father may even have been crucial to Dalí's project of constructing or reconstructing his life as though it were a work of art: "The anagram 'avida dollars' was a talisman for me. It rendered the rain of dollars fluid, sweet and monotonous. Someday I shall tell the whole truth about the way in which this blessed disorder of Danaë was garnered. It will be a chapter of a new book, probably my masterpiece: 'On the Life of Salvador Dalí Considered as a Work of Art'." (DG, p. 35)

The book was never written but the life as a work of art was indeed realised. And it was … a life's work. "Before, less aware of what was inside me, I felt no responsibility at all. Today I pay more attention to my actions and my thoughts. I measure my ideas against those of the greatest living men. In my everyday life every action becomes ritual. The anchovy I chew is in some way a part of the fire that lights me. I am the dwelling of a genius." (PSD) When, at other moments, Dalí states, "I know that I am a genius", we can understand that this genius was not innate, that an appropriate dwelling had to be build for it.

It was also a collaborative work. "Popularity, even at its most mediocre, delights me. […] I behave nicely with the public, out of the same concern for
166 prudence that makes me generous in cases of epidemics or other collective

calamities. [...] Beware, I tell myself, because you may be judged at the end of time, if there is an end of time and a judge. [...] Beware of the day when no one asks you for anything any more, be nice while playing with the cretinization of advertising! [...] Any reflection of my existence in others calms my worries about the feeble degree of reality of things, the world and myself. It's from all these eyes, in which I see myself seen, that I take my substance." (PSD) As this speech was transcribed by Louis Pauwels, we don't know whether Dalí used the precise word "substance". If he did it would represent an interesting extension of the doubt he had previously expressed when, for example, he saw his hand gradually losing materiality. He brings this vision back in conversation with Pauwels and adds, "but where is substance? If it is not in nature it can't be in God. [...] In a reality that endlessly disperses before the eye, fades away between our fingers, the only really material matter, the only really substantial substance, would be God."

While being only a man, it seems Dalí manages to acquire some of this substance from the eyes of others looking at him. From this perspective there is no body that pre-exists its image multiplied in all the eyes turned on him, and the image must first be made to appear in the eyes of others so that a substantial being can be born out of it.

This conception has a Gnostic resonance. According to the Gnosis, individual human beings are merely the projection into the world of their true, essential being. In the Gnostic texts this transcendent being is given different names: "essential man", "real man", "man of light", "light and my light" and so on, and for some it is assimilated to an "angel".[115] I note this last word because Dalí's thinking went through an "angelic" period and a few angels pass through the paintings of the early 1950s. In one of his bold theoretical constructions, he assimilated angels to protons and neutrons, observing that it was their force that brought about the assumption of the Virgin Mary, who went to join God, the one substantial being. According to Gnostic theology the body, that fallen part of man, is merely an appearance or mask, no more real than its reflection in a mirror. Hence the disdain with which some adepts treated this body, with which they refused to identify. Surely Solange de Cléda is a Gnostic saint, abandon-

ing her body to sickness as she does and allowing herself to die, transported by the power of her love, which causes her to split in two. As she is dying she sees herself already dead and asks that the coffin lid should not be nailed down before she gives the order. Her creator pretends to have observed "vestiges of Clédalism in which the mind seemed to function not only independently of but in contradiction to certain laws of the organism, thus offering an exception to the old idea that the body is the mirror of the soul". (HF, p. 158) And with good reason, since the body is trash, a husk; for some Gnostics our carnal state already means we live as dead people. Narcissus can lose his body and a flower will be born in its place. Despite his narcissism and self-glorification, it is verging on understatement to say that Dalí did not try to present himself in an idealized light in either his physical transformations or his confidences. The man who shows himself, or who is seen by turns as beautiful and ugly, proud and grotesque, bold and reactionary, manipulatory and masochistic and who is put on display in his later years, emaciated and diaphanous, dressed entirely in white, is in reality a mere appearance. Though this appearance is embodied, it has no more reality than its reflections in mirrors, self portraits and autobiographies, in the eyes of his fellows. At best we can hope to grasp the most possible of these appearances, add them together, superimpose them and try to synthesize them, but we will only ever gather shards of the real person. In the last years of his life, arguing that scientific theories suggested the body could be made to survive through dehydration, Dalí refused to eat. So the doctors fed him through a nasal tube. Gilles Néret comments, "In his earlier *Recettes d'immortalité*, Dalí had spoken of 'immortality assured by dehydration and the periodic return to the larval state attested by the discovery in 1967 of a type of micro-organism of the family of Collembolae. This was a living fossil group, known since the Devonian period (Palaeozoic era – 400 million years ago).' In reality he was losing interest in his body. Only the immortality of the 'garden of his mind' mattered to him."[116]

The dynamic that causes reflections to proliferate also causes them to scatter. Though Dalí regarded himself as a good writer, and rightly so, he had to speak through transcribers and translators. The first of these was Gala, helped by Eluard and Breton, then Haakon M. Chevalier, who translated *Hidden Faces*

and *The Secret Life* into English, Hélène Pasquier for the French version of *Hidden Faces* and Michel Déon for the French adaptations of *The Secret Life* and the *Diary of a Genius*; then, if we include the books of interviews, Louis Pauwels, André Parinaud and, to a lesser extent, Alain Bosquet. As has been said, Dalí wrote mainly in a phonetic French with whimsical spelling and almost no punctuation **fig. 57**. According to Michel Déon he had to be made "accessible" to readers.[117] Déon also says that Dalí asked him to reinforce "the exasperating detail of it all",[118] in other words to respect his hallucinatory concern for detail, but was not very punctilious about how this was done. Having straightened out sentences that were too long or incomplete and cut whole passages, Déon worried about the author's reaction. But the author was very happy, recorrected very little, did-n't argue with the cuts and dedicated the original edition to his interpreter with the words, "With my thanks for his dalinian adaptation". It seems likely that Haakon Chevalier met with no more opposition when he had to

169

57 *Suvenirs hintrahuterins*, 1941, blue ink on paper, 27 x 20.2 cm, Fundacío Gala-Salvador Dalí, Figueres, Centre d'Estudis Dalinians

"temper the native exuberance of [Dalí's] expression and reduce it to written language without losing its essential qualities".[119] It would doubtless be good for all readers to experience this exuberance for themselves, and no doubt one day they will be able to do so,[120] but we should not be more dalinian than Dalí. Let us accept this Narcissus who looks for himself not in some flattering magic mirror, nor in water deep enough too drown in, but in the eyes and where necessary the words of others, of us.

Glory is an echo chamber of fantasies and desires. Dalí is right to rejoice that "the more I see people who know about my existence, the better I observe that the mind circulates round the planet and that the noosphere is taking shape, so that anywhere in the world I can swim in my own bath" (PSD) – because that bath is much bigger and safer than the trough of warm water he used to sink into as a child. Dalí speaks of waiting at the now mythical Perpignan station: "There are people all around me. I feel isolated and that is when I have an instant of absolute pleasure …. I sit on my bench as at a border crossing, I feel myself available, and intense jubilation invades me, a monumental joyfulness." (UC, p. 156) This is one of the peaks of solitary pleasure: under pressure from the eyes of others, one feels expelled from their gathering as pleasure is released from the organ that has been pressed. One is "returned" to oneself, not in death-dealing solitude, but on the contrary, "available".

Moral

I would not have given this book the orientation that it has if I had not had the experience of writing an autobiographical work myself, and if that book had not found a very broad echo. Before that certain character traits or, some might say, neurotic tendencies (priority given to visual perception, obsession with detail, a parallel penchant for dissimulation and scrupulous honesty), sexual inclinations (onanism, benign scatology, a tropism of the behind), and also certain events of varying importance (premature loss of a brother, Catalan attachments) had led me to begin to deepen my interest in Dalí's work through an interest in his personality which, I felt, I could understand somewhat from the inside. But the fact that so many readers gained some personal use from my exposure of my own private life – many, I'm sure, through readings that were superficial, fragmentary or more or less blind, but always valid – led me to a greater understanding of the form of psychic organization exemplified by Salvador Dalí.

The first time – of what proved to be many – that I was asked if I had written my book in order to know myself better, I was stunned. That was one thing that had never occurred to me! I wanted to reply that it would be truer to say that I'd written it so that I wouldn't have to know myself any more. I had also stopped having psychoanalysis precisely so I wouldn't have to pursue my investigations any further. It's just possible that I wrote it so that others would take over the task, which they certainly did. To this I can add that the written narrative overlays memory and that it's now almost impossible for me to remember the events contained in the book other than through the descriptions I chose to give of them. My memories, which are all "true", have become "false memories". I would like to adopt Dalí's statement, "But I very early realized, in-

stinctively, my life formula: to get others to accept as natural the excesses of one's personality and thus to relieve oneself of his own anxieties by creating a sort of collective participation" (UC, p. 17), had I not started so late, and with so much less excess and brio.

One day someone affably said to me, "It's fine, you're still young, you're starting a new life". I hadn't thought of that either. Rebirth is not a theme of Dalí's that I share. In everyday terms I don't really have a new life. Instead what happens is that, every time I'm with someone I don't know who thinks they know me, far from feeling trapped by their view, on the contrary I feel washed clean of myself.

New technologies now allow us to melt into an infinite mass of endlessly rearranged pixels, expanding our presence to the world and to others by teleportation, while our knowledge of human beings should anyway have caused us to abandon the idea of a monolithic subject. So it is strange, and in my view regrettable, that a reaction of fear has encouraged the spread of a morality that forces us to identify ourselves absolutely. We are enjoined to "find ourselves", to express "our inner truth", to defy influences that might prevent us from "being ourselves". As a result everyone braces themselves against what they think is their platinum core when it is only a tiny heap of micaceous sand, and this attitude is of course a source of conflict and suffering.

Clinging to an absolute self is as vain and absurd as it would have been to try to dissuade Dalí that a cottonless cotton reel abandoned in the gutter was worthy of our full attention or that two stones spontaneously placed upright facing each other showed exactly the same configuration as the man and woman in Millet's *Angélus*. The paranoiac-critical method applies in the same way to people as to objects, with the advantage, as we know, of being contagious. Dalí gambled on his power of persuasion and Lacan acknowledged that paranoia could be a factor in "human communication".[121]

The general opinion of Dalí and his work in intellectual and artistic circles has been evolving for some years now. This is due firstly to the efforts of critics and historians, those whose work I have used in the preceding pages, and who brought Dalí out of both the gilded prison of Surrealism (his work being

regarded as interesting only during that period) and the cupboard in which the reactionary buffoon had been shut away. More importantly, many artists perhaps feel more at ease talking about Dalí these days and describe how important he was for them, often in the crucial period when their vocation was taking shape. Indeed Dalí's advice is very good. Not only, as he pointed out, was he not mad ("the only difference between a madman and me is that I'm not mad"), we might even say he was a sage.

58 Salvador Dalí rereading and correcting the manuscript of Catherine Millet's *Dalí and Me,* submitted to him by the author

Appendix

List of Dalí's written works cited in the text

The Secret Life of Salvador Dalí, translated by Haakon
 M. Chevalier, first published 1942; page nos.
 given from the edition published London,
 Vision Press, 1976 [SL]
Hidden Faces, translated by Haakon M. Chevalier, first
 published 1942; page nos. given from the edition
 published London, Peter Owen, 1973 [HF]
Le Mythe tragique de l'Angélus de Millet, first published
 1963
Diary of a Genius, first published as *Journal d'un genie*,
 1964; page nos. given from the edition published
 London, Pan Books, 1976, 1980 [DG]
Entretiens avec Salvador Dalí (by Alain Bosquet), first
 published 1966 [ESD]
Les Passions selon Dalí (by Louis Pauwels), first pub-
 lished 1968
Oui, méthode paranoïaque-critique et autres texts, Paris,
 Denoël, 1971; nos. given are those of the short
 pieces (this has been published in English
 Boston MA 1998, but the excerpts quoted are
 translated anew from the original French)
The Unspeakable Confessions of Salvador Dalí, *as told to*
 André Parinaud, first published as *Comment on*
 devient Dalí, les aveux inavouables de Salvador
 Dalí, 1973; page nos. given from the edition
 published London, W.H. Allen, 1976 (but the
 excerpts quoted are translated anew from the
 original French) [UC]
Journal d'un genie adolescent, Monaco, Le Rocher,
 2000 [JGA]

Translation of Catherine Millet's text and of original
 texts by Dalí in French (except those of *Diary of*
 a Genius) by Trista Selous

Notes

1 Conference *Les Écrits d'artistes depuis 1940*, 6–9 March 2002, organized by Les Archives de la creation for the IMEC (Institut Mémoires de l'édition contemporaine).

2 Dalí's emphasis.

3 André Chastel, *L'Illustre Incomprise*, *Mona Lisa*, Paris, Gallimard, 1988.

4 On the relationship between the theories of Dalí and Lacan and the possible influence of each on the other, see Sarane Alexandrian, *Le Surréalisme et le Rêve*, Paris, Gallimard, 1974; Patrice Schmitt, "De la psychose paranoïaque dans ses rapports avec Salvador Dalí", in exhibition catalogue *Salvador Dalí*, Paris, Centre Georges-Pompidou, 1979; José Ferreira, *Dalí-Lacan, la rencontre*, Paris, L'Harmattan, 2003.

5 Jacques Lacan, "Le problème du style et les formes paranoïaques de l'expérience", in *Minotaure* 1, 1933.

6 "Une rencontre avec Michel Déon de l'Académie française", in Frédérique Joseph Lowery (ed.), *Lire Dalí, Revue des Sciences humaines* 262, Lille III, Université Charles-De-Gaulle, 2001.

7 In *Pages françaises*, Gallimard, 1999. Cited by Frédérique Joseph-Lowery, *op. cit.*

8 Cited by Frédérique Joseph-Lowery, who transcribed them in "Du nez en peinture", in *Lire Dalí, cit.* I should say that the discovery of these transcriptions by Frédérique Joseph-Lowery, which make snatches of Dalí's outrageous writing accessible, was one factor that encouraged me to write this book. Pages of manuscript are reproduced in the catalogue of the exhibition *Dalí una vida de libro*, Biblioteca de Catalunya, Barcelona, 2004.

9 "Introduction à Salvador Dalí", in *Journal d'un génie adolescent*, Monaco, Le Rocher, "Anatolia", 1994–2000.

10 Describing his reactions during his "trial" by the Surrealists, Dalí writes (*Diary of Genius*), "the polymorphous pervert that I had been during my adolescence reached a peak of hysteria".

11 Cited by Ricard Mas Peinado in *Dalí*; from the French translation Éditions Hazan, Vanves, 2003. Preface by Carlos Rojas.

12 In *The Shameful Life of Salvador Dalí*, New York, London, WW Norton & Co., 1997, Ian Gibson mentions an interview in 1973 for a programme on British television in which Dalí advanced the same theory.

13 But not everyone. Ian Gibson, *op. cit.*, tells us that the piece published as an appendix to the French edition of the *Diary*, the extract from *L'Art de péter, ou Manuel de l'artilleur sournois*, by the Comte de La Trompette, was suppressed by the American publisher.

14 According to the account of the poet Rafael Alberti, on hearing of Dalí's relationship with Gala, García Lorca exclaimed, "That's impossible! He can only have an erection when someone sticks a finger up his arse." Gibson reproduces this quotation. We can surely suppose that, were "someone"'s finger not available, his own would do the job.

15 The phrase "first painter of arses" is Luis Romero's, published in French translation in *Dalí, tout Dalí en un visage*, Cercle d'Art, Paris, 1975 and 2003. Jean-Louis Gaillemin, in *Dalí, désirs inassouvis, du purisme au surréalisme 1925–1935*, Montreal, Le Passage, 2002, notes that Dalí was almost certainly the first "in the history of official painting" to use masturbation in the subject and title of a painting (p. 140). However Gaillemin is forgetting Egon Schiele.

16 Notably the group of connoisseurs called Le Zodiaque [the Zodiac], who made it their aim to support Dalí financially. Cf. Gaillemin, *op. cit.*

177

17 We can appreciate the urgency with which Dalí presented this undertaking all the more for its strong contrast with the approach of that hygienist and future reference-point for the avant-garde, Marcel Duchamp. Duchamp adorned his head with a star-shaped tonsure to meet the requirements of a photograph, abandoned paintbrush bristles and made a large, hairless nude (*Étant donnés: 1° la chute d'eau, 2° le gaz d'éclairage*). Cf. Didier Ottinger's demonstration, "des Nus, vite" in *Art Press* 154, January 1991.

18 Jacques Lacan, *op. cit.* note 5.

19 A good search will reveal the Catalan "delir", meaning "ardent desire" My thanks to Father Verdaguer for this information.

20 Bernard Lamarch-Vadel suggests this idea in *Erik Dietman*, Paris, La Différence, 1989.

21 Which, as we have said, did not prevent Dalí from attaching to his *Diary* a humourous appendix, "The Art of Farting", by Count Trumpet.

22 Jean-Jacques Rousseau, *Confessions*, Book I.

23 For amateurs and fetishists we can cite a motif of shoes designed by Dalí for ties in 1951, which is somewhat reminiscent of the shoe designs that earned Warhol his early successes.

24 David Vilaseca, "Le réel de l'œuvre autobiographique de Salvador Dalí" in *Lire Dalí*, *op. cit.* note 6.

25 "He was taking up too much space in my life" said Valerie Solanas to explain her action, although she was not a friend of the artist. Cited by David Bourdon in *Andy Warhol*, Paris, Flammarion, 1989.

26 *Radioscopie*, 4 January 1971, on France Inter, released on CD by Radio France, 1999.

27 For more detail on the Surrealists' accusations against Dalí, see Ian Gibson, *op. cit.* note 12, pp. 375–80, and Salvador Dalí, *Diary of a Genius*, for May 1952. The description Dalí gives of Hitler's "chubby flesh", soft and milky, comparable to that of a wet-nurse, is a sexual diagnosis worth noting. The comparison also figures in *Hidden Faces* in relation to a Nazi soldier whose chubby back is like that of a nurse. Showing a great deal of perspicacity himself, Pierre Naville offers a fine analysis of all the aspects on which Breton and Dalí agreed in this area: "The down-to-earth maxims of historical materialism that Breton tried to acclimatize to the ambiance of objective and more or less miraculous chance mattered little to him [Dalí]. He upended the relationship, so that social realities bent before the delirious requirements of the surreal. This made both Hitler and Stalin no more than fantastical dolls in an ironic game of history, of which Freud was the brilliant magician." See "Dalí, Dalí, Dalí!", *Le Temps surréel*, vol. I, *L'Espérance mathématique*, Paris, Galilée, 1977.

28 Marie-José Mondzain, "Image, sommes-nous propriétaires ou possedés", in *Art Press* no. 284, November 2002.

29 From Andy Warhol, *My Philosophy from A to B*.

30 Jorge-Luis Borges, "L'Auteur" in *Oeuvres complètes II*, "Bibliothèque de la Pleïade", Gallimard, 1999.

31 Severo Sarduy, "Un art monstre" in exhibition catalogue *Baroques 81*, Musée d'Art moderne de la Ville de Paris, 1981. Author's emphasis.

32 *Vanguardia Grandes Temas* 1, Barcelona, January 2004.

33 Jean-Louis Gaillemin, *op. cit.* note 15.

34 *Aurore, midi, couchant et crepuscule* [Dawn, midday, sunset and dusk]. As there's no stopping progress, in principle the canvas is presented with a sound track: "What time is it?" "It's time for the Angelus!" "Then, Waiter, bring me a Harlequin!" ("Harlequin" is the name of an aperitif).

35 Cited by Gaillemin, *op. cit.* note 15, p. 47. St Sebastian is also known as a homosexual icon.

36 René Crevel, "La minute qui s'arrête, ou le bienfait de Giorgio De Chirico" [The minute that stops, or Giorgio De Chirico's good deed], in *Sélection* 7, 1924, reprinted in René Crevel, *Mon corps et moi* [1925], Paris, LGF, "Livre de poche", 1991.

37 I could not have failed to note this phrase, which was used an incalculable number of times by critics in relation to *The Sexual Life of Catherine M.*

38 For the connoisseur of contemporary art this example inevitably recalls the work of video artist Douglas Gordon.

39 Dalí is backing up his description of two schematic images that are no more than collections of points.

40 Similar effects can be found in Malraux's work: "When the professor's car stops, the military salutes of Commander Berger and the lieutenant adjutant are met by the large movement of a wide-brimmed felt hat; a hand pushes back a muffler worn as a scarf (in June), another throws a half-finished cigarette at their feet: hands, cigarette, muffler, grey hair that is almost long, a whole pigeon loft flies up from the professor's face"

41 Both quotations are taken from Francis Ponge, "Proêmes", 1943 in *Tome premier*, Paris, Gallimard, 1965. Ponge's emphasis.

42 In particular Dalí criticized Buñuel for his "primary anticlericalism. [...] I don't mind a few blaspheming images, but you have to put some fanaticism into it, as you do for real sacrilege!" (VSD)

43 James Bigwood, "Cinquante ans de cinema dalinien", in exhibition catalogue *Salvador Dalí*, *op. cit.* note 4.

44 In *La Parisienne* and reprinted *ibid.*

45 Breton, in *L'Union libre*.

46 Catalogue for the exhibition *Haptisch, la caresse de l'oeil*, Musée de l'Abbaye Sainte-Croix, Les Sables-d'Olonne, 1993, and particularly Gérard Simon, "L'apparition des valeurs tactiles en optique géométrique".

47 Luis Romero, *Dalí, tout Dalí en un visage, op. cit.* note 15.

48 Dalí's short story of 1931 is contemporary with the first re-editions of the Marquis de Sade, initiated in 1926 by Maurice Heine. In 1929 Heine was asked to acquire the roll of the *Cent Vingt Journées de Sodome* [120 Days of Sodom] for Dalí 's patron, the Vicomte de Noaille. We can assume that Dalí had access to it before its publication in 1935.

49 These are the opening lines of *La Pornographie, une idée fixe de la photographie* by Alain Fleischer, Paris, Éditions de la Musardine, 2000.

50 *Car elle s'en va la figure du monde*, Paris, Grasset, 1985.

51 I would like to thank Frédérique Joseph-Lowery for letting me have her transcription of Dalí's original text. She also observed that the saliva membrane is like a hymen and that it is one of the clues Dalí gives to his androgynous character.

52 Richard Hamilton, "Romanticism", in *Collected Words 1953–1982*, London, Thames and Hudson.

53 Like horns, arseholes are a subject of Dalí's theories, particularly – again – rhinoceros arseholes. See *Aspects phénoménologiques de la méthode paranoïaque-critique*, lecture given at the Sorbonne in 1955 (MPC 67).

54 *Tardes d'estiu* (Summer afternoon), a short story written in 1919–20, manuscript cited by Robert Descharnes in *Dalí, l'oeuvre et l'homme*, Paris, La Bibliothèque des Arts, 1984.

55 Cited by Luis Romero, *op. cit.* note 15.

56 Ian Hacking, *Mad Travelers*, Charlottesville, University of Virginia Press, 1998.

57 Philippe Tissié, 1887, *Les Aliénés voyageurs*, Paris, Doin, cited by Ian Hacking. Dr Tissié recorded Albert's observations.

58 Freud asks this question during one of the discussion sessions of the first group of psychoanalysts, at his house in Vienna. See *Les Premiers psychanalystes. Minutes de la Société psychanalytique de Vienne, 1910–1911*, Paris, Gallimard, 1979. This phrase is cited by Sarane Alexandrian, *La Sexualité de Narcisse*, Paris, Le Jardin des livres, 2003. The latter work was very useful to me for the following pages.

59 *Les Confessions*, Flammarion, "GF", I, p. 147.

60 Sarane Alexandrian, *op. cit.* note 58.

61 This quotation is from *Les Confessions*, Book IX, Paris, GF Flammarion, vol II. In a note the editor, Alain Grosrichard, cites the entries on "pollution" and "nocturnal pollution" in the *Encyclopédie*. Voluntary pollution, which is accompanied by daydreams, is of course more blameworthy than involuntary or nocturnal pollution, which occurs during sleep.

62 René Crevel, *Mon corps et moi* [1925], Paris, LGF, "Le livre de poche", 1991.

63 Thomas Laqueur, *Solitary Sex. A cultural history of masturbation*, New York, Zone Books, 2004.

64 Jean-Yves Tadié (ed.), Paris, Gallimard, "Bibliothèque de la Pléiade", 1987, vol 1. In the final version the narrative is separated into two distinct passages and, instead of the feminine curves

of the hills, the panorama offers the vision of a tower, the Roussainville keep. The vocabulary is not quite the same either, less violently "dalinian".

65 Paris, Éditions surréalistes, 1934.

66 In the meantime Robert Descharnes says that in 1982 he found a manuscript in a New York storage facility whose contents Dalí had asked him to repatriate. However, the text of the 2004 edition (Paris, Sabine Wespieser (ed.)) is the same as that of the first edition, Paris, Stock, 1973.

67 Postscript to the French edition of *Hidden Faces*, Paris, Stock, 1973.

68 Dalí's own foreword to *Hidden Faces*.

69 In conversation with Pauwels, Dalí refers to the medievalist René Nelli. In *L'Érotique des troubadours* (Paris, 1963, new edition 10-18, 1974), Nelli describes "the contemplation of the naked lady" and "the 'asag' (test of love)", both ceremonies very similar to the relations between Grandsailles and Solange imagined by Dalí, with the difference that, in the medieval tradition, it was the lady who imposed them on her lover as a reward for his continence.

70 See above, note 26.

71 But to Pauwels Dalí claims that this nickname was initially chosen in preference to the description "archangelic", which friends wanted to give him.

72 Cf. David Lomas's entry on the *Metamorphosis of Narcissus* for the catalogue *Salvador Dalí*, edited by Dawn Ades, exhibition at the Palazzo Grassi, Venice and the Philadelphia Museum of Art, 2004. English language edition New York, Rizzoli International Publications, 2004.

73 *"Hon"* means "She" in Swedish. The artist made the work in collaboration with Jean Tinguely and P.O. Ultvedt for the Moderna Museet, Stockholm, in the summer of 1966. Niki de Saint-Phalle and Jean Tinguely had previously taken part in a "Homage to Dalí" in the Figuerés bullring in August 1961.

74 Respectively Dalí's native town and location of the museum of the Fundació Gala-Salvador Dalí; location of his childhood holidays; nearby fishing port where he lived and worked; chateau that he bought Gala and where he moved after

her death. All within spitting distance of each other.

75 Although the author of a guide to Dalí's places notes in relation to Port Lligat that "the contemplation of an enclosed sea can generate a melancholic feeling" and that the cypresses planted by the master create a romantic atmosphere close to that of Böcklin's *Island of the dead* (the painting which the author of *Rêverie* was supposed to be studying). See Sebastià Roig, *Dalí, le triangle de l'Ampurdan*, Figuerés, Fundació Gala-Salvador Dalí and Triangle Postal, 2004.

76 Anton Ehrenzweig, *The Hidden Order of Art: A Study in the Psychology of Artistic Imagination*, first published in English 1967.

77 Catherine Millot, *Abîmes ordinaires*, Paris, Gallimard, "L'Infini", 2001.

78 Vermeer's *The Lacemaker* was "baptized" in the waters of Cap Creus. A photograph by Robert Descharnes, reproduced in *Dalí de Gala* [Gala's Dalí] (Edita/Denoël, 1962) shows the couple up to their necks in water holding a reproduction of the famous masterpiece.

79 Reprinted in exhibition catalogue *Salvador Dalí*, *op. cit.* note 4.

80 Cf. Jennifer Mundy, entry for *Autumn cannibalism*, catalogue for the exhibition *Salvador Dalí*, Venice, *op. cit.* note 72.

81 Before the photograph of the *Saut dans le vide* taken by Shunk and Kender in October 1960, and for which he made his leap above a tarpaulin held by two judo experts, Klein made a few spontaneous attempts without protection. During one of these, he sprained a muscle. During another he hurt his shoulder, which gave him problems for several months. Cf. Thomas McEvilley, "Yves Klein, conquistador du vide", in exhibition catalogue *Yves Klein*, Paris, Centre Georges-Pompidou, 1983.

82 In parallel with what has just been said about Dalí, I recall that Klein alternated his visions of the infinite with praises of the flesh whose trace is preserved by anthropometrics, and that he predicted an "anthropophagous era" in a written piece called *Naturemétrie* [Naturemetry].

83 Luis Romero, *op. cit.* note 15.

84 Ian Gibson, *op. cit.* note 12. The interview, published in *El País*, was reprinted in Ricard Mas, *La Vida pública de Salvador Dalí a través de sus mejores entrevistas*, Barcelona, Parsifal ediciones, 2004.

85 Ian Gibson, *Lorca-Dalí, el amor que no pudo ser*, Piaza & Janes Editores, 1999; French trans: *Lorca-Dalí, un amour impossible*, Stanke, Montreal, 1999. Cf. also Gaillemin, *op. cit.* note 15.

86 "Discours prononcé à l'occasion de l'exposition Tinguely à Düsseldorf (January 1959)", in Yves Klein, *Le Dépassement de la problématique de l'art et autres écrits*, Paris, École nationale des beaux-arts, 2003.

87 The reversibility of double images has been analysed by Patrice Schmitt. "In the double image, form presides as a kind of articulating pivot of desire. [...] The double image appears to carry the fantasy of fragmentation-unification in which reversibility is guaranteed by the reversibility of the structuring *Gestalt*." In other words, once one has distinguished the eyes that belong to the face in the *Enigma*, one can still, if one so chooses, "see" the bowl again.

88 The easels were suspended from wires, Mme Halsman, out of frame, was holding the chair, the assistants threw the water and cats at the precise moment that Dalí jumped and Halsman pressed the button. Halsman used twenty-eight rolls of film but his photograph is printed from a single negative. Within one of the empty frames placed on one of the easels, Dalí later painted forms reproducing those of the cats, his supposed models, directly on to the photograph. Cf. Félix Fanés in exhibition catalogue *Dalí. Cultura de masas*, Barcelona, CaixaForum, 2004.

89 Many of us had no doubt forgotten that this pupil of Meissonier was the champion of military painting. Dalí described him as follows: "He dresses as an officer before taking up his brushes and throwing large compositions on to the canvas, treated with the minute exactitude inherited from his teacher". (MPC 73) When I read these words I cannot help "seeing" Georges Mathieu, dressed as a samurai, "throwing large compositions on to the canvas".

90 On the meaning to give Picasso's *Guernica*, his opinion was at least shared by Philippe Sollers, who saw in it "a real domestic row". In "De la virilité considerée comme un des beaux-arts", *Art Press* 50, summer 1981.

91 On the occasion of the presentation of his large painting *Tuna Fishing* in 1967 (MPC 73).

92 Published on several different occasions in different forms, notably as an appendix to his *Diary of a Genius*.

93 Pierre Naville, *op. cit.* note 27.

94 Francis Picabia, "Ils n'en mourraient pas tous", in *Paris-Journal*, 23 May 1924.

95 Jean Clair, *Marcel Duchamp ou le grand fictive*, Paris, Galilée, 1975.

96 Despite studies of the relationship between Marcel Duchamp and Salvador Dalí including Pilar Parcerisas, "Salvador Dalí and Marcel Duchamp: a game of chess" in the catalogue *Dalí, Elective affinities*, Barcelona, Sala Verdaguer, Palau Moja, 2004; Estrella de Diego, "'To be a painter' or 'to be Duchamp'? Dalí, Warhol and autobiographical conflict in a media society", exhibition catalogue *Dalí. Mass culture*, Barcelona, CaixaForum, 2004.

97 Pierre Guyotat, "Langage du corps", in *Artaud, Bataille*, colloque de Cérisy 1972, 10/18, 1973, reprinted in *Vivre*, Paris, Denoël, 1984; Paris, Folio, 2003.

98 Cited by Sarane Alexandrian, Maneewan and Mantak Chia, *Le Tao de l'amour retrouvé: l'énergie sexuelle féminine*, Paris, Guy Trédaviel, 1991.

99 Ian Gibson, *op. cit.* note 12.

100 In an article on *The Great Masturbator* (reprinted in *Hereses du désir*, Sayssel, Champ Vallon, 1985), Alain Roger cites Freud, according to whom "the masturbator tries, in his conscious fantasies, to feel the sensations of both man and woman in the situation he represents to himself". We could add that, in the same piece, "Hysterical phantasies and their relation to bisexuality" (Standard Edition IX), Freud suggests that the unconscious fantasies of hysterics, which are repressed fantasies that were one conscious, "fully correspond in their content to the satisfactions that perverse individuals consciously realise". Lorca's initiative resembles a first step towards this kind of satisfaction. The erotic "ceremonies" later organized by Dalí would fully reflect this objectivization of fantasies.

101 Luis Romero, *op. cit.* note 15.

102 Robert Descharnes, Gilles Néret, *Salvador Dalí, 1946–1989, l'œuvre peint*, vol. II, Benedikt Taschen, Cologne, 1993.

103 By the same logic it can be argued that Jacquet's *Acrobate*, whose mouth meets its anus, is at once a masturbator and a hermaphrodite; its body and thus, it can be supposed, its organs are reversible (a bit like Marcel Duchamp's *Objet-Dart*).

104 Preface to Salvador Dalí, *Journal d'un génie adolescent*, 1994; French edition Monaco, Le Rocher, "Anatolia", 2000.

105 Jean-Louis Gaillemin, *op. cit.* note 15. See *ibid.* for the quotation from the correspondence.

106 Jacopo de Voragine, *The Golden Legend*, under 13 December.

107 Cf. J.-J. Tharrats, *Dalí et le ballet*, 1983, an extract from which is reproduced in Ricard Mas Peinado, *op. cit.* note 11.

108 The most arrogant presentation of dalinian "genius", the *Diary*, is introduced by a quotation from Freud as an epigraph: "He is a hero who revolts against paternal authority and conquers it".

109 Dalí notes things that were said in an exchange with Marcel Duchamp. Just before this one can read: "This is why Marcel Duchamp devoted the rest of his life to filling suitcases with everything that – from near or far, or rather from very near – might interest him, fully aware that the excrements that accumulated in Louis XVI's navel should have been preserved, which is not true of those of an anonymous liftboy."

110 Félix Fanès, exhibition catalogue *Dalí. Cultura de masas*, *op. cit.* note 88. This wonderful exhibition identified all the exchanges between Dalí's work and popular culture. While Dalí produced pieces for the press, fashion, advertising, cinema and more, these sectors also made great use of his work, part of which can be described as pre-Pop.

111 This quotation and the next are taken from Charles Baudelaire, *The Painter of Modern Life* (*Le Peintre de la vie moderne*), III.

112 Ian Hacking, *op. cit.* note 56.

113 Charles Baudelaire, *op. cit.* note 111, his emphasis.

114 Ian Hacking, *op. cit.* note 56, Document 2, Tissié (*Les Aliénés voyageurs*): observation of Albert.

115 My knowledge is drawn from Henri-Charles Puech, *En quête de la Gnose*, Paris, Gallimard, 1978. This book was very helpful to me some time ago when I was working on Andy Warhol, supreme master of appearances.

116 Robert Descharnes, Giles Néret, *op. cit.* note 102.

117 Cf. Frédérique Joseph-Lowery, "Une rencontre avec Michel Déon de l'Académie française", in *Lire Dalí*, *op. cit.* note 6.

118 Letter from Dalí to Michel Déon, cited in the conversation above.

119 Haakon Chevalier, preface to *Hidden Faces*.

120 Thanks to the work of Frédérique Joseph-Lowery, who is studying the manuscripts and preparing a precise transcription of *La Vie secrète de Salvador Dalí* to be published by Éditions L'Âge d'homme (Lausanne). The manuscripts are preserved at the Fundació Gala-Salvador Dalí. Dalí's writings have been the subject of two exhibitions: *Dalí et les livres*, Generalitat de Catalunya/Ville de Nîmes, 1982, and, more complete and accompanied by a remarkable catalogue, *Dalí, una vida de libro*, Barcelona, 2004. I should like to thank those in charge of the latter exhibition, its director Vivenç Altaió and curators Daniel Giralt-Miracle and Ricard Mas, for their very kind welcome. Thanks in particular to Ricard Mas for information that satisfied my own love of detail.

121 Jacques Lacan, *op. cit.* note 5.

Published with the support of the Ministère Français
de la Culture et de la Communication, Paris

Cover photo: Dalí naked with a swan in Port Lligat, photograph, 1940s
© Salvador Dalí, Gala-Salvador Dalí Foundation / 2008, ProLitteris, Zurich

Endpapers: Ernst Scheidegger, Salvador Dalí in his studio, photograph
© 2008 Neue Zürcher Zeitung, Zurich

Frontispiece: Salvador Dalí, *Young Virgin auto-sodomized by the horns of her own chastity*,
1954, oil on canvas, 40.5 × 30.5 cm, Playboy Collection, Los Angeles
© Salvador Dalí, Gala-Salvador Dalí Foundation / 2008, ProLitteris, Zurich

Translation: Trista Selous
English-language editor: Paul Holberton
Design: Guido Widmer, Zurich
Printed by: DZA Druckerei zu Altenburg GmbH, Altenburg, Germany

First published in French as *Dalí et moi*
© 2005 Éditions Gallimard, Paris

© 2008 the English-language edition
Verlag Scheidegger & Spiess AG, 8001 Zurich, Switzerland

ISBN 978-3-85881-711-2

German edition:
ISBN 978-3-85881-204-9

www.scheidegger-spiess.ch